AN ANG LEE FILM

GEMINI MAN

THE ART AND MAKING OF THE MOVIE

MICHAEL SINGER

GEMINI MAN: THE ART AND MAKING OF THE MOVIE

ISBN: 9781789092233

Published by
Titan Books
A division of Titan Publishing Group Ltd
144 Southwark St
London
SE1 0UP

WWW.TITANBOOKS.COM

First edition: October 2019

10 9 8 7 6 5 4 3 2 1

To receive advance information, news, competitions, and exclusive offers online, please sign up for the Titan newsletter on our website: www.titanbooks.com

Did you enjoy this book? We love to hear from our readers. Please e-mail us at: readerfeedback@titanemail.com or write to Reader Feedback at the above address.

A CIP catalogue record for this title is available from the British Library.

Printed and bound in Canada.

AN ANG LEE FILM

GEMINI MAN

THE ART AND MAKING OF THE MOVIE

MICHAEL SINGER

TITAN BOOKS

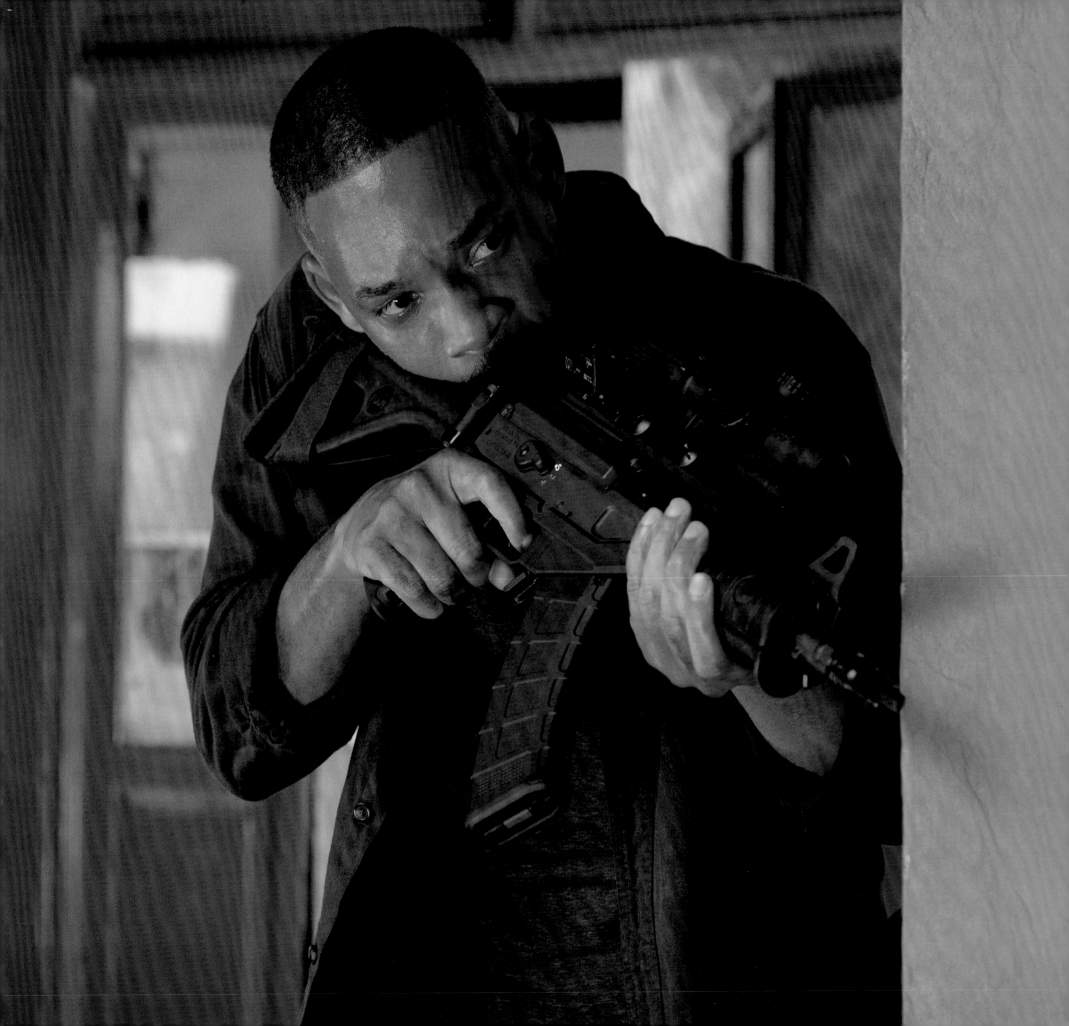

CONTENTS

COMING INTO FOCUS
THE JOURNEY OF GEMINI MAN

After more than two decades in development, with innumerable starts and stops along the winding path to active production, the first day of principal photography of the greatly awaited *Gemini Man* began in February, 2018. Just as he had on previous films, two-time Academy Award-winning director Ang Lee began the production's filming with a joyous opening 'Big Luck' ceremony. Each member of the cast and crew were invited to light incense sticks while Lee regaled the company with rousing words and best wishes for a successful shoot. After everyone bowed to the four directions, and a moment of silent meditation, Lee enthusiastically banged the gong several times. It was a warm and wonderful way to begin a communal enterprise on the right foot.

By any Hollywood standards, *Gemini Man* underwent an unusually long gestation period of some two decades

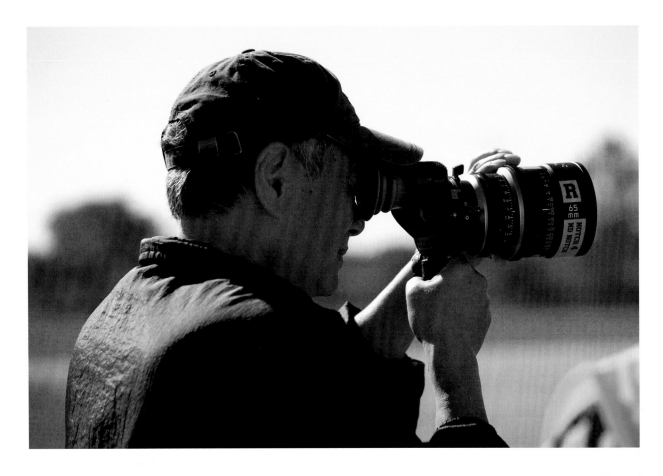

before it would finally go before the cameras. The film was originally developed by Hollywood Pictures, an arm of Walt Disney Studios which produced films for more mature, rather than family, audiences. The story idea was strikingly original and presented no end of possibilities for development into a fascinating thriller: an aging assassin is suddenly pursued by a younger, even more lethal antagonist who turns out to be himself at half his current age.

Mike Stenson, executive vice president of Walt Disney Pictures (and later president of Jerry Bruckheimer Films), developed the original screenplay with executive producer Don Murphy (*Natural Born Killers*, the *Transformers* films), and screenwriter Darren Lemke, ultimately attracting the participation of Tony Scott, one of Hollywood's most successful filmmakers. Throughout its development phase, the screenplay would attract some of Hollywood's top screenwriting talent, including Christopher Wilkinson and Stephen J. Rivele, Jonathan Hensleigh, and Andrew Niccol.

Rejecting the use of makeup to either age up or age down the protagonist to effectively portray either his older or younger self, the studio was determined to explore options of

creating a fully digital and performance capture character as the younger version of the central character. In the early 2000s, Walt Disney Studios began a series of tests to see whether this was possible. The always busy Tony Scott, with projects on his slate piling up, could no longer wait for the technology to catch up with the times, and moved on to other films

What originally intrigued Disney executive Stenson was the ability to tell a character driven story in the middle of an action thriller by splitting the lead character, forcing him to confront his younger self. The master of this kind of filmmaking, Jerry Bruckheimer, responded to these same elements and assumed producer reins in 2006. "I loved the concept," recalls Bruckheimer. "It was unique, fresh, and different. It was not something I had seen before, and I always look forward to making movies that are different in the marketplace."

Bruckheimer and his team brought a new writer onboard to tackle the script: the pre-*Game of Thrones* David Benioff. Benioff deliberately chose not to read any previous *Gemini Man* scripts, deciding to build upon the concept with his own characters and plotline, and would write seven revisions. In 2009, Curtis Hanson, who had directed such highly praised films as *L.A.*

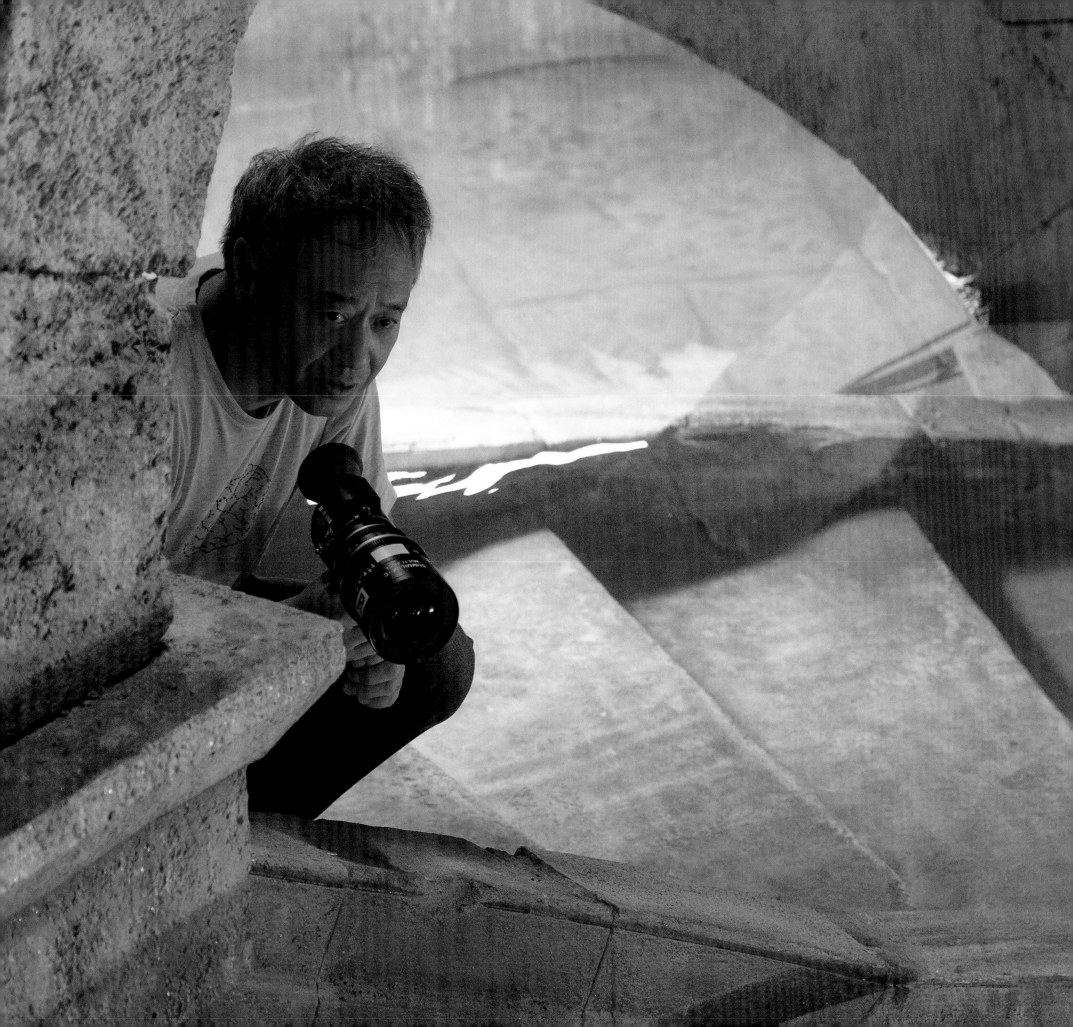

Confidential, Wonder Boys, and *8 Mile,* came onboard the project. Sadly, Hanson's subsequent illness prevented him from continuing with *Gemini Man,* and he passed away in 2016.

Meanwhile, more visual effects testing was being done to see if advances could finally allow the creation of a believable digital and performance capture character. "We spent a year and a half on such testing with some of the best visual effects artists in the business," says executive producer Chad Oman, president of Jerry Bruckheimer Films, "but it just didn't work… the technology still wasn't there to create a fully believable, one hundred percent photo-real leading character in a film."

With Walt Disney Pictures now focusing on family films, Jerry Bruckheimer was seeking a different home for *Gemini Man.* And in October 2016, he found a willing and able partner in David Ellison, whose Skydance Media was a vibrant new production company. Skydance's film

division was founded in 2010, and since that time had fearlessly focused on top-tier, big-scale titles for global audiences spanning action, adventure, science fiction, fantasy, and western genres. Ellison's lofty ambitions had already seen Skydance's films grossing nearly $5 billion in worldwide box office, with titles including three of Tom Cruise's massively successful *Mission: Impossible* films, as well as the star's *Jack Reacher* and *Jack Reacher: Never Go Back.* Skydance's other films have included both *Star Trek Beyond* and *Star Trek Into Darkness, Annihilation, Life, Terminator Genisys, World War Z, G.I. Joe: Retaliation,* and *True Grit.* Both companies were enjoying production relationships with Paramount Pictures (returning Bruckheimer to the studio for which, with late partner Don Simpson, he produced such huge successes as *Flashdance, Beverly Hills Cop,* and *Top Gun*). Together, Bruckheimer and Ellison found a director with the creative vision and utter determination to, if necessary, not only invent new technologies to finally bring *Gemini*

◀ The hands-on director filming a scene in the catacombs.

▼ Jerry Bruckheimer captured the 'Big Luck' opening ceremony in one of his on-set stills.

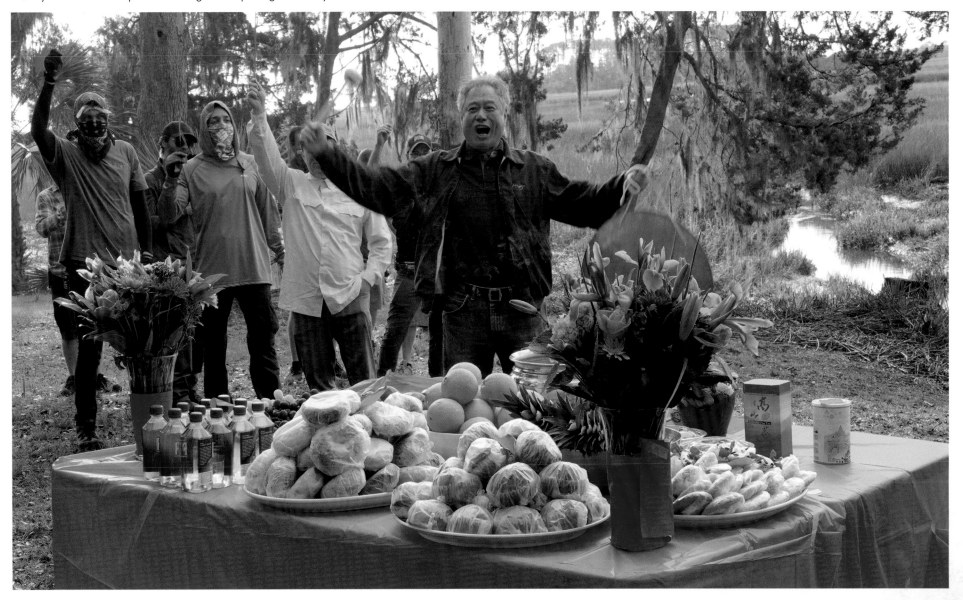

Man to life, but also how audiences experience a motion picture.

"I love how the *Gemini Man* screenplay explores the dynamic between youthful ambition and hard-earned experience," says Ellison. "And I knew that if we could assemble the right creative team, we could do justice to this incredible story."

Enter Ang Lee, one of the world's most heralded filmmakers, who had worked in a wide range of genres, infusing them all with an artful balance of humanism and cinematic innovation. Lee, with an intense intelligence which has imbued every film since the beginning of his career, immediately perceived the more complex aspects of the story, as well as its ability to entertain.

"Ang is a master visual storyteller who can immerse you in an epic tale," notes David Ellison, "but still craft characters you can identify and truly fall in love with — and he does it while pushing the boundaries of what's possible in cinema, which I really admire. I had wanted to work with him for many years, so when Jerry first brought up the idea of *Gemini Man* to me, I immediately thought of Ang. But the question was, would he say yes?"

"I was developing something else and I passed by L.A.," recalls the filmmaker. "I knew that David Ellison of Skydance Media had been wanting to talk to me for a couple of months. I heard David's passionate pitch, an assassin in this case is meeting his younger self and they fight each other."

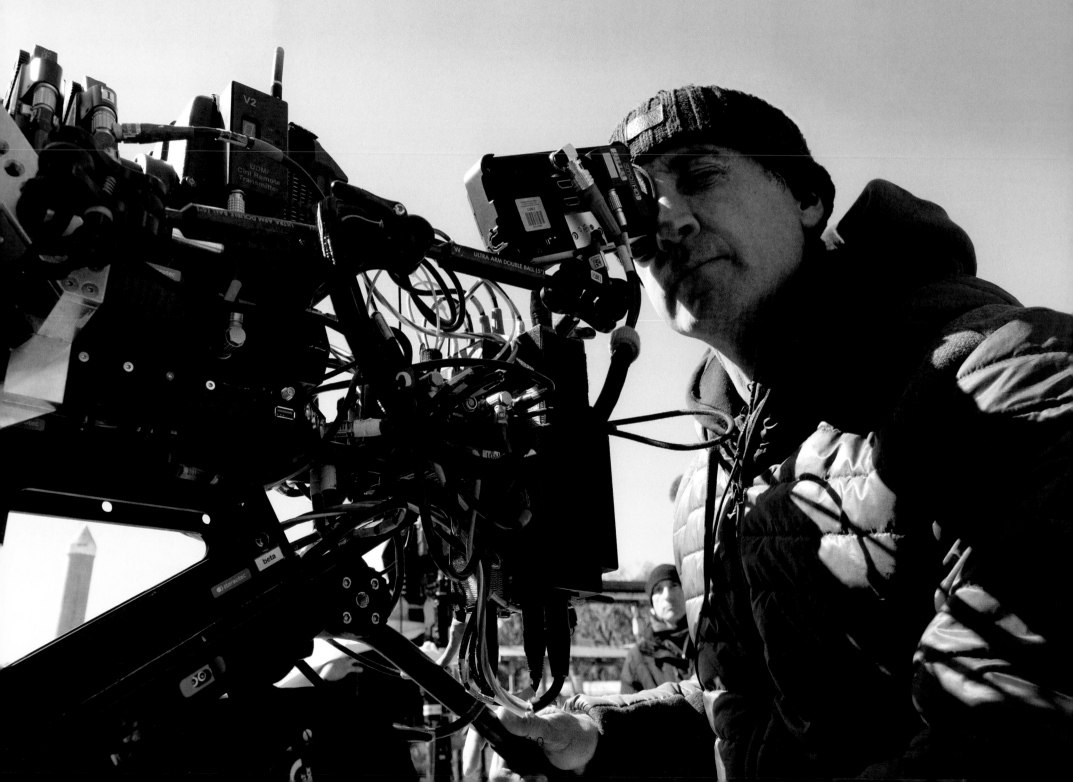

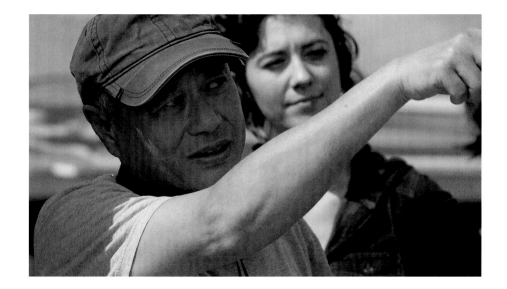

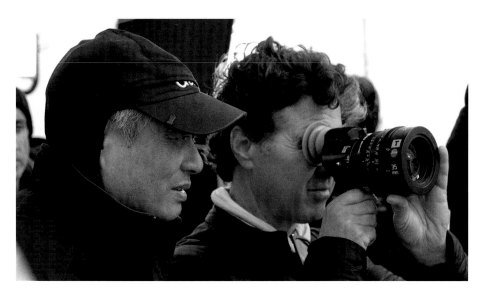

▲ Ang Lee and Mary Elizabeth Winstead on set (top). Director of photography Dion Beebe filming with Lee (bottom).

▲ Producer David Ellison with Ang Lee on set in Georgia (top). Jerry Bruckheimer working alongside director Ang Lee (bottom).

Lee continues: "There were a few things about the project that really got to me. The concept of a man facing his younger self in an action thriller, in kind of an existential environment, is a very attractive idea. Not only how a man can look back on his life and see what could be corrected, what could be done better, not only reflecting on one's life, but all the other issues. Is a clone a person? Are we clones ourselves? Are we really human, do we have free will? It's a fascinating, very provocative idea and it can be fulfilling, thought-provoking, and it has a heart too. However, you don't want to get heavy-handed, we still want to entertain a broader audience. It's an action movie, so the audience needs to get the thrilling and amusing parts of the movie. So the tone of *Gemini Man* is quite tricky. I want drama and I want levity, and I've got to have some kind of a wicked sense of humor to blend the two together."

Of all the challenges that would face the filmmakers, perhaps the greatest of all was the question of who would portray not only Henry Brogan but also Junior, his twenty-three-year-old clone. For Jerry Bruckheimer, there was no doubt in his mind that it should be a man with whom he had worked three times in the previous twenty years, reuniting him with Will Smith after their collaborations on *Enemy of the State* and the first two *Bad Boys* films.

"You always try to get great actors, at least I do," says the producer, "and Will's a phenomenal actor, and also a very likeable personality on screen. Will is also a wonderful person to work with, and he's got the temperament to play these two parts. We knew that it would be very grueling and tough for him, a lot of stunts, the rigors of dealing with the incredibly sophisticated technology required to create Junior. But Will is somehow always in a good mood, always cheerful. He's a joy to work with."

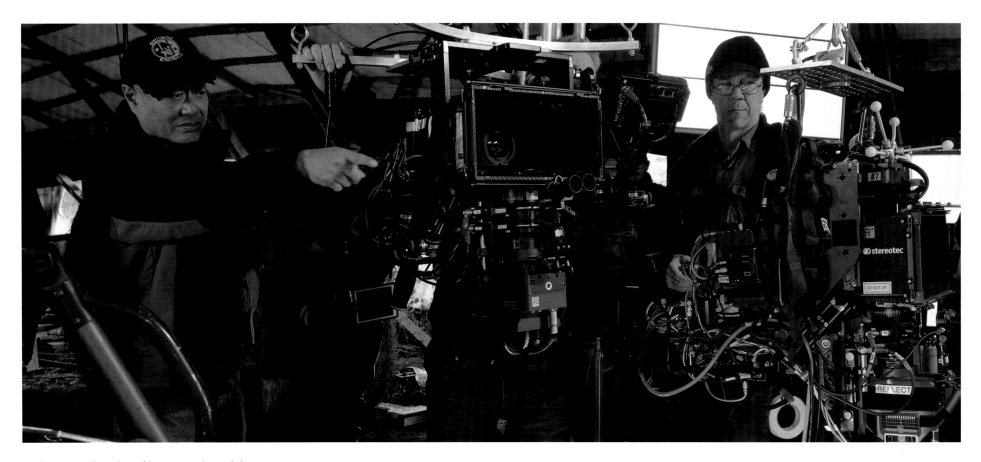

▲ This groundbreaking film required an elaborate camera rig.

Smith himself was immediately compelled by the possibilities when approached for the role. Recalls the actor, "The contact with a version of your younger self, and as I discovered when I started playing it, the converse, the contact with the version of your older self, it's intriguing, it's scary. I've heard people ask a lot of times, 'If you could go back to your younger self and give yourself some advice, what would it be?' And *Gemini Man* actually creeps into that experience. It brings up existential questions about how to live a life."

Which brings us back to that first day of filming after months of active pre-production, casting the other roles in the film and assembling the team of top-notch behind-the-scenes artists. There was also a huge amount of research and development, not only to create a landmark photo-real all-digital main human character for the first time, but based upon Ang Lee's decision to break more than 100 years of moviegoing tradition: shooting *Gemini Man* in 120 frames per second as opposed to the usual twenty-four, as well as in 4K resolution and in 3D. "This technology doesn't enslave us," insists Lee. "Technology helps us to visualize what we want to see. I think that visual effects can be visual art, which we use to tell a story and to visualize what is abstract. You make the impossible visual. I think any media, certainly movies, are always progressing. *Gemini Man* has an exciting story to tell, but first we have to create a

digital world, a movie world, to make that story possible."

"Leveraging 120 fps gave us important information that ultimately allowed us to create the most believable Junior possible," says David Ellison. "It's something that's never been done before and I know audiences will respond when they see it on the big screen. Personally, I just love going to the movies, and for the theatrical experience to thrive, we have to continue pushing the boundaries of what's possible to draw the broadest global audience. I'm really excited about what we have achieved on *Gemini Man* because, as amazing as the incredible technological advancements are, they're all in service of the story. Only someone as innovative and thoughtful as Ang Lee could envision how to use this technology so subtly and so seamlessly, while letting Will Smith's performance and the narrative take center stage."

Finally, after its long journey through the wilderness of development, experimentation, and roadblocks, Gemini Man went before the state-of-the-art cameras. The intention was to create a film that works on its own terms as a gripping and suspenseful international thriller with science-fiction elements, but also with carefully integrated philosophical elements of what it means – and what it takes – to be, or to become, a human being.

ANG LEE
RIDING THE DRAGON

By any standard, one of the true masters of contemporary cinema, Ang Lee was always quiet on the set – it was his talent that spoke loudly. While intensely focused and immersed in the task at hand, and fully expecting every person in the cast and on the crew to work to their utmost abilities and beyond, Lee was never heard to raise his voice to accomplish his goals. Rather, he quietly but forcefully pursued another exploration, through the technology of film, of who and what we are, utilizing the medium as a tool of nearly microscopic examination.

"Ang is completely and almost exclusively focused on the human experience," notes Will Smith, "so everything in the technology, and everything in the creation of the characters, he has an opinion about that experience that he's trying to share. And as he uses technology to try to augment the ideas, he's only trying to figure out how

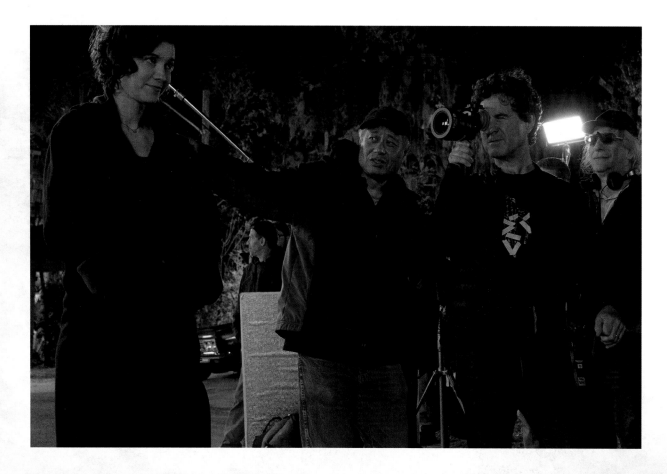

the specific use of that technology has a corresponding vibration in the human soul. So, as an actor, it's great to be with that kind of visionary artist, because you can get hamstrung by technology sometimes. You can get trapped, and you get forced into performing false moments to cater to the needs of a technological necessity, but Ang is firm in not allowing that to happen."

Mary Elizabeth Winstead, who portrays Danny in *Gemini Man*, was challenged and thrilled to work with the famed filmmaker. "It's amazing to work with Ang," she says. "He's such a lovely person, such a visionary and he's so committed to saying something with his work. It feels like you're working on a project that means something at the end of the day. You're creating a piece of art and it feels really special to be a part of it. Ang is always focused on performance and the meaning behind each scene. And he has a real radar for authenticity. It's very important to him that every scene, every moment, feels authentic and true, which is also really important for me. It's great to have a director who's always looking for that, because that way, I know I won't be able to get away with doing something on screen that doesn't feel true. You can trust Ang in that he's not going to let your performance in the film turn into something that doesn't feel real."

Jerry Bruckheimer notes, "It's great to watch Ang work because he'll go up to an actor and whisper something like three words… and the performance totally changes. I would love to know what those three words are. He's got such a close collaboration with Will and the other actors, and it's something beautiful to watch how he can help them mold and shape their performances." Actor Benedict Wong confirms, "Ang is such a wonderful man, and takes care with how he crafts his films. Meticulous, but yet very humble. He's like the quiet conductor. He just plants the seed, and you know you're in good hands."

Ang Lee's heralded and highly honored career in film has always confounded expectations and avoided predictability, crashed through cultural boundaries, and won over audiences around the world. The commonality between all of Lee's films is his keen and compassionate insight into the human condition, and the human heart. While his cultural roots are obviously in his native Taiwan, Lee has divided his time between Asia and the United States since he arrived in America in 1979 to attend college, first in Illinois and then at the Tisch School of the Arts at New York University, where he received an MFA in film production.

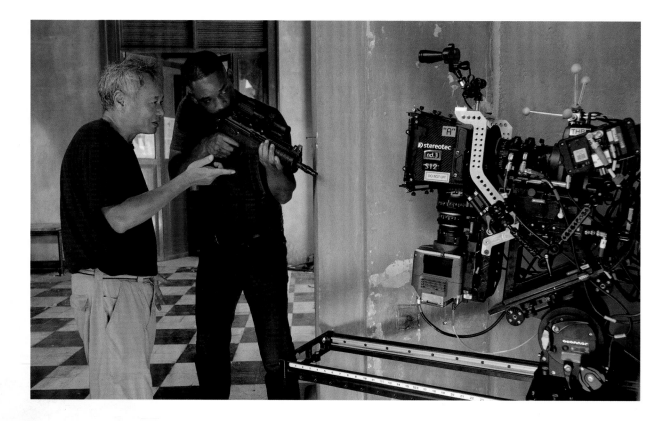

▶ Ang Lee's close collaborations with the actors helped to inspire performances.

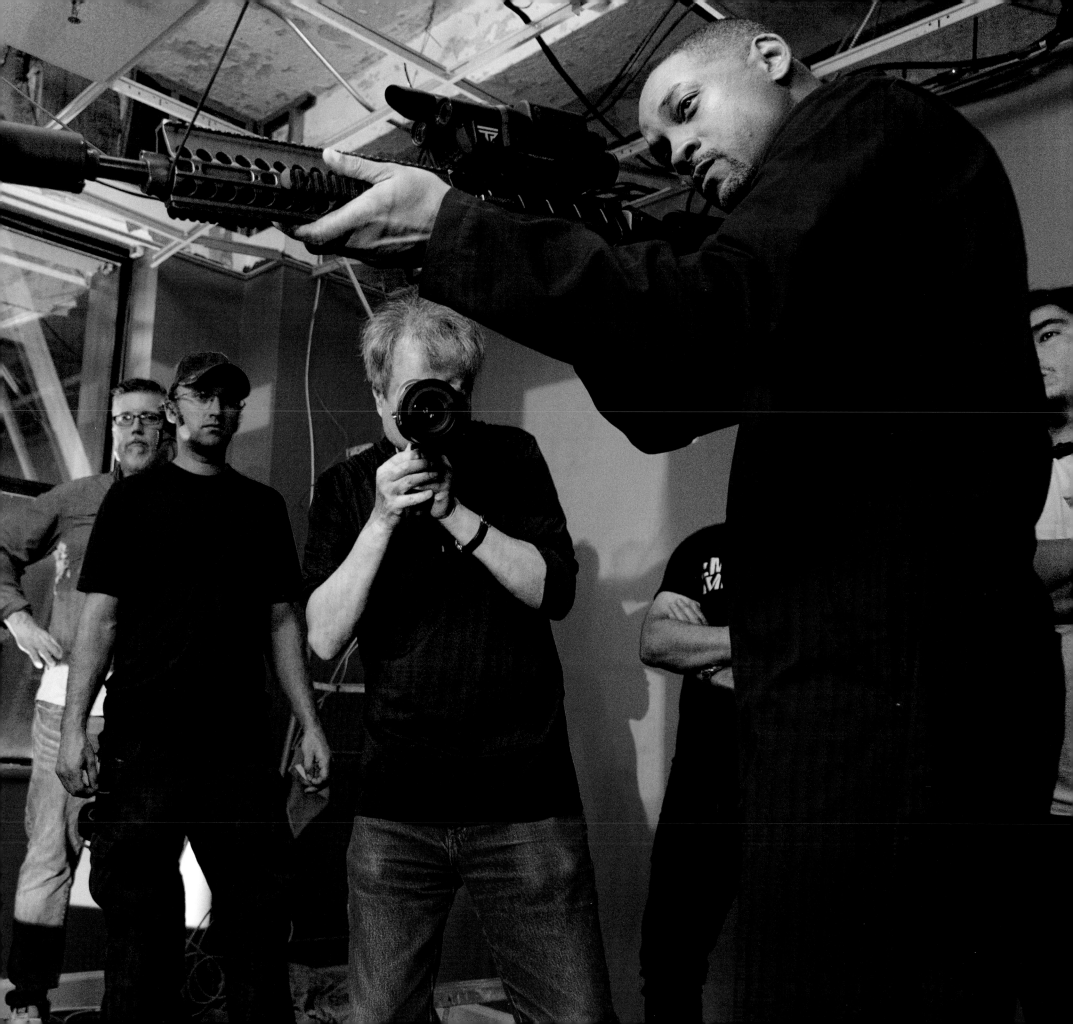

And so, Lee's heartfelt examinations of Confucian family values in his so-called early "Father Knows Best" trilogy of *Pushing Hands*, *The Wedding Banquet*, and *Eat Drink Man Woman* find equal expertise in his depiction of life and love in Connecticut suburbia in *The Ice Storm*, or the unexpected passion between two men in his landmark *Brokeback Mountain*. Lee has approached period settings with the same sureness on both sides of the Pacific, whether the 19th century worlds of Jane Austen's England in *Sense and Sensibility* and the American Civil War in *Ride with the Devil*; 18th century China in the thrillingly balletic *Crouching Tiger, Hidden Dragon* and World War II-era Hong Kong and Shanghai in the controversial *Lust, Caution*. Then there have been films by Lee which have heavily utilized progressive visual effects and camera technology, with great originality in his thoughtful version of *Hulk*, the exquisite *Life of Pi*, and the deeply moving Iraq War-era *Billy Lynn's Long Halftime Walk*, the first feature film in history to be filmed in 120 frames per second.

These remarkably diverse and beautifully realized cinematic works have earned Lee three Academy Awards, two for Best Director (*Brokeback Mountain*, *Life of Pi*) and one for Best Foreign Language Film (*Crouching Tiger, Hidden Dragon*), along with a raft of Golden Globes, BAFTA, DGA, Independent Spirit, Golden Horse, and film festival awards. While working in a great range of genres throughout his heralded career, Ang Lee is one of film's great humanists, always finding his way into the heart of his characters and their stories. Balancing his depictions of life as we know it, Lee is also a relentless technological innovator who has sought to advance cinema to new levels with each successive film, never more so than with *Gemini Man*. Ang Lee has spent his entire career riding the dragon, risking everything in pursuit of what film could be, and how it must change, with his quietly ferocious and uncompromising vision.

With *Gemini Man*, Lee saw an opportunity to further explore the complexity of human interaction and screen action by literally inventing new technologies to create a fully digital leading character and lift the curtain which has always existed between films and their audiences by reaching out to them with the deeply immersive 120 frames per second, 4K 3D processes. "I would say the key emotional element of *Gemini Man*, to me, is honesty," says the director. "I think that's the base of all relationships. Can we trust each other? And most importantly, can you even trust yourself? To keep a relationship going, we lie a lot. We cover up. We pretend. That's what we do most of the time we're doing life. And I think the drama is to get underneath that and see what's really going on. Henry, when he faces his younger self, has to make sure he's level with himself. I think that's the biggest test, and it's highly emotional to me." As for the highly advanced technology being utilized by Lee and his vast crew for *Gemini Man*, the director insists, "It's not just technology. Technology allows you to make the endeavor. It's not a push button. It's painstaking, with a lot of craftsmanship and art, but instead of one person making the art, you have hundreds of people making the endeavor for a year to see the art begin to be created."

"Ang's not only comfortable with the technology, he is absolutely convinced that this is the future," notes Clive Owen, "that he's at the beginning of something that is going to change the way we make films and the way we see films. He's incredibly visceral, and the detail is beyond what we're used to seeing. It sort of takes you a little time to gather yourself and really understand what's coming at you."

"I hope a year from now when the movie comes out that audiences like the experience," says Lee, during filming. "Not just enjoying a movie, a story, watching movie stars, being entertained, or even to be inspired by this existential story. I hope with this media and our efforts, the audience takes away an extraordinary experience. To engage in a theatrical experience in a new way. It's immersive. You're participating in a story rather than watching somebody else's story. I hope I earn their trust and that they feel like they're inside of our story. I hope they get an immersive experience in theatrical fictional storytelling."

Lee continues: "Nothing is more rich in nuances than human faces. When I think about digitally creating a human being, I'll be more interested in what's to study on his face, to look at his inner life. That's my biggest interest in using technology. When you see two Will Smiths, we hope to create something very dramatic, thought-provoking, and, most of all, something we've never seen or experienced before."

For the entire *Gemini Man* company, working with Ang Lee at the helm was not just an honor, but also a challenge. "It's an adventure," says executive producer Brian Bell, who had also worked with the filmmaker on *Billy Lynn's Long Halftime Walk*. "It's not about what we're used to, what we're comfortable with. It's actually about *not* being comfortable. His process is demanding, that being good at what you do may not be enough. Being humble enough to know that you don't know is really the key to it all. So we shouldn't have too much hubris, because with hubris comes rigidity, and what Ang needs and expects from everyone, including himself, is humbleness and fluidity."

▶ Ang Lee's search for the perfect settings took the cast and crew to beautiful cities across the globe, including Budapest, Hungary.

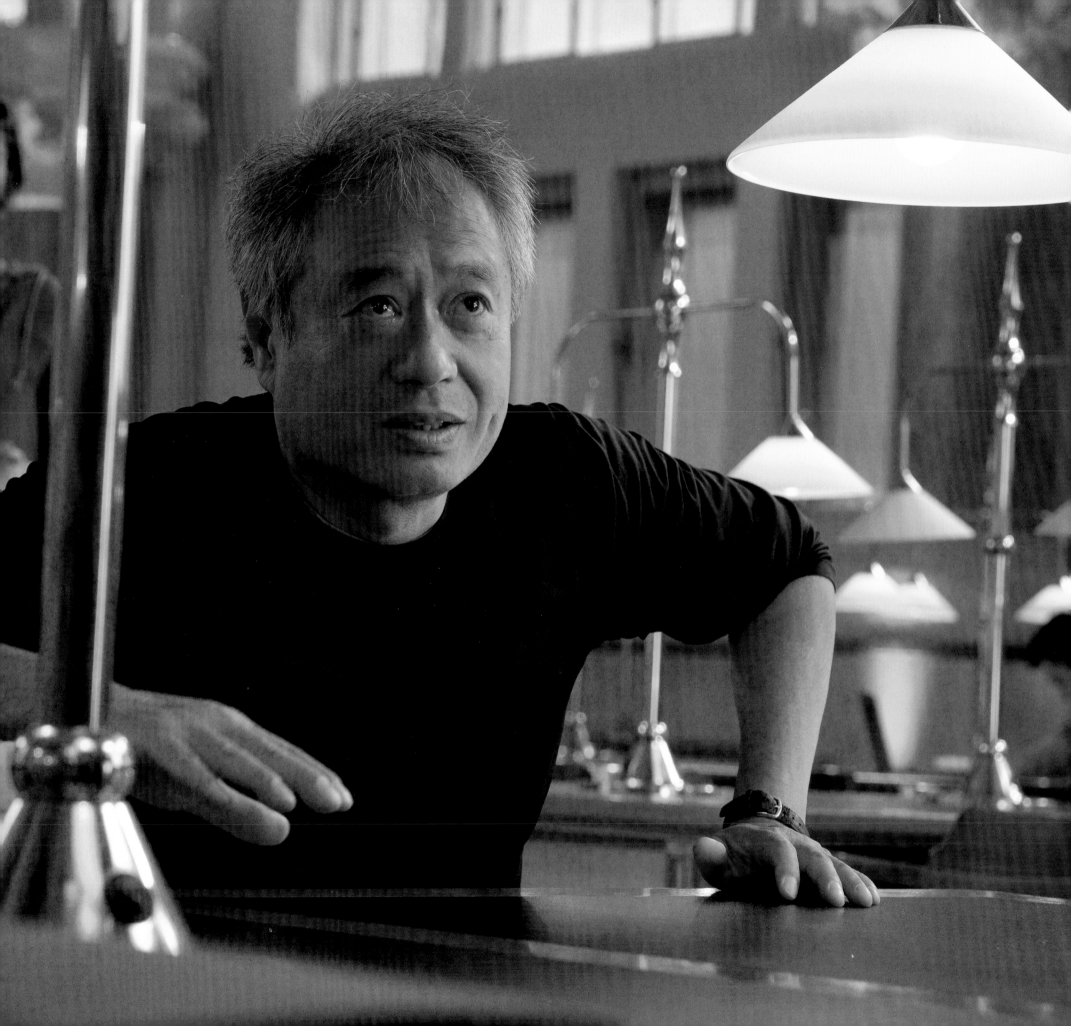

JERRY BRUCKHEIMER
BOLT OF LIGHTNING

By this juncture in time, more than forty years after his first film credit as a producer, much of the world recognizes the logo of Jerry Bruckheimer Films and Television which appears at the beginning and end of the company's feature films and television programs: a lone tree on an otherwise empty stretch of highway, dark clouds looming in the background overhead, being struck by a bolt of lightning. Its meaning to the man behind that logo has always been clear: "Lightning symbolizes how an idea can

spark something special," he says. In other words: it's the lightning of creation, not destruction.

And it's the art and act of creation which has driven Bruckheimer forward from childhood to fulfill his dream of producing movies, forged during long afternoons and nights in his local cinema in Detroit, where he was born and raised. "I fell in love with the power that films have to take us somewhere we've never been," he says, "and that passion for filmed entertainment has never let go of me."

▼ Jerry Bruckheimer with John Campbell, production executive for Jerry Bruckheimer Films.

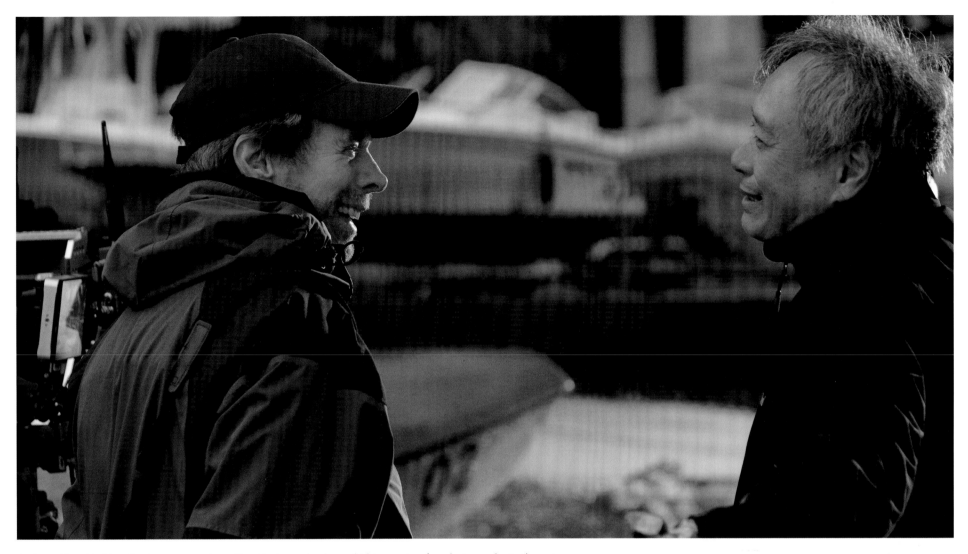

▲ As well as his friendly demeanour, Jerry Bruckheimer also brought his passion for photography to the set.

Bruckheimer's simple answer to a much-asked question – what's his formula for success – has always been "I make movies and TV shows that I want to see." Easy enough, but how to explain why the movies and TV shows he wants to see have also been the ones that billions of people around the world have enjoyed for so many decades? In 2001, Bruckheimer told a journalist, "I feel like I'm a producer who makes movies for the common man. Movies are not only for the highbrow or the lowbrow, but for people in the middle who like to be entertained."

Bruckheimer's brand of entertainment has made him one of the few producers recognizable to the mass public not just in the United States, but all over the world. His creative acumen is testified not only by the huge success of his endeavors, but also by the loyalty and friendship of so many major stars who have returned to work on his films again and again, including Will Smith, Tom Cruise, Eddie Murphy, and Nicolas Cage, as well as such directors as the late Tony Scott, Michael Bay, Gore Verbinski,, and Jon Turteltaub.

Jerry Bruckheimer is well known for supporting the vision of the filmmakers who have directed his films through the decades, as confirmed by Ang Lee. "Jerry is the king of action and big production, and quality movies. It's a sense of security that somebody like Jerry is there. Psychologically, you know that we're going to be okay with Jerry Bruckheimer sitting next to you."

Emerging from the world of advertising, Bruckheimer's producing career began with such memorable films as *Farewell, My Lovely* and *American Gigolo*. With producing partner Don Simpson, the pair created one hit after another, including *Flashdance*, *Top Gun*, the first two *Beverly Hills Cop* films, *Bad Boys*, and *Crimson Tide*. Following Simpson's passing, Bruckheimer continued to produce great hits, among them *Armageddon*, *Enemy of the State*, *Gone in Sixty Seconds*, *Black Hawk Down*, the two *National Treasure* films, and the huge *Pirates of the Caribbean* franchise, which collectively has amassed more than $4 billion at the worldwide box office.

There are few producers in the history of Hollywood who could be defined by simply

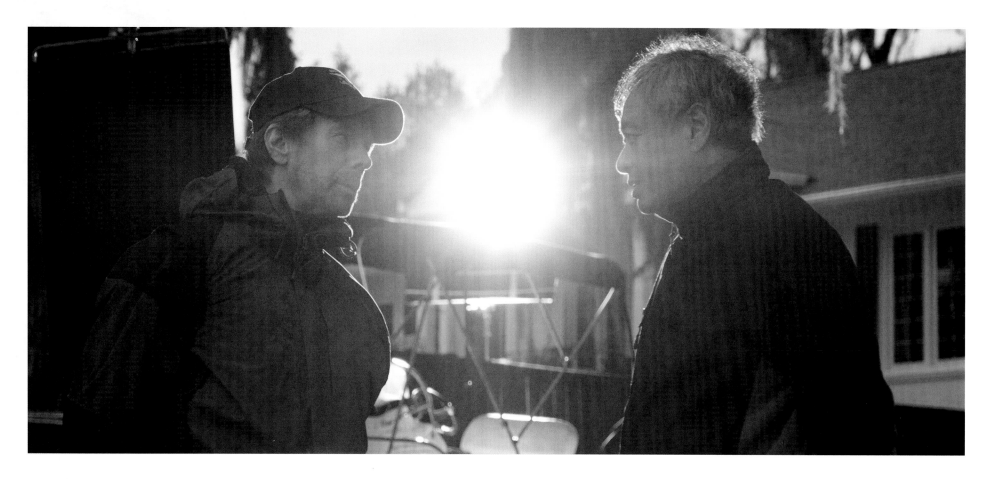

listing the titles of their films, but Jerry Bruckheimer is indeed one of those indelible few. His name is an actual brand, but the man behind that brand often catches people by surprise with his almost Zen-like composure and friendly, but reserved, demeanor.

With his lifelong passion for photography, Bruckheimer enjoys shooting stills on his sets, and is sometimes mistaken by crew members not yet familiar with him as a unit photographer. "Jerry is so fantastic because he's so passionate about filmmaking," confirms Mary Elizabeth Winstead. "He's here on set all the time, and he's at the point in his career where I'm sure he could just slap his name onto something and rest on his laurels. But he's here. He's interested. He's passionate. He's totally invested, supportive of Ang, the crew, and the cast. I love how he takes photos on set, as if he wants to commemorate the moment. The fact that Jerry has been doing this as long as he has and has such a roster of incredible films and it still seems like this is his first one, is amazing. It's a wonderful energy for me to be around, and I'm so appreciative of that. A Jerry Bruckheimer film to me means that it's really good, really accessible, and the kind of movie that you're going to want to go to the theatre to experience. I'm really happy to be a part of it."

"Jerry is the king of action and big production, and quality movies. It's a sense of security that somebody like Jerry is there."

Ang Lee - *director*

▼ Jerry Bruckheimer in conversation on set with executive producers Chad Oman (left) and Brian Bell (middle).

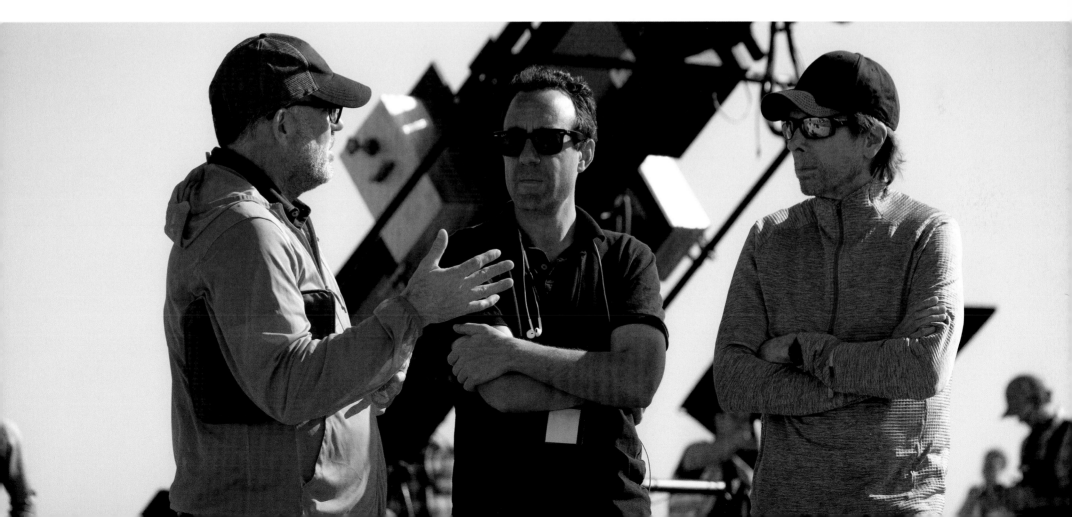

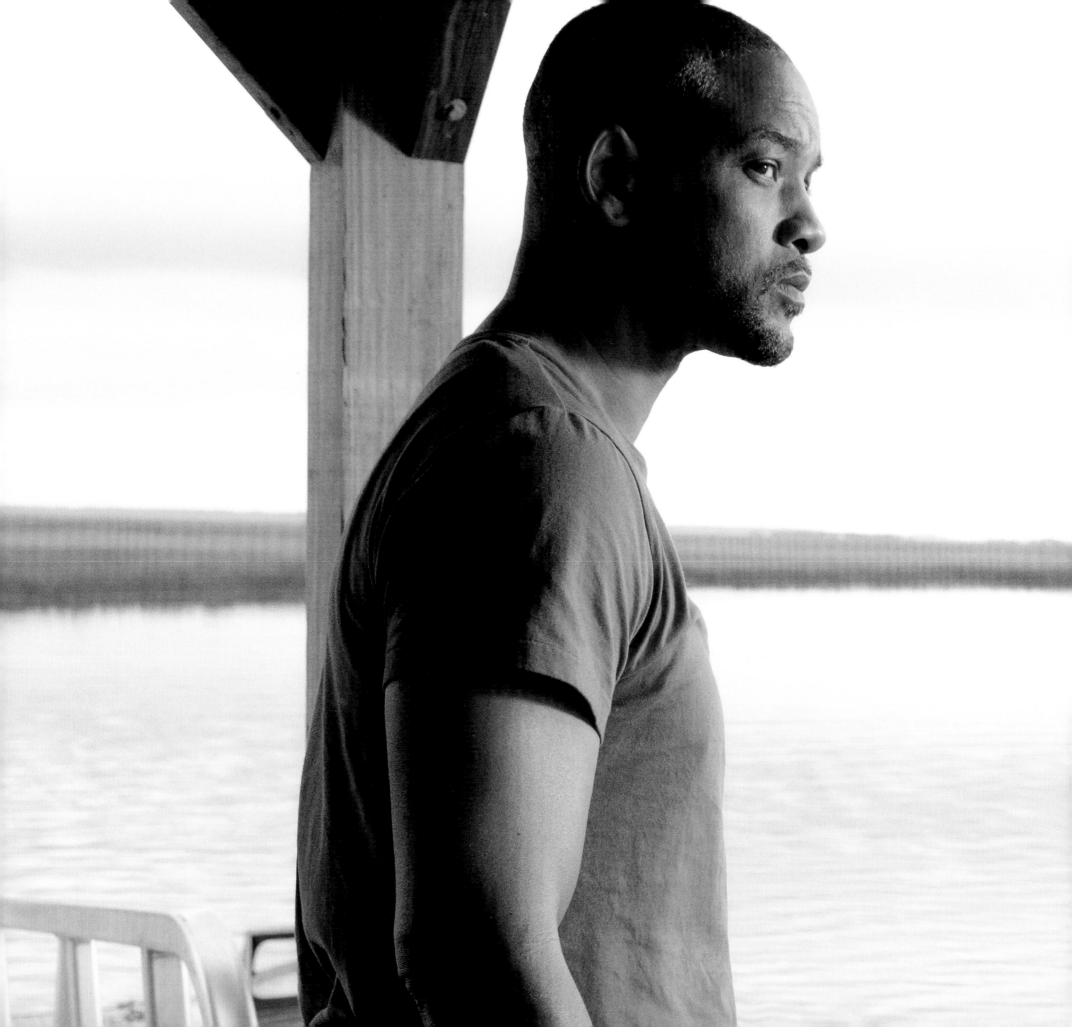

A RETIRED ASSASSIN

HENRY BROGAN

Henry Brogan is a complicated man. A steely killer with a conscience, he believes that those he is ordered to remove deserve their fate, but nonetheless absorbs the impact of taking their lives. Slightly obsessive/compulsive, and with a phobia of drowning which stems from a childhood trauma, Henry takes whatever peace he can find in his rustic rural Georgia home, where he builds birdhouses and other objects with fine carpentry skills, and enjoys being on the water in his tiny little boat, the *Ella Mae*. He is also fiercely loyal and protective to friends and associates who win his trust – such as Baron,

Del Patterson, Jack Willis, and, ultimately, Danny Zakarewski.

"Great stories hinge on great characters, and we have always tried to have some of the most interesting and memorable main characters in our films," says Jerry Bruckheimer. Bruckheimer's films have given the world some of the most iconic characters in history, and to that list of notables can now be added Henry Brogan, the top government assassin grown weary of killing, an extraordinary performance by Will Smith in a startling contrast to his performance as Mike Lowrey in *Bad Boys*, and, in another collaboration with Bruckheimer, Robert Clayton Dean in *Enemy of the State*. And to the second role he plays in *Gemini Man*, the twenty-three-year-old prime Gemini asset, Junior. The three-decade long journey by *Gemini Man* from inception to Ang Lee's film was made worth it, according to Bruckheimer, by the perfect pairing of filmmaker and star. "Having Ang as our director and Will as our star is honestly

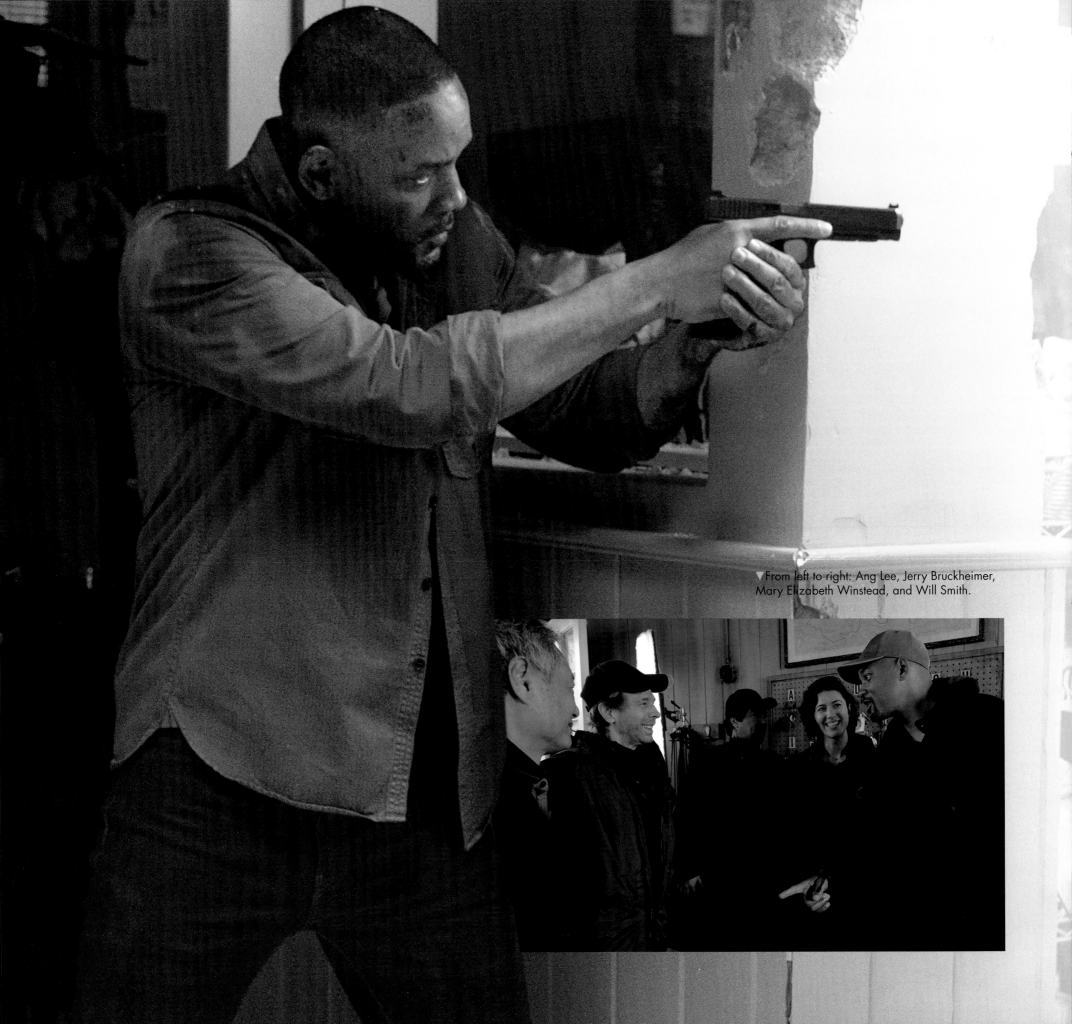

▼ From left to right: Ang Lee, Jerry Bruckheimer, Mary Elizabeth Winstead, and Will Smith.

a dream come true," says the producer. "We could not have hoped for more."

Neither could director Ang Lee. "I think Will is a terrific actor and a big movie star. He's funny and can do action. I couldn't ask for a better movie star and actor to perform these two roles, as both Henry and Junior." Lee notes that audiences have taken a long journey with Smith since his ascension to stardom as television's *Fresh Prince of Bel-Air*. "We all know about the younger Will, the swaggering, humorous, root-for-him kind of character. And the more mature, thoughtful Will of today. We will see how the two of them conflict and work together with each other."

David Ellison adds: "Will is more than just one of the biggest movie stars in the world. He's a brilliant and versatile actor who has entertained audiences for decades. Part of the fun of the *Gemini Man* concept is the opportunity to experience not *only* the actor you love now, but *also* the one you loved twenty-five years ago. There are really only a few out there who could pull off such complicated roles within the same picture and Will was our first choice. I knew he would deliver a first-rate performance, but could also physically deliver on the action."

"I play Henry Brogan," explains Smith, "a DIA agent who is essentially a spy hitman. He comes to the end of a long career, and he's done a lot of things that he is not happy about, and he wants out. He retires from the agency, and they send someone to kill him. So, in trying to figure out what's going on and why they would send someone to kill him, Henry finds out that nearly twenty-five years ago, he was cloned, and they created an identical version of him that is just twenty-three years old, who they sent to kill him. So in the process of that, the technology is such that I played the older version of Henry, playing scenes with another actor

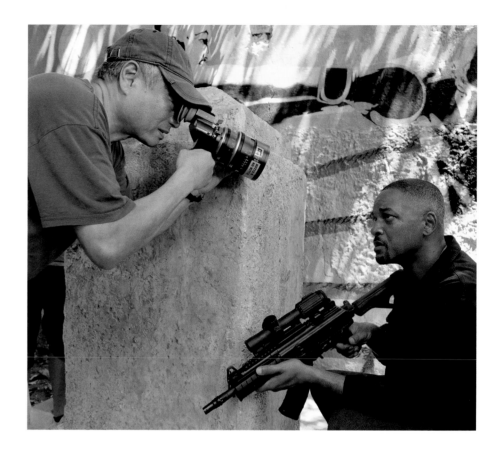

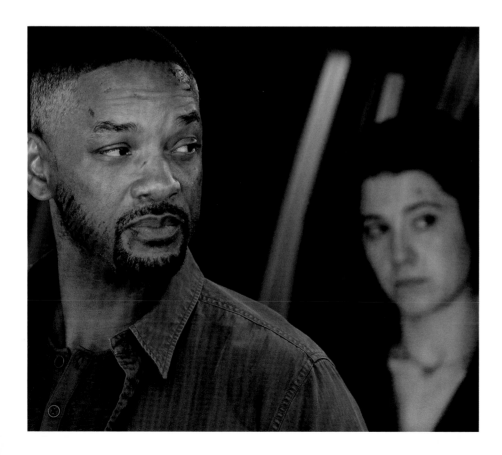

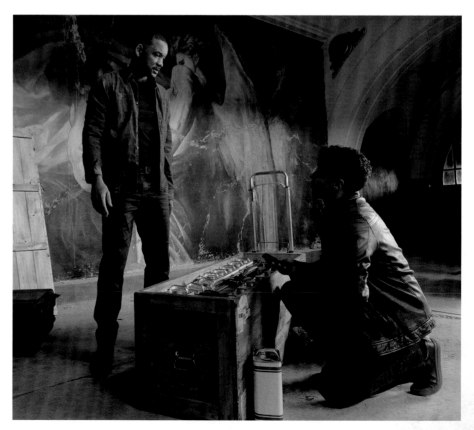

standing in as Junior, the younger version of Henry, and then switched, where I played Junior in performance capture."

Costume designer Suttirat Anne Larlarb understood that what Henry wears must, to a large degree, define him. And Henry is definitely not in the sleek, sartorial tradition of James Bond, who also has a license to kill but inhabits an utterly different universe. "Ang and I spoke from the very outset about the distinction of character," she explains, "and to make sure that we had very specific characters. With Will as Henry, we always thought of him as the old school, intuitive, zen-like warrior, the person who can feel and sense a situation and never really overthinks anything.

"So even in terms of Will's clothing, I never wanted to telegraph anything that said he thought too much, or too heavily, about what he'd be wearing. Every time we see him, everything about Henry feels natural. So I actually looked at pictures of Marlon Brando in some beautiful black and white photos, telegraphing the kind of solid, brooding, masculine, and heroic look, and never looking styled. I didn't want to deglamorize Will to the point of anonymity but clothe him as a natural and organic figure."

"The concept of *Gemini Man*," says Smith, "with two characters played by one person across generations, the technology didn't exist until today to be able to deliver this in a timely and affordable way. So it's really the first time that the vision of the film was technologically able to be realized. I think that the technology in this case is a part of what creates the authenticity. People have played younger characters in a movie where they make the hair all grey and you make the person older, and then you make them younger, and that is an interesting approach, and acting-wise, it's spectacular to be able to do that. But this technology allows you to see something that is shocking, and jarring, and beautiful, and technologically exquisite." And playing both roles allowed the actor to reflect on himself at his age now, and who he was as a younger man. "One of the emotional benefits is the connection to mistakes," he says. "We all have fears, and it's almost like when you speak to your child, that connective tissue has emotion in it of itself. So, I think that the one person playing both roles gives you an opportunity to see to the core of the other characters in a way you generally don't."

◀ Will Smith's action movie experience helped towards his portryal of not one, but three government agents.

To understand both Henry and Junior, Smith had to examine himself at both of the characters' ages. "Shoot, it was almost a hindrance having me play both. I had to go back and look at old film and old tape of myself. There was almost an unrecognizable quality to my twenty-three or twenty-four-year-old self when I went back. There was a freedom, and a recklessness, to my early *Fresh Prince, Bad Boys, Independence Day,* and *Men in Black* days. There was a creative recklessness that, at fifty, I admire, and that was one of the things I was trying to go back and recapture to get a sense of what were the thought patterns that led me to some of the behavior that I had at that time. It was fun to explore and to seek."

However, Smith also recognized that "I couldn't have done it the other way… I couldn't have, at twenty-three years old, played a fifty-year-old version of my character with this technology. That would've been a mess. But this way, I was able to understand and capture both characters because of the amount of experience I've had as an actor. What's really great now in my life, more than ever, is that I'm paying attention to things a lot more than I ever did. I was one-pointed, and I knew where I was going. I knew what I was doing. And now that I'm starting to reflect a little more, a film like this opens up so many different ideas and concepts. Just to try to get into the thoughts, and to be free to find the thoughts of the twenty-three-year-old version of myself was interesting, because people generally think of the wisdom of age as being more powerful. But as I was looking, and as I was playing these characters, there's a certain power to naiveté. There's a serious power to not knowing you can't do something, and I really bumped into that in playing these characters. The deficiencies of both, and the strengths of both, was an interesting exploration."

What is still true of Will Smith today as it was in years past is the actor's joyous, charismatic, and inspirational personality, as evidenced by the experiences of everyone who has worked with him. First as a rapper charting new musical territory in the late 1980s as one half of DJ Jazzy Jeff and The Fresh Prince, then starring in *The Fresh Prince of Bel-Air,* Smith then transitioned into feature motion pictures – becoming a superstar in Jerry Bruckheimer's production of *Bad Boys* in 1995 – and very quickly proved himself an almost bewilderingly skilled and versatile star. Effortlessly shifting between action, comedy, serious drama, science fiction, and genres in-between, Smith was nominated for Academy Awards for both his performance as homeless salesman Chris Gardner in *The Pursuit of Happyness,* and as the great champion boxer in the title role of Michael Mann's *Ali.*

So what would Will Smith tell himself if he actually had a chance to bump into his twenty-three-year-old self? "I finally answered the question for myself in exploring both of these characters' minds," he says. "And I wouldn't tell him anything. I wouldn't tell him a single thing. The twenty-three-year-old version of myself was so hardheaded, right? So he wasn't going to hear anything I had to say anyway. But the twenty-three-year-old version of myself, he had a couple of really solid ideas that ultimately would never make him happy, but they were on the right track."

And what might his younger self say to the older Will Smith? "He would be like, 'Man, what did you do to our body?'" laughs Smith. "So, you just gonna eat anything you want? Man, you got to slow down on the Krispy Kremes!"

▼ Henry Brogan's happy place: on the *Ella Mae.*

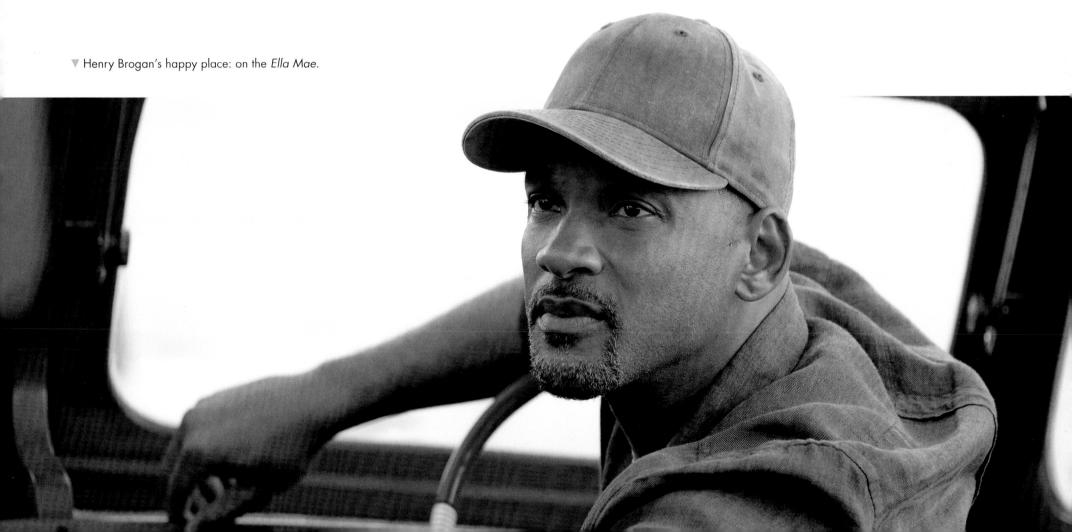

THE TRAIN SHOOTING

A man of fifty-one years of age, fit and good looking, casually dressed, walks through a green but deserted knoll in the Belgian countryside, chooses a spot which looks like it would be appropriate to lay down a blanket for a rustic picnic, and instead shoulders a Remington Model 700 sniper rifle. He inserts one bullet in the chamber of the bolt action weapon, lies down on his stomach, makes adjustments to the scope mounted on the rifle, aims… and waits. His target, Russian bio-terrorist Valery Dormov, is speeding through the fields of Belgium, seated in the passenger car of a high-speed train at 188 kilometers per hour. Henry finds the train, then Dormov, in his scope. Four other shooters have missed. Henry has one bullet, one chance. And despite another success,

another kill, Henry is ready to call it quits. "Shooters don't get better with age. They just get older," he tells Del Patterson, his friend and supervisor at the Defense Intelligence Agency.

Welcome to the world of Henry Brogan, ex-Marine, government agency assassin, and the best there is at his work. While the filming of the live action elements of the train shooting sequence which opens *Gemini Man* was relatively simple compared to the complexities of the rest of the shoot, it's a prime example of how the collaboration between parts is necessary to create the whole. Considerable efforts were required from multiple departments and behind-the-scenes artists, including the cinematographer, production designer, props and armorer, costume,

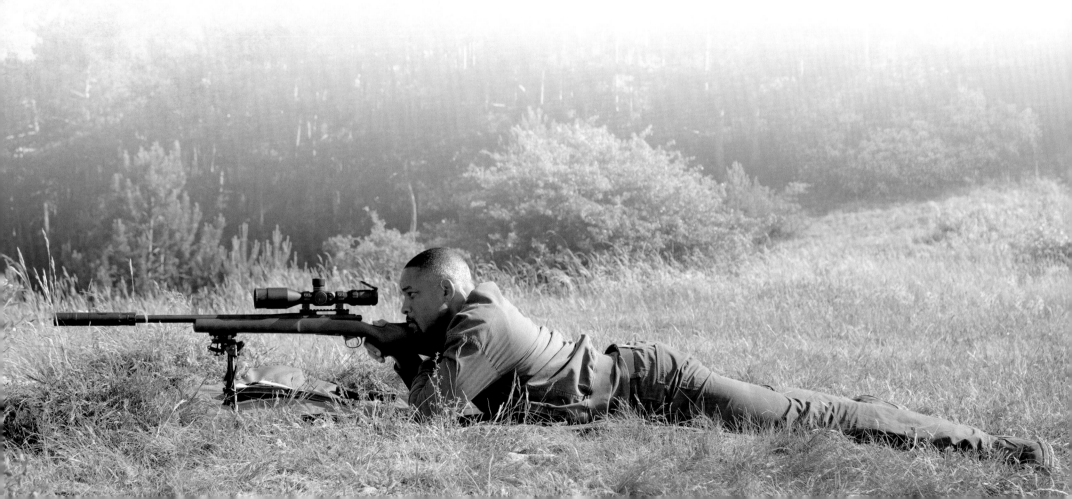

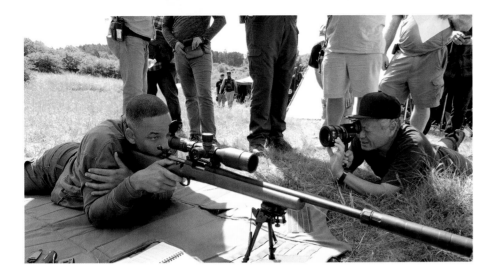

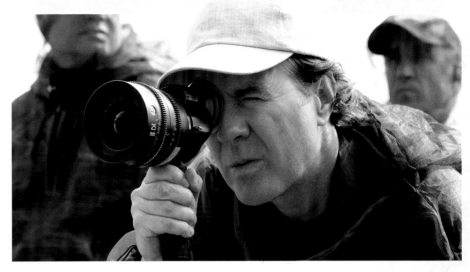

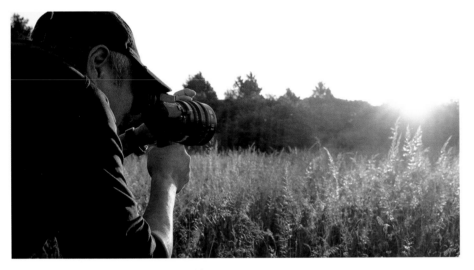

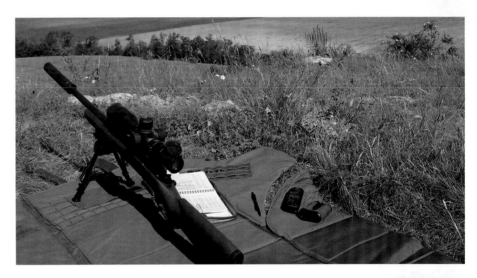

▲ The tools of the hitman trade (top). Ang Lee captures the picturesque "Belgian" countryside (bottom).

▲ Dion Beebe films the scene on a handheld camera (top). Henry Brogan's last hit as a member of the DIA was made from this "desolate knoll" (bottom).

locations, visual effects, and, of course, the entire supporting crew. "It's a crucial sequence because it not only sets the tone of the film, but introduces us to Henry Brogan, Will Smith's character," says producer Jerry Bruckheimer. "So it's absolutely essential that every element of the scene works for the audience."

The train shooting sequence combined two real locations in Europe with digital objects and landscapes created by visual effects supervisor Bill Westenhofer and his team. During filming in Budapest, a reduced crew, including director of photography Dion Beebe, flew to Liege and filmed establishing shots of the strikingly futuristic Liege-Guillemins Railway Station, where Dormov boards a high-speed train. Designed by the Spanish architect Santiago Calatrava, the steel, glass, and white concrete structure provided starkly dramatic opening images, but even then, as Westenhofer explains, "We removed some regular-speed trains and added in our TGV high-speed version to the tracks. The train that pulls out of the station is also full

CGI." The hilltop in the Belgian countryside outside of Liege which provides Henry Brogan with the best vantage point from which to assassinate Dormov was actually a rural area some forty-five minutes due west of Budapest, used to replicate what's described in the script as a "desolate knoll" outside of Liege, Belgium. "The work there was mostly 'in camera,'" explains Westenhofer, "with VFX working in a digital train track, bridge, and tunnel into the existing landscape. We also added a digital train as well when it appears. The tracks, bridge, and train are 3D digital assets rendered in 3D stereo. We made some modifications to the landscape to fit the track in by clearing some houses and beefing up the hill to work in the tunnel."

Westenhofer and his troops also contributed some full CGI shots to the sequence, among them a 180 degree perspective of the train whipping past the camera; shots of the train through the scope of Henry's rifle, including fully CGI Dormov and passengers; and the shot from outside the train where Henry's bullet strikes the glass.

BELGIAN COUNTRYSIDE

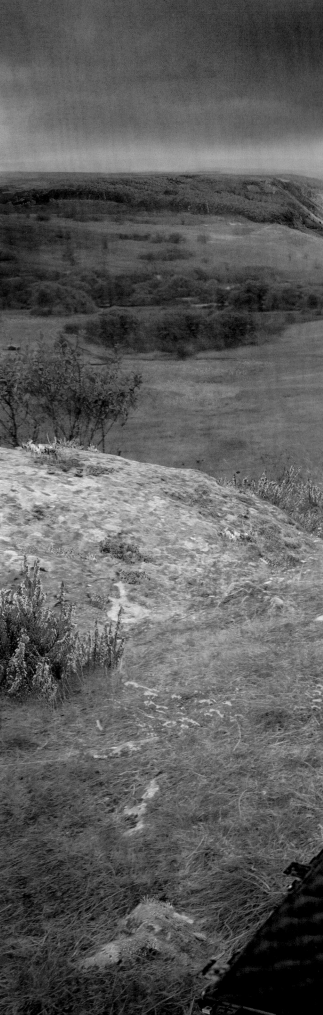

"The opening sequence for our film shows the skill and proficiency of Henry as an assassin," says production designer Guy Hendrix Dyas. "The location for his long distance 'impossible' shot was chosen very carefully to double for the Belgian countryside. Although, in Budapest, we were able to discover areas that were convincing as the described rolling fields of our script. We were unable to find the perfect site, complete with distant train tracks and a tunnel. Also, the timing for the shot taken by Henry was so critical that it was decided that we should add the train in CGI to better control the timing of the scene. I took photographs and prepared artwork to show how the distant train and tunnel would look in the final scene, how Henry could take the shot and the orientation of the train car as the bullet punctured the glass.

"I then consulted with Bill Westenhofer, our visual effects supervisor," Dyas continues, "to confirm that our plan was achievable. The greensman and his team went to great lengths to ensure that the flora around Henry's position was correct and matched what would typically be found in the meadows of Belgium. Inspired by the conversations about flowers and insects, Ang planned for special micro-shots of bugs and plant life moving in slow motion around Henry in time with his controlled breathing. He wanted to slow everything down and capture the intensity of the moments before the shot. Only Ang could conceive of something so brilliant to visually express the anticipation of the scene."

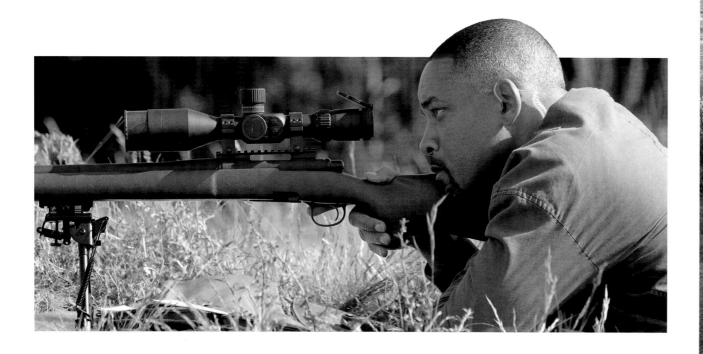

▶ Concept imagery of the shooting scene demonstrates how perfectly the scouts matched the final location.

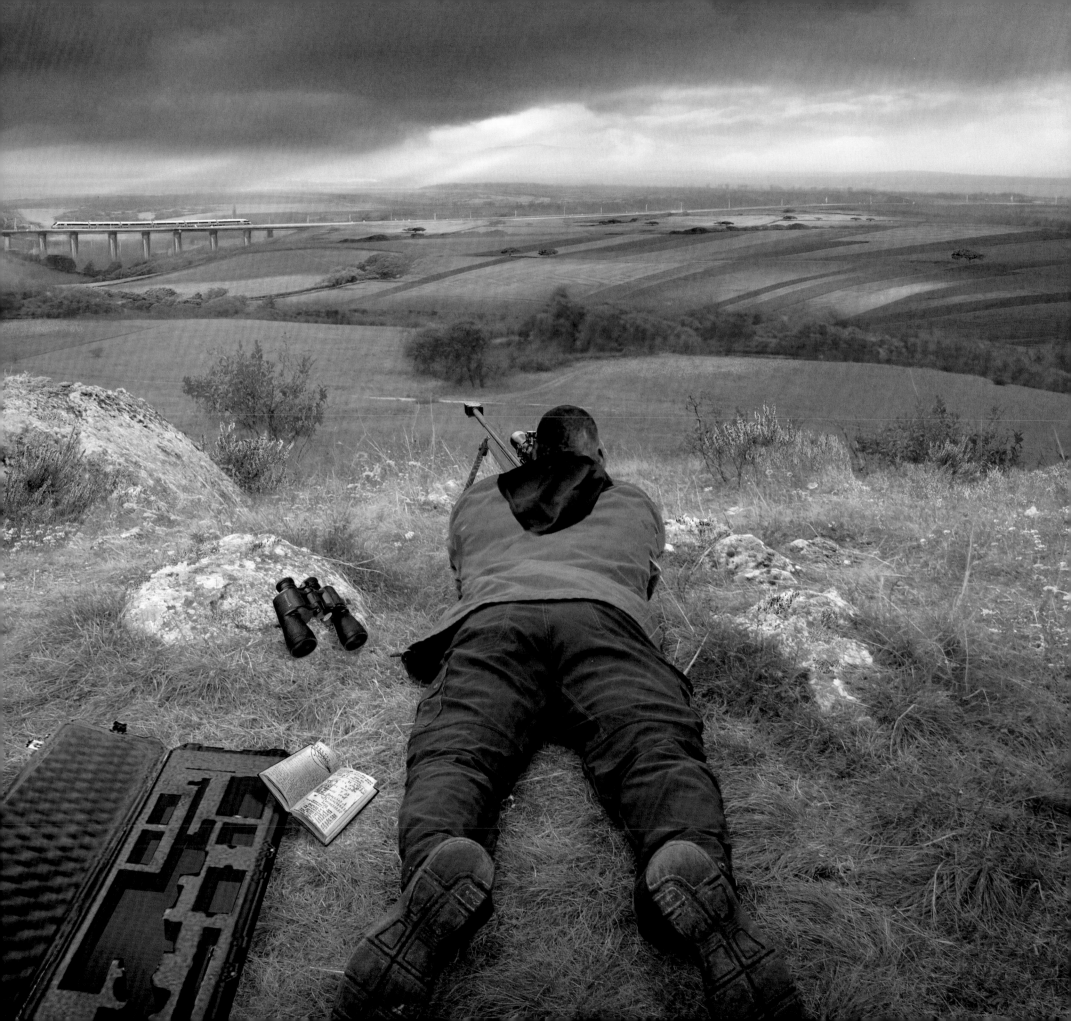

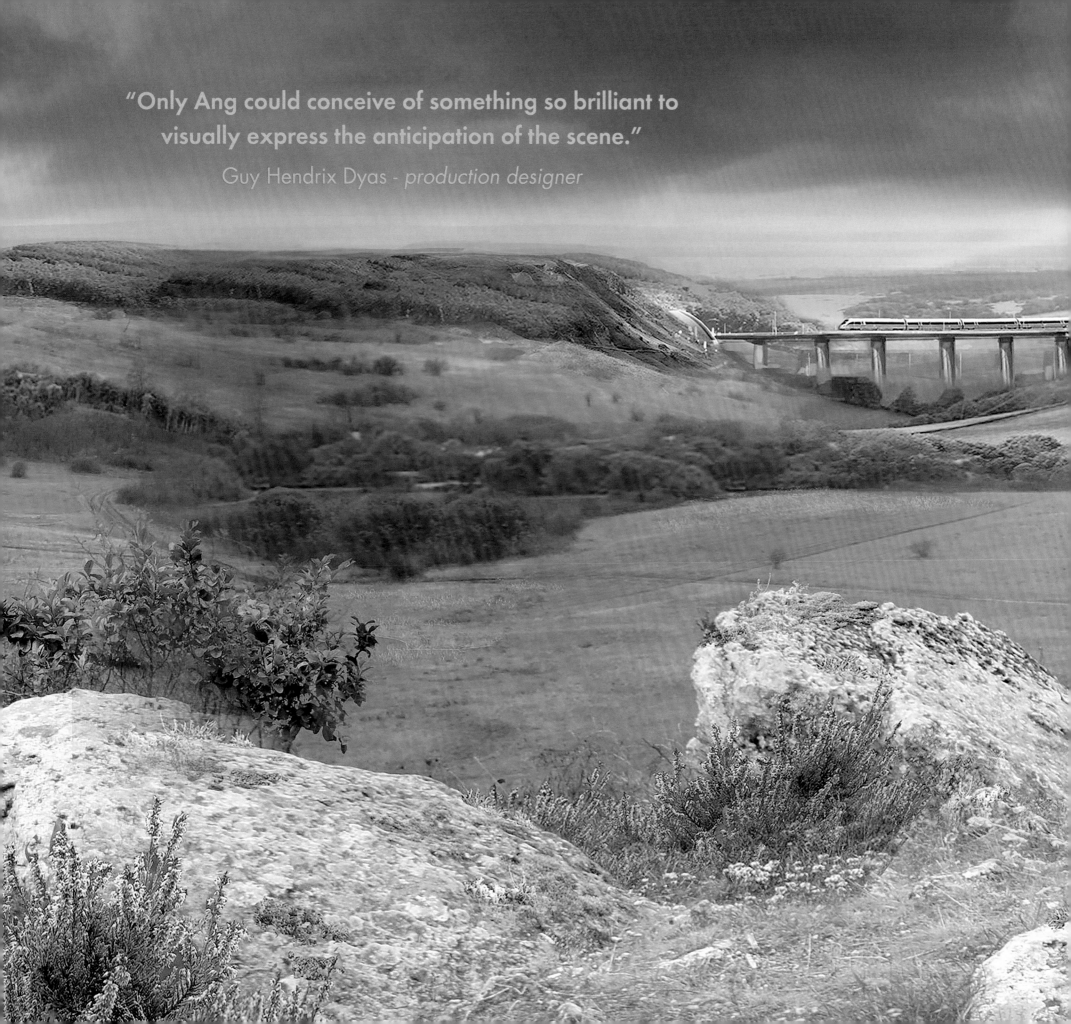

"Only Ang could conceive of something so brilliant to visually express the anticipation of the scene."

Guy Hendrix Dyas - *production designer*

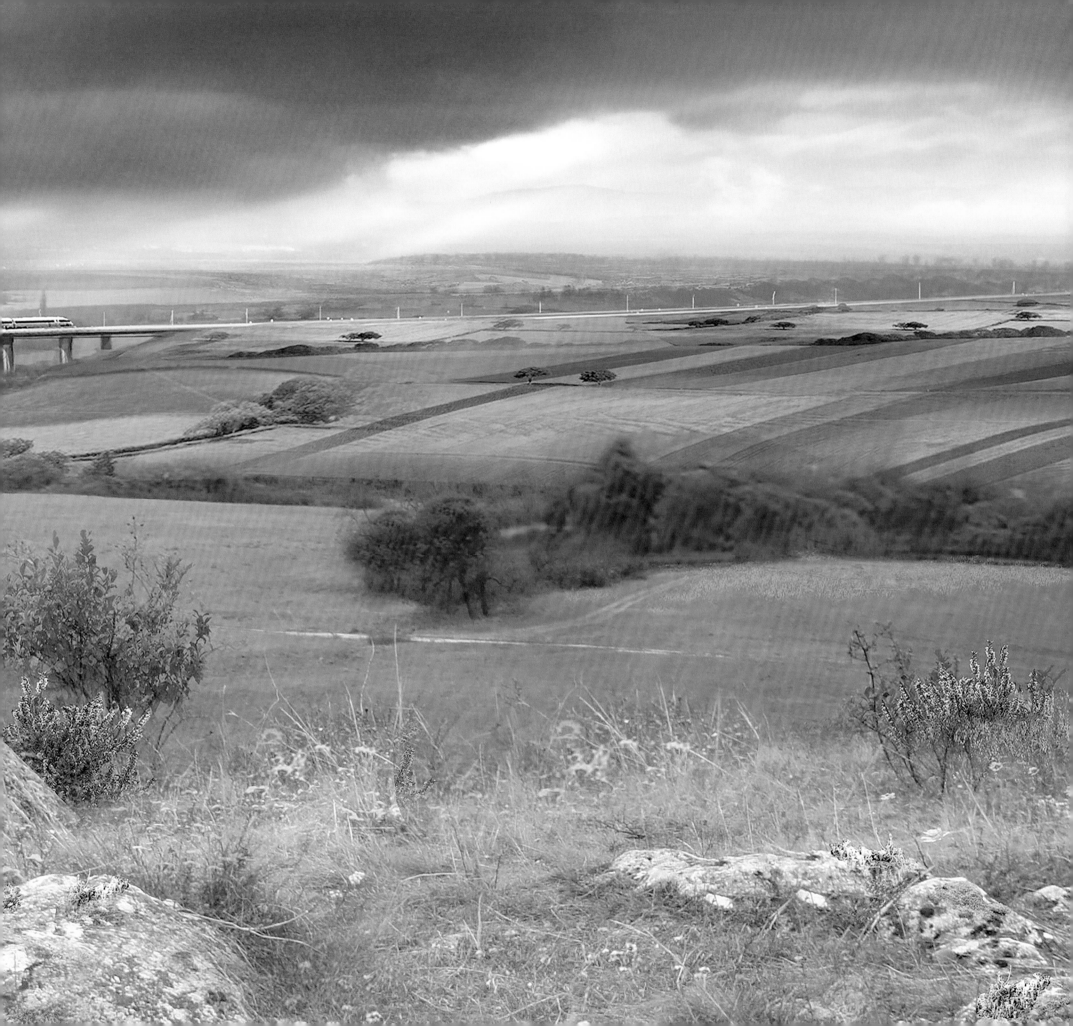

THE TRAIN

The interior of the train carriage in which Dormov is seated was a stationary set designed by Guy Hendrix Dyas and constructed on Stage One at Origo Studios outside Budapest with blue screens outside the windows. "The backgrounds were filmed by mounting a camera array on a flatbed truck and driving down an interstate in Hungary," notes visual effects supervisor Bill Westenhofer. Although the train resembles many European TGV high-speed carriers, the design was original. "For the design of the train, we needed a very modern interior as it was designed to be a fictional high speed rail company," explains Dyas. "I leaned towards natural materials, light toned colors, and cream leather, which all helped create a relaxing atmosphere that would be easy on the eye. This intentional use of light colors was to help the dramatic effect of seeing the vivid blood red after Dormov is killed."

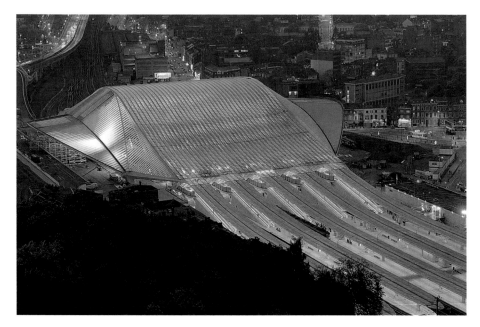

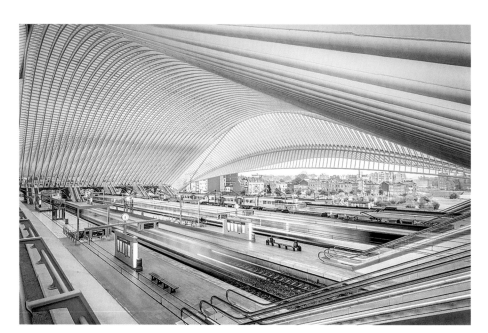

▼ The high-speed train was designed to stand out in the Belgian countryside.

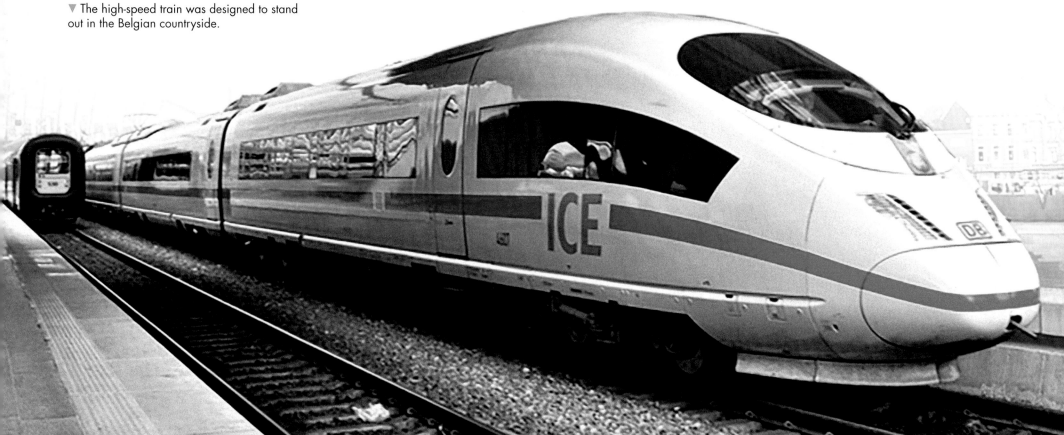

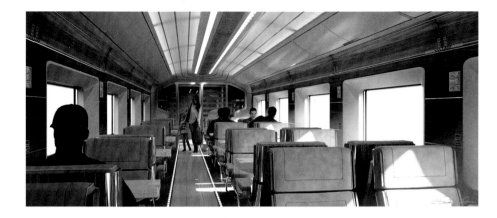

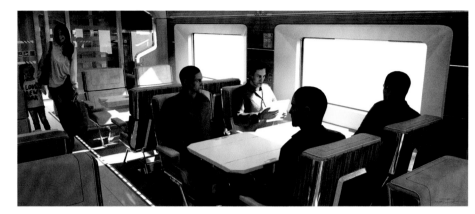

▲ Concept imagery of the train exterior and interior, complete with bodyguards.

VALERY DORMOV

Russian scientist Valery Dormov would appear to be a prime target to be taken down by Henry Brogan's sniper rifle. He's a bad enough guy to have had four previous DIA attempts on his life, and only Henry, of course, succeeds with an impossible shot through the window of a high-speed train. Henry believes what his agency told him — that Dormov was a bio-terrorist — until his old Marine buddy Jack Willis informs him that Dormov was actually a molecular biologist who worked in the United States for thirty years before suddenly disappearing to Europe. The question is why, and who, did Henry actually kill? The small, one-day role of Valery Dormov was expertly portrayed by local Hungarian actor Igor Szasz.

▶ Actor Igor Szasz filming his character's death scene before the VFX team adds in the view from the train windows.

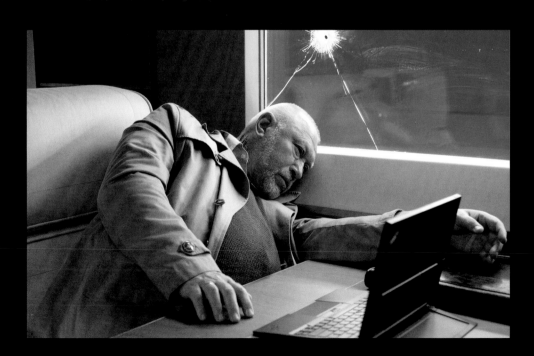

39

MARINO

As a former sniper himself, Marino Reed (portrayed by E.J. Bonilla) is a great admirer of the older, more accomplished DIA agent, Henry Brogan. "Marino is Henry's protégé," says Jerry Bruckheimer, "and the older man feels responsible for him. When Marino gets caught in a deadly web, Henry takes it really hard, which only adds to his sense of guilt and regret." It's particularly thrilling for Marino to assist Henry by hitting his target, supposed bio-terrorist Valery Dormov, by spotting the Russian in the same railway car of the European train speeding through the Belgian countryside. And when the deed is done, Marino excitedly shows a video he took of the fruits of Henry's labor, much to the more senior agent's distress. Unfortunately for Marino, the agency he serves so loyally may not be so loyal to him in return…

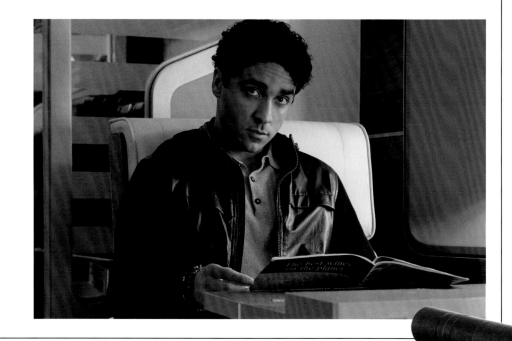

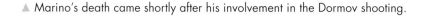
▲ Marino's death came shortly after his involvement in the Dormov shooting.

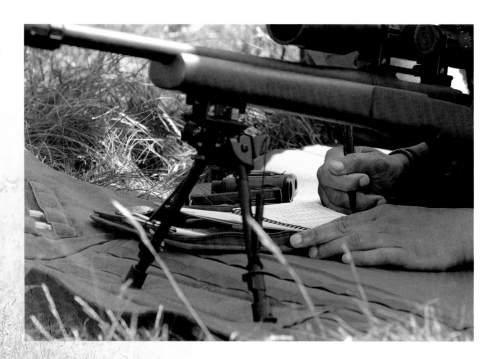

SNIPER RIFLE

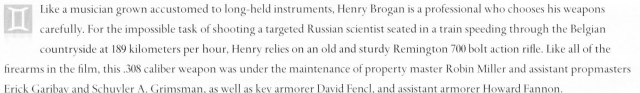

Like a musician grown accustomed to long-held instruments, Henry Brogan is a professional who chooses his weapons carefully. For the impossible task of shooting a targeted Russian scientist seated in a train speeding through the Belgian countryside at 189 kilometers per hour, Henry relies on an old and sturdy Remington 700 bolt action rifle. Like all of the firearms in the film, this .308 caliber weapon was under the maintenance of property master Robin Miller and assistant propmasters Erick Garibay and Schuyler A. Grimsman, as well as key armorer David Fencl, and assistant armorer Howard Fannon.

SAVANNAH

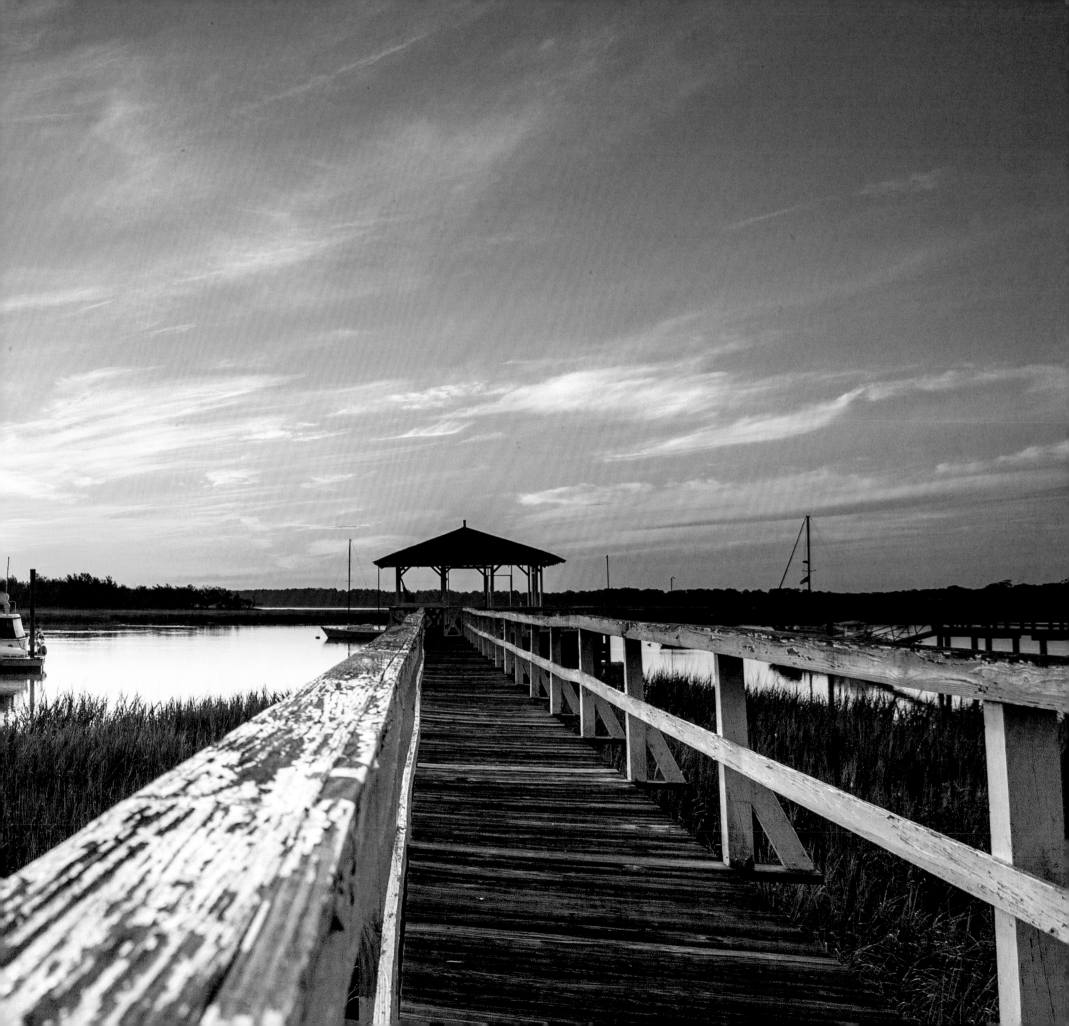

GLOBETROTTERS
GEMINI MAN ON LOCATION

"From its inception," explains Jerry Bruckheimer, "*Gemini Man* was always designed to be an international thriller with multiple locations. What kept changing over the years was which locations those would turn out to be." In David Benioff's first draft script of *Gemini Man*, dated October 29, 2007, the settings of the film were extensive: Serbia, Austria, Virginia, Florida, Brazil, Cuba, Thailand, Vietnam, New Mexico, and the Gulf of Mexico. Eleven years later, *Gemini Man* would finally shoot in and around Budapest, Hungary; Cartagena de Indias, Colombia; and Savannah, Georgia; with a splinter crew side trip to Liege, Belgium for brief scenes. Georgia would replicate Virginia and Florida, and the outskirts of Budapest would replicate the outskirts of Liege, but it was important to Ang Lee that the primary locations play themselves.

Most of the actors and crew made the entire journey from beginning to end, with new members of the family from Georgia, Colombia, and Hungary joining for those portions of the shoot. In the end, production was a true international effort, and all the better for it, a real demonstration of the global language of film and the plethora of

▷ Concept imagery of the Cartagena police station and graphic logos created for the film. Plus on-set photography of the Colombian location.

cinematic talent that exists all over the world. The film's stars certainly enjoyed the months-long odyssey, which lasted from late February to mid-July 2018 (and much longer for those continuing on with fifteen months of post-production work). Recalls Mary Elizabeth Winstead, "We started out in Savannah, Georgia, a beautiful, charming old Southern town on the water. Then we went to Cartagena, Colombia, which was incredible, a total change of pace, hot, tropical, and fun. Then we moved on to Budapest, Hungary, which brought a whole new energy. What I love is that each of these places played themselves in the movie. In so many films, you're going to Budapest but pretending it's Paris or something. It's special to be able to go to each of these places and film it for what it is and really use the beauty and culture of each of these places for the story. And you can feel that from the people in the city. I think people are excited to have *Gemini Man* filming and to have their cities reflected for their beauty and all of the things that are real about them."

Production designer Guy Hendrix Dyas agrees. "I think one of the early decisions that Ang made, which was really a masterstroke, was to play the locations as the locations in the story. In our industry, we have a tendency to go to places like London or Sydney and imagine that they're New York or the Sahara Desert. But Ang was smart enough to say, 'Well look, let's just play them as they are. Let's immerse ourselves in those places and really show the details and cultures of those individual cities.'"

Executive producer Brian Bell, who handled the day-to-day nuts-and-bolts of the production, explains, "We started with Ang's process over a year before we began filming. There were locations written into the script, but there were no locations scouted at that point. And Ang's process requires that we go out into the world to find places that inform the story as much as the story informs the places. We flew from New York to Budapest, then to Paris, to Cartagena, and back again. Ultimately, we decided on Budapest, because it was less known, less seen, less overshot,

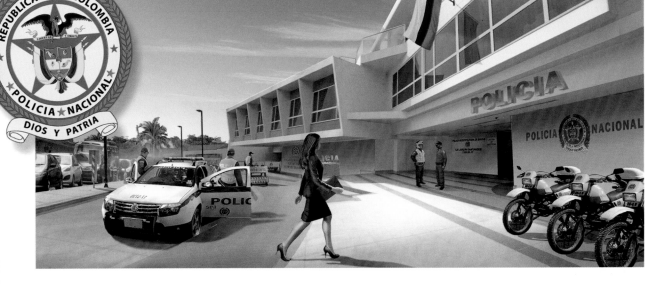

more interesting locations, and it's a real filmmaking city, so there was support. Although there were scenes originally set in Cuba, Ang fell in love with Cartagena at first sight. It's a special location and has barely been seen in feature films. And we started in Savannah, which was probably one of the more manageable locations from a tactical production standpoint."

"Exciting locations make *Gemini Man* appealing to the broader global audience and help show the universality of the movie's themes," notes David Ellison. "I go to the movies to be transported — and who doesn't like escaping to another world, even for just a few hours."

Remarkably, the *Gemini Man* production company took over an entire abandoned elementary school in the Savannah suburb of Thunderbolt, with its various buildings turned into offices for different departments, workshops for costumes, props, set decoration, and more. The former gymnasium was converted into a combination soundstage for camera tests as well as a training and rehearsal facility for J.J. Perry's stunt department,

and an auditorium was transformed by technical supervisor Ben Gervais and stereographer Demetri Portelli into a state-of-the-art technology base. "We built a facility in Savannah that had a screening room, editorial space, and all of the computers we needed to deal with this giant influx of footage that shooting 120 frames in 3D at high resolution generates," says Ben Gervais, "so the only way for Ang and our whole team to really respond to that footage was to see it as quickly as possible after it left the set. When we went to Cartagena, it was just too logistically difficult to bring all that equipment with us and we ended up uploading ten terabytes of footage a day. But when we came to Budapest, we moved into a facility at Origo Studios, so we packed up all the computing power that we had in Savannah, and then after we finished shooting we moved all of it to a facility in New York City for post-production. It's sort of a traveling circus that follows us around."

Each location was a startling contrast to the one preceding it. "One second we were in a car, then straight into a plane and landing straight into

Colombia," says Benedict Wong. "We arrive at the hotel, open the curtains, and see all of the vibrant colors of Cartagena. The heat really hit the crew, and we all individually had to battle against the heat." Also, Wong adds laughing, "We were also battling with Will-mania. It's amazing to see the joy he brings, that someone at the very top of their game can be so generous with his time. And then there was the copper oxide architecture and look of Budapest, moving away from the vibrancy of Colombia. At the end, it's like, can you believe we did that? We were all bonded by the shared experience of that journey."

▼ Budapest, Hungary has often been used as a location double for different cities around the world.

HENRY'S HOUSE

Savannah and its outskirts provided any number of splendid locations for *Gemini Man*, not least of which is Henry Brogan's house, a real location discovered in the small town of Darien. "Ang was very clear that Henry's home had to immediately give the impression of a recluse," explains production designer Guy Hendrix Dyas, "a man who's chosen to disappear into the wilderness, perhaps to minimize contact with his employers or to forget his own past, perhaps both! Henry's character is complicated, a semi-retired assassin who has remained single and kept his lifestyle simple and streamlined.

"Our locations team searched deep along the Georgia coast to find a secluded home that might fit our requirements," Dyas continues. "Perhaps one of the hardest locations to find. After months of searching I was taken to a concealed private residence that was a well kept

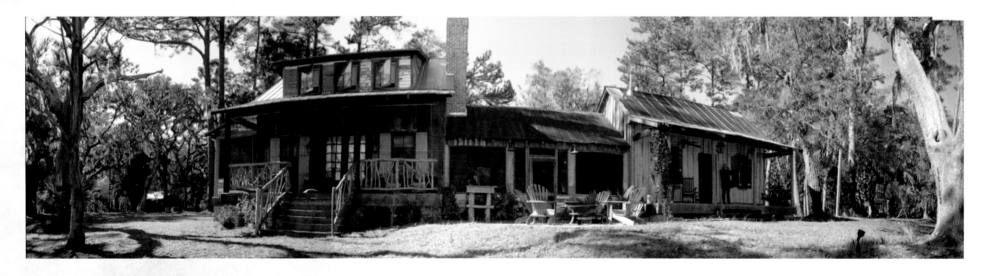

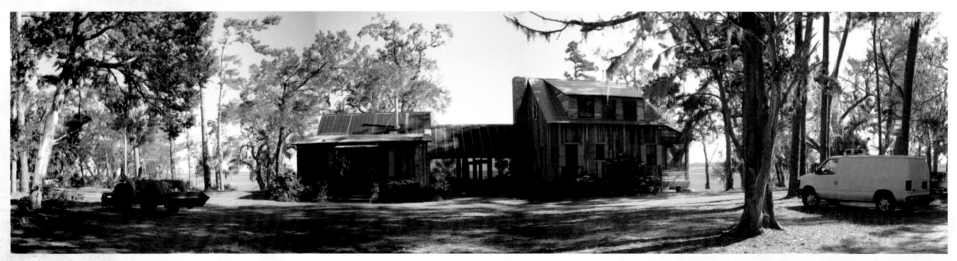

48

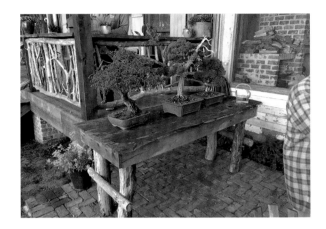
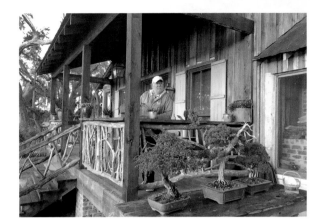

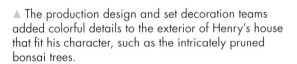
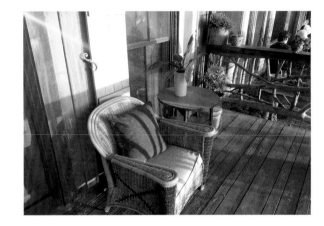
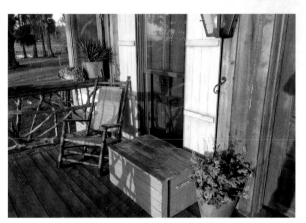

▲ The production design and set decoration teams added colorful details to the exterior of Henry's house that fit his character, such as the intricately pruned bonsai trees.

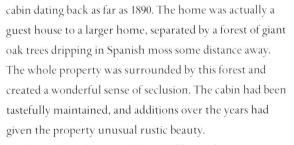

cabin dating back as far as 1890. The home was actually a guest house to a larger home, separated by a forest of giant oak trees dripping in Spanish moss some distance away. The whole property was surrounded by this forest and created a wonderful sense of seclusion. The cabin had been tastefully maintained, and additions over the years had given the property unusual rustic beauty.

Dyas and set decorator Victor Zolfo sought to create details inside of Henry's home which give subtle indications of his personality and interests. "We had determined with Ang that Henry would be a talented carpenter," explains Dyas, "showing all his precision and attention to detail."

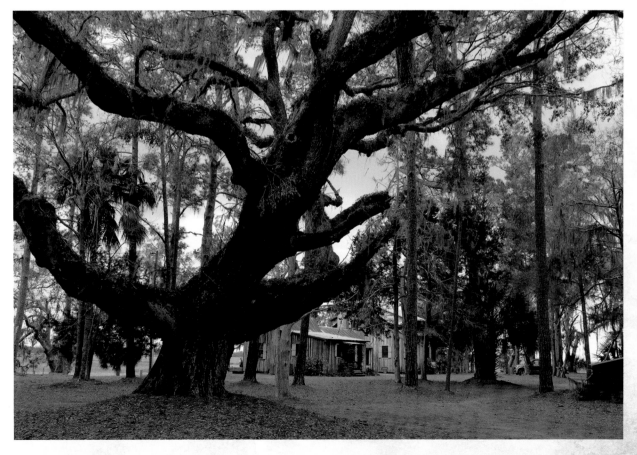

DEL PATTERSON

To portray the supporting characters of *Gemini Man*, director Ang Lee hired true actors' actors, most of them with long careers and a huge variation of roles. For Del Patterson, a close friend and associate of Henry Brogan at the DIA (Defense Intelligence Agency), Lee selected British-born Ralph Brown. Brown's formidable career has spanned an almost impossible number of roles over more than thirty years in US and UK films, stage, and television, with several projects as a writer as well. An actor of great versatility, he initially made a lasting impact as Danny, the long-haired, slow-talking, perpetually and hilariously stoned drug dealer in *Withnail & I*. Brown has a keen understanding of his *Gemini Man* character. "Patterson is the classic man-in-a-suit who works for the DIA, a Washington insider who is Henry Brogan's boss, and has been for many years," says Brown. "He is Henry's contact person, the man who tells him who the next target is, without telling him why. Generally, Henry wouldn't want to know but, as the film opens, the doubts are starting to assemble in Henry's mind about many things.

"It's a trusting relationship, as it has to be in these situations," Brown continues. "They have worked together for a long time, and they have a great deal of respect for each other and genuine warmth." For Brown, the relationship depicted on screen between Patterson and Henry Brogan was a reflection of his real-life interactions with Will Smith. "My working relationship was very good," he notes. "Will is very easy-going on set, amusing the crew, making jokes, but always on the money when we turn over. He included me in the make-up trailer where we compared insect bites at the location that served as Will's house down on the Georgia coastline. It wasn't until the final shot when I confided that he had been my favorite actor back in the day when *Ali* came out. I thought he was phenomenal in that role. Will was touched and gave me a big hug. A very generous man who is a true team player."

> "Henry, we've been through a lot together, you and me. We made the world safer. I'm not gonna trust a new guy like I trust you."
>
> Del Patterson

Brown, who has worked with no small number of fine filmmakers in his day, appreciated working with his *Gemini Man* director, starting with the opening 'Big Luck' ceremony on the initial day of filming. "Ang Lee was a dream," he states. "We all gathered on the shore to perform a blessing before the first shot, we held incense and bowed to the four corners of the sky, then cheered as Ang banged on a Chinese gong and we all ate a piece of prepared fruit from the blessing table. It was a very special moment and quite unique in my experience."

As with his fellow cast members, Ralph Brown faced the challenge of working with the film's groundbreaking techniques, but their director was always there to support and advise. Brown continues, "We were all rather concerned about the 3D, 120 frames a second format,

where we felt we could be exposed as actors doing too much acting. He was our guide and companion in this. [Ang Lee] actually gave me my favorite ever note as an actor in over 200 films and TV shows. After take one he came over and said – 'Ralph, less face, more heart,' and walked off. Gold!" While he has played many Americans in his career, Ralph Brown needed to make certain that no British-isms peeked through. "Courtney Young was our dialect coach on the movie," he says, "initially for Benny Wong, then for all the English actors. Very easy to work with, she gave me very condensed and accurate notes, and I found her to be a huge help in the process."

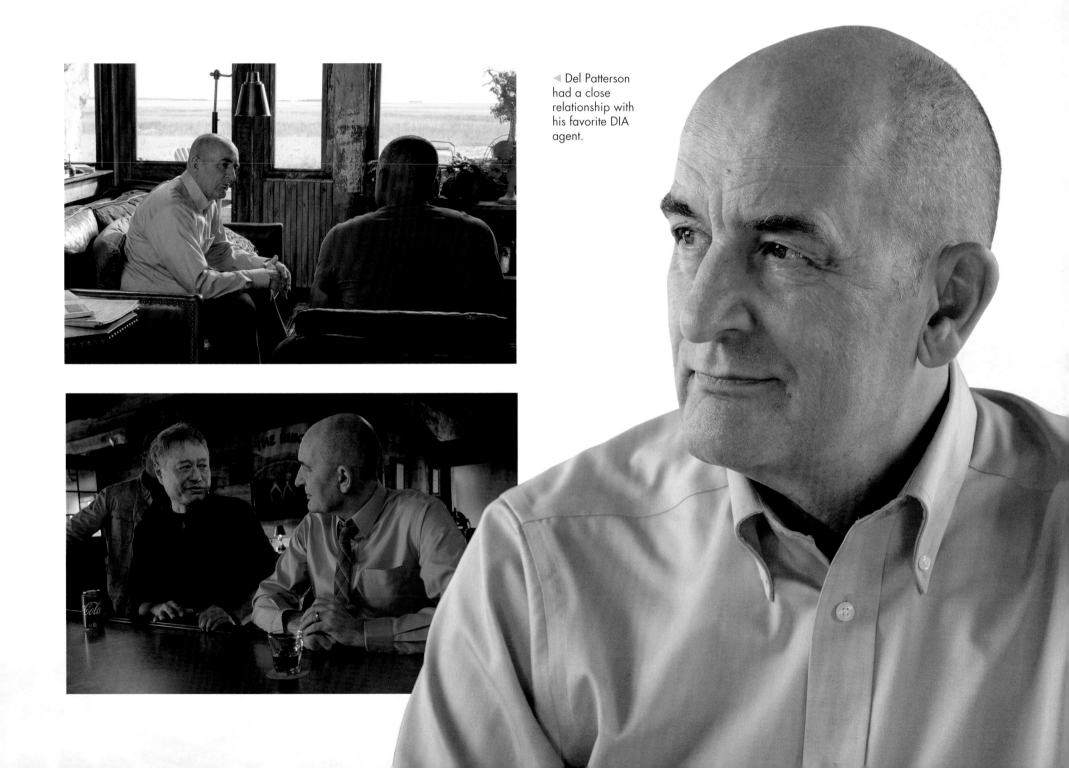

◀ Del Patterson had a close relationship with his favorite DIA agent.

JACK WILLIS

Jack Willis, like his old friend and Marine buddy Henry Brogan, is a soldier who survived the wars, both while in the military and then in the equally dangerous world of international espionage and security. "Jack is one of Henry's oldest friends," explains actor Douglas Hodge, taking a break from filming aboard Jack's yacht, *The Scratched 8*, on a Georgia dock called Priest Landing on the Skidaway River. "They were together in combat and have forged the kind of brotherhood that you see again and again in people who can't describe to people back home what they went through. Will's character, Henry, is intrinsically decent and straightforward… I think Jack is a little bit more off the rails, takes a few more risks, and has decided to get very, very rich using the more mercenary aspects of his knowledge. Will's character, Henry, is still working and shouldn't be, but he's still the best at it and, in the story, I get a little piece of information that tells me Henry is in trouble. We haven't seen each other in twenty years, and I sail my much larger boat up to his tiny little tug and tip him off." In fact, Douglas Hodge and Will Smith hadn't seen each other in nearly ten years, and their first meeting was under somewhat less conventional circumstances: the evening Hodge won a Tony

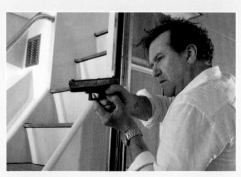
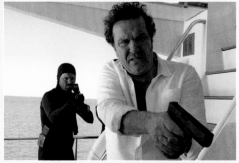

▲ Jack in the last few moments of his life, before his loyalty to Henry signed his death warrant.

Award for his starring role on Broadway as the outrageous and endearing Albin in the musical *La Cage aux Folles*. When Hodge performed a song from the show in full drag, he descended from the stage into the audience and sat on Smith's lap. "I'm still not sure if I should remind him of that," Hodge laughed .

THE SCRATCHED 8

Willis' "much larger boat" is *The Scratched 8*, a lavish and beautifully appointed seventy-three-foot long yacht actually named *Bettina Vita*, built in 1994 by Yachtwerf Neptunus, a company based in The Netherlands.

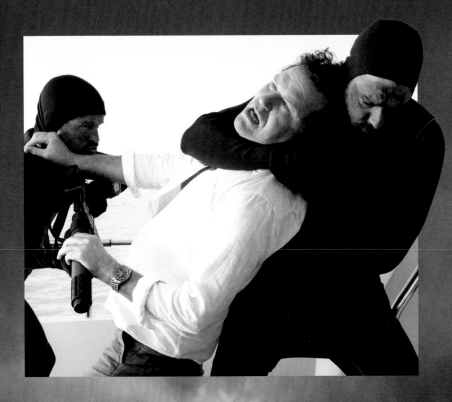

▼ Concept imagery for Jack's murder scene.

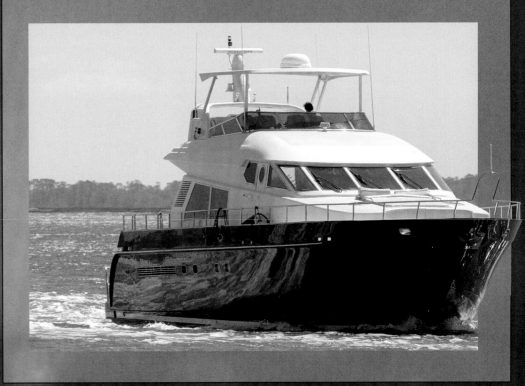

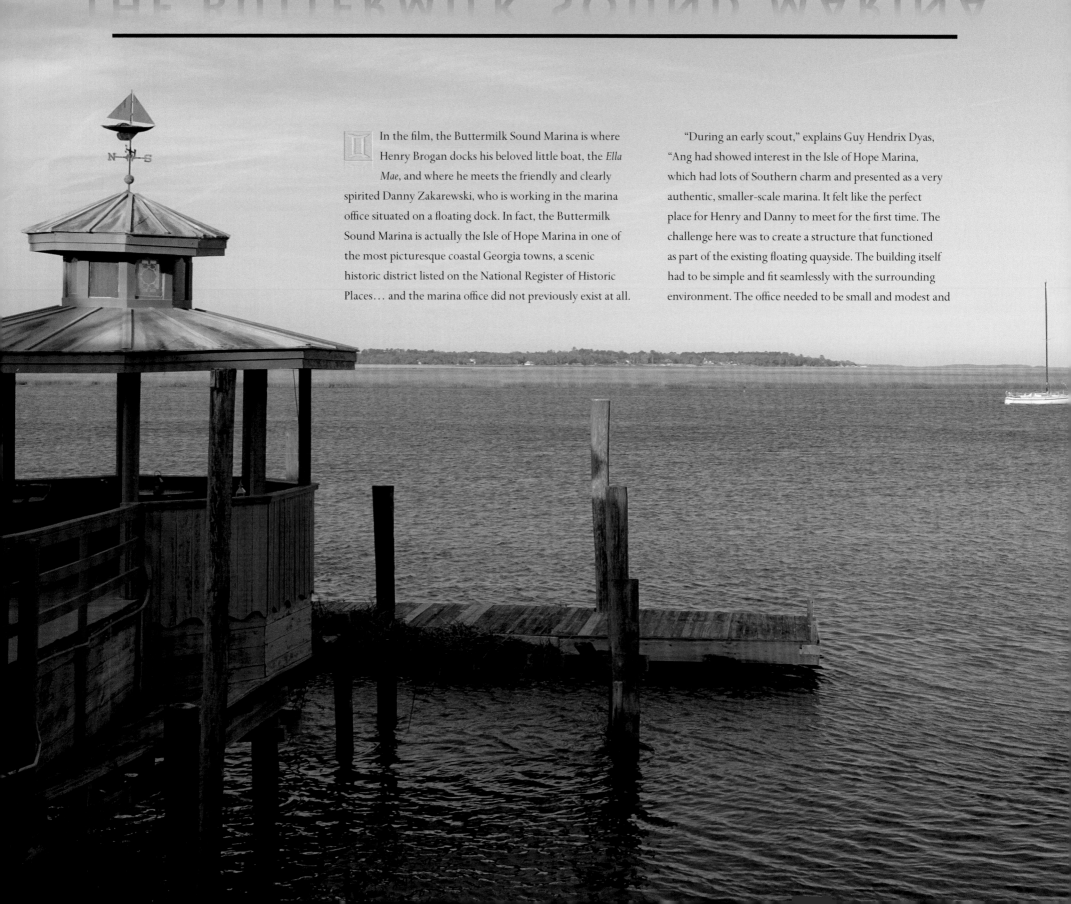

THE BUTTERMILK SOUND MARINA

In the film, the Buttermilk Sound Marina is where Henry Brogan docks his beloved little boat, the *Ella Mae*, and where he meets the friendly and clearly spirited Danny Zakarewski, who is working in the marina office situated on a floating dock. In fact, the Buttermilk Sound Marina is actually the Isle of Hope Marina in one of the most picturesque coastal Georgia towns, a scenic historic district listed on the National Register of Historic Places… and the marina office did not previously exist at all.

"During an early scout," explains Guy Hendrix Dyas, "Ang had showed interest in the Isle of Hope Marina, which had lots of Southern charm and presented as a very authentic, smaller-scale marina. It felt like the perfect place for Henry and Danny to meet for the first time. The challenge here was to create a structure that functioned as part of the existing floating quayside. The building itself had to be simple and fit seamlessly with the surrounding environment. The office needed to be small and modest and

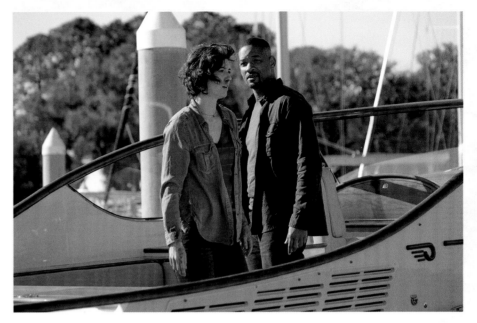

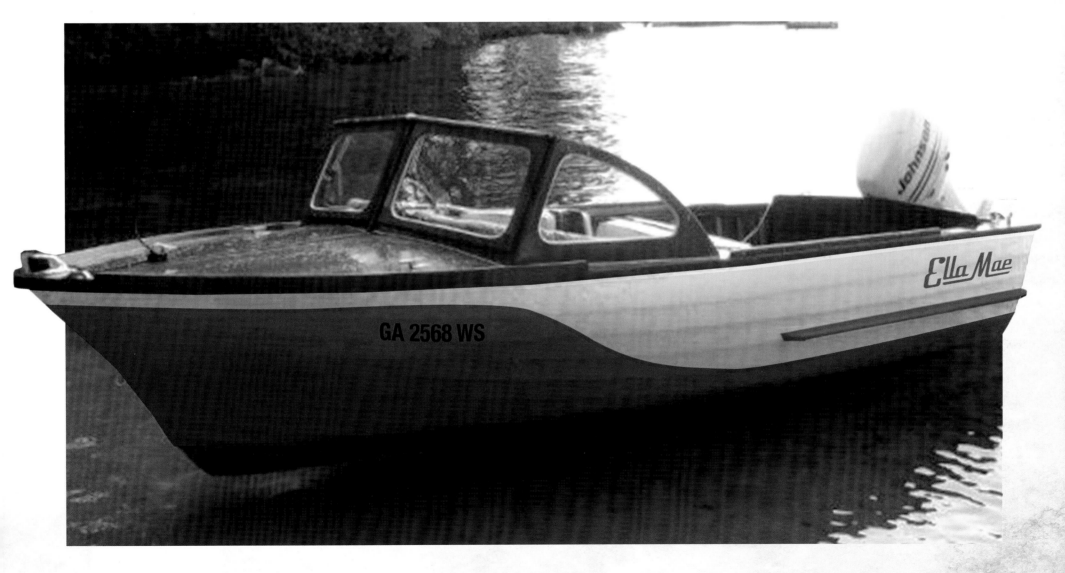

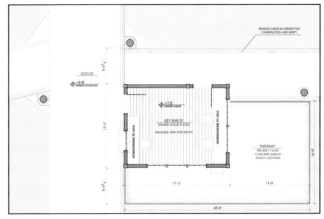

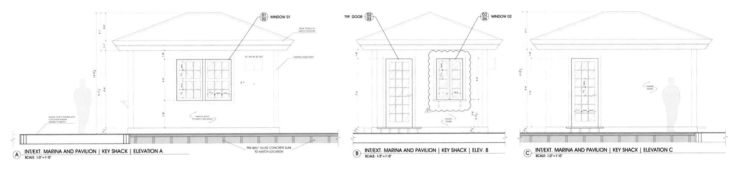

▲ Graphic signage created for the apartments and shops surrounding Buttermilk Sound.

show all the characteristic aging of a wood sided building that had been floating on the river's edge for years. The set walls were designed to come apart at a moment's notice for crew and camera access as the interior was naturally very tight. The structure also had to be engineered to remain stable and support the extreme weight of the camera and lighting equipment as well as a large scale crew. Essentially we built a 'real building' as we realized that the structure might need to survive the harsh storms at that time of year."

And indeed, the heavens did open up while the company was filming over three days of shooting at the marina, with driving rains and temperature changes of

some thirty degrees in the course of a day, along with stiff winds. But cast and crew literally shot between the raindrops and completed their work. And thankfully, the *Ella Mae*, a delightfully diminutive fourteen-foot vintage 1952 Oldtown boat with fifty-horsepower engine, emerged unscathed as well.

"Our set must have been very convincing as I look back on the experience," muses Dyas. "I recall an amusing episode where a group of tourists showed up at our office trying to buy refreshments and plan a day trip on the river — they really thought it was a store and information office!"

DANNY

The role of Danielle "Danny" Zakarewski, a young, ex-Navy DIA agent who begins her relationship with Henry Brogan by surveilling him and ultimately becomes his most loyal and courageous ally, is portrayed by Mary Elizabeth Winstead, an actress who producer Jerry Bruckheimer calls "one of the most talented and versatile of her generation." The much sought-after role of Danny was the subject of great scrutiny in film industry media. "We saw Mary in the television version of *Fargo*," notes Bruckheimer, "and thought she was an amazing young actress who could embody the kind of agent she plays in the film, someone smart, physical, and who the audience comes to care about."

Indeed, audiences have cared about Mary Elizabeth Winstead since her cult role as Ramona Flowers, she of the multi-hued hair for whom the titular character of *Scott Pilgrim vs. the World* battles an army of her exes. Since then, whether in films swimming in the mainstream or more independent, among them *Smashed*, *A Good Day to Die Hard*, *The Spectacular Now* — with a role as Huntress in DC's *Birds of Prey* directly following *Gemini Man* — the North Carolina

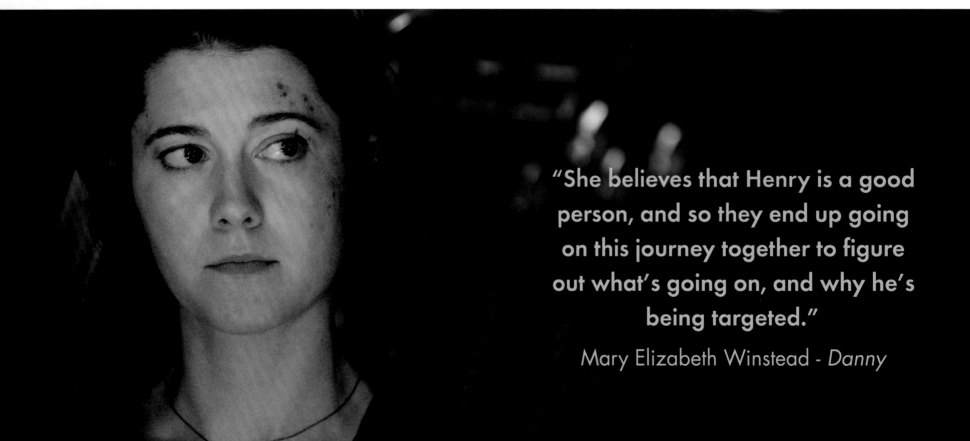

"She believes that Henry is a good person, and so they end up going on this journey together to figure out what's going on, and why he's being targeted."

Mary Elizabeth Winstead - *Danny*

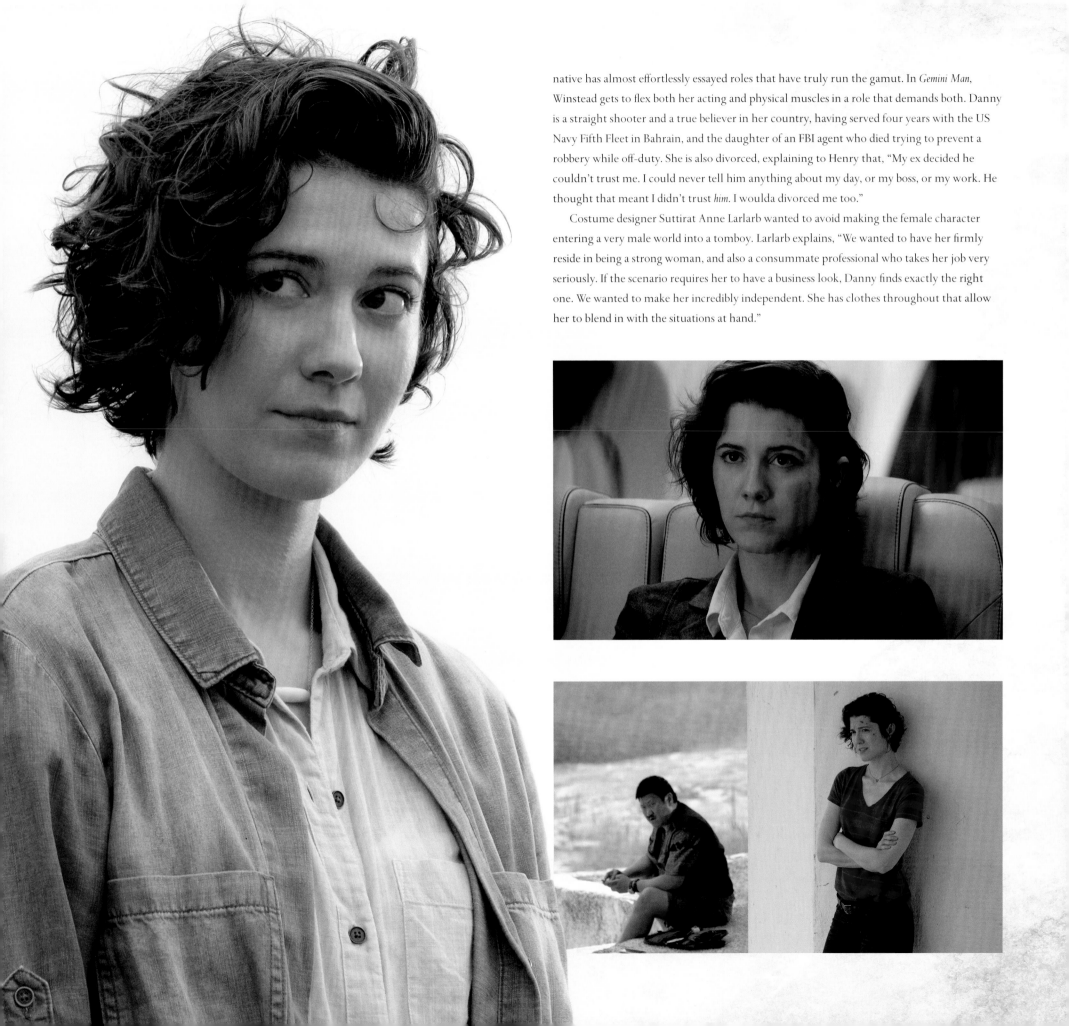

native has almost effortlessly essayed roles that have truly run the gamut. In *Gemini Man*, Winstead gets to flex both her acting and physical muscles in a role that demands both. Danny is a straight shooter and a true believer in her country, having served four years with the US Navy Fifth Fleet in Bahrain, and the daughter of an FBI agent who died trying to prevent a robbery while off-duty. She is also divorced, explaining to Henry that, "My ex decided he couldn't trust me. I could never tell him anything about my day, or my boss, or my work. He thought that meant I didn't trust *him*. I woulda divorced me too."

Costume designer Suttirat Anne Larlarb wanted to avoid making the female character entering a very male world into a tomboy. Larlarb explains, "We wanted to have her firmly reside in being a strong woman, and also a consummate professional who takes her job very seriously. If the scenario requires her to have a business look, Danny finds exactly the right one. We wanted to make her incredibly independent. She has clothes throughout that allow her to blend in with the situations at hand."

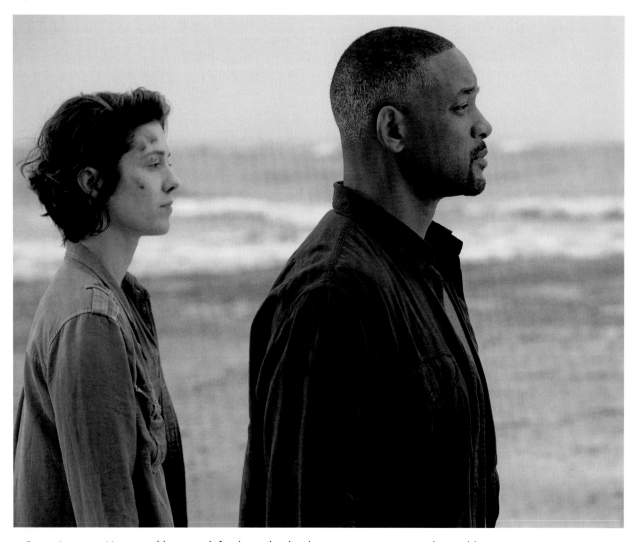

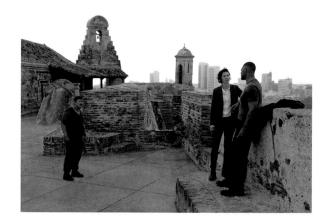

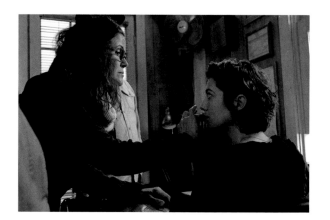

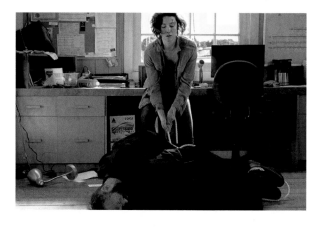

▶ Danny's trust in Henry and her search for the truth takes her on a journey across the world

"Danny doesn't really ask questions," Winstead explains of her character, "she just does her job. Working on the docks while undercover, when she comes to realize that Henry is being tracked by people who want to kill him, Danny is confused. She believes that she works for a good organization that wouldn't go after somebody who hasn't done something really, really wrong. But she believes that Henry is a good person, and so they end up going on this journey together to figure out what's going on, and why he's being targeted.

"*Gemini Man* is a fun ride," she continues, "but also quite moody and cerebral in lots of ways. The film asks a lot of questions about ourselves, what we believe in, who we are now and who we're going to be. And because it's an Ang Lee film, he's a director who is always asking esoteric questions under the guise of this really fun popcorn action film."

Like the rest of the cast, Winstead was delighted to be working with Will Smith, with whom she shares many on-screen moments of intense emotion, personal interaction, and action. "Working with Will, you're just surrounded by this positivity at all times," she exclaims. "I feel so lucky to be working with somebody like him, who every day comes in and says wow, we're so lucky to be here making a movie and being in this industry. It's really infectious and makes everybody else kind of go hey, yeah, we ARE really lucky to be here! And wow, we're shooting in all these amazing places. And you just feel that sense of awe just to be a part of something so great. Will infuses every moment with that energy."

Winstead shares with her fellow cast members a fascination with the new technologies being utilized to film *Gemini Man*, particularly being shot in 120 frames per second

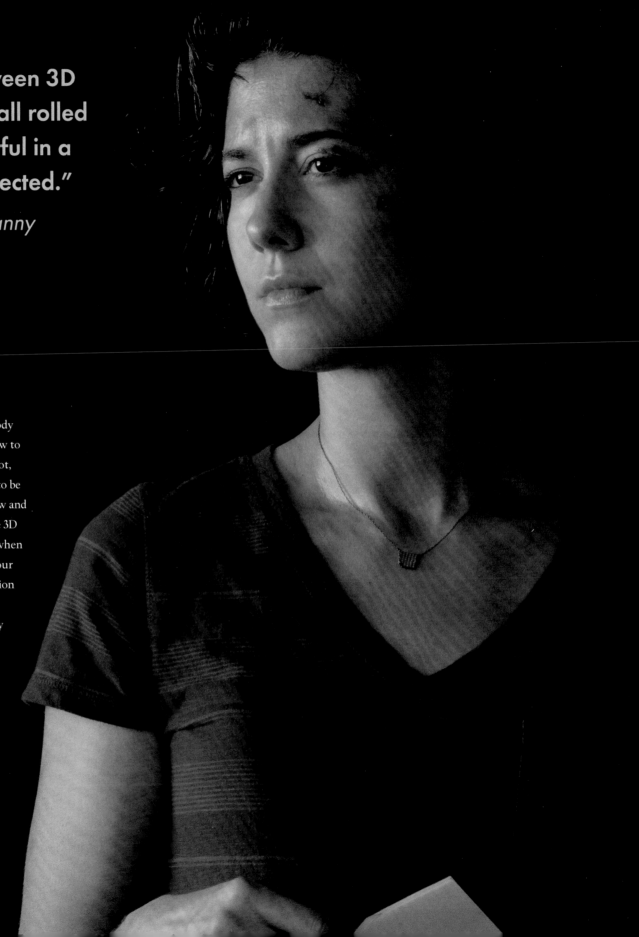

> "It's almost like a bridge between 3D and virtual reality and cinema all rolled into one. It's beautiful and artful in a way that I wouldn't have expected."
>
> Mary Elizabeth Winstead - *Danny*

and in 3D, which accentuates and magnifies every facial expression, body movement, and even costume and makeup. "The technology is so new to me and it's different shooting in this way," she confesses. "When I shoot, typically I don't watch playback very often because I don't really like to be watching myself when I'm in the middle of the process. But every now and then it's really tempting to want to go and watch everything with the 3D glasses because it's so special and unique. So, I do watch footage, and when we're doing action scenes Ang wants us to watch so we can see what our bodies are doing, then take notes and go back with it. Some of the action scenes I've been watching look so incredible and unlike anything else I've seen before. It's almost like a bridge between 3D and virtual reality and cinema all rolled into one. It's beautiful and artful in a way that I wouldn't have expected. It's exciting to be on the forefront of something like this.

"I try not to get overwhelmed by the technology and just focus on trying to do my job, because when you stop to think about how crazy it is what we're doing, and how big and new and exciting it is, it can be a little bit overwhelming. So I kind of stay in my lane and focus on just being Danny, but every now and then I look around and think "Oh my God, what are we doing? This giant camera, those giant lights, everything's just sort of magnified. It's like doing a film, but just on a totally different scale!"

Just as nearly every scene filmed in Savannah is set in Savannah, an important one in which Henry and Danny get to know each other features The Fish Dock at Pelican Point, situated on the Sapelo River in Townsend, Georgia, playing itself… with a little visual boost from the filmmakers.

"The Fish Dock is a popular riverside restaurant at Pelican Point and was always an obvious choice for us to transform into a lively and atmospheric night spot for Henry and Danny to get acquainted," says production designer Guy Hendrix Dyas. "The script suggested a cheerful ambiance and a perfect setting for Henry to reveal that he knows Danny's true identity and objective." While The Fish Dock is a perfectly charming site for a waterfront lunch, Dyas and his team decided to kick it up a few notches to make it even more cinematically attractive

"After many weeks of planning, a careful transformation of The Fish Dock started to take shape just days before we were scheduled to shoot," continues Dyas. "My construction team made several structural changes to the rear patio in order to frame our two actors perfectly against the evening river. The painters carefully applied color to the premises with a palette of teal greens and turquoise blues with lemon yellow accents to emphasize the playful nature of the scene and reflect the natural colors of the riverside. Finally the set decorating team dressed the bar and restaurant in a collection of fishing and river boat antiques."

PELICAN POINT
BAR & GRILL

Pelican Point Specialties

DEVLIED CRAB - $15.95
Two Large House made Deviled Crabs in Blue Crab Shells with cocktail sauce

SHRIMP & GRITS - $16.95
Locally grown organic Canewater Grits, Georgia Shrimp drizzled with a seasoned cream sauce.

SHRIMP PLATTER - $13.95
Fried Georgia Shrimp served with Tartar 2 Ways.

LOW COUNTRY BOIL FOR TWO - $24.95
Local Darien, Georgia Shrimp, Charred Andouille Sausage, Potatoes, Grilled Corn in a Tomato Based Broth & Cajun Old Bay

A TOUR OF THE RIVER SEAFOOD PLATTER - $32.95
A Seafood Platter overflowing with Locally Caught Seafood. More food than one person can eat! Ask your server about today's variety.

CHARLIE'S DAILY CATCH - $22.95
Our Fresh Catch, straight from our boat to your plate. Ask your server about today's catch. Prepared to your liking: Fried, Sautéed or Blackened.

WHOLE FISH & FRIED SHRIMP - $29.95
Choice of Whole Fried Fish with Fried Georgia Shrimp.

SOFT SHELL CRAB DINNER - $22.95
Two Local & Fresh Georgia Blue Soft Shell Crabs Fried to perfection.

SOFT SHELL CRAB DINNER - $22.95
Two Local & Fresh Georgia Blue Soft Shell Crabs Fried to perfection

Homemade Desserts

$2.50 EACH

· Coconut Cake · Carrot Cake

· Strawberry Cake · Lemon Cake

· Sweet Potato Pie · Banana Pudding

· Peach Cobbler · Apple Cobbler

· Blackberry Cobbler · Red Velvet Cake

Georgia Caught Buckets

PEEL & EAT SHRIMP
+ Half Pound $10.95
+ Full Pound $17.95
Local Georgia Shrimp boiled to perfection, your choice of being served Hot or Cold.

OYSTERS - $19.95
Bucket of Fresh Steamed Or Raw Oysters

JALAPENO BOURBON CLAMS - $10.95
Fresh Caught Sapelo River Clams, Bourbon Broth with Toasted Crostini.

CLASSIC CLAMS - $9.95
Fresh Caught Sapelo River Clams in a Buttery Wine Sauce with Toasted Crostini

Sunday Brunch Buffet

11:30am to 2:30pm
SUNDAY BRUNCH SPECIAL - $15.95

· French Toast · Breakfast Casserole

· Course Ground Cane Water Grits

· Bloody Mary Low Country Boil

· Fried Whole Catfish · Fried Chicken

· Biscuits & Gravy · Smashed Home Fries

· Potato Salad · Cole Slaw · Fresh Fruit

· House Granola and Yogurt

· Chefs Choice of the Day

CATCH OF THE DAY
+ Half Pound $10.95
+ Full Pound $17.95
Local Georgia seafood boiled to perfection, your choice of being served Hot or Cold.

OYSTERS - $19.95
Bucket of Fresh Steamed Or Raw Oysters

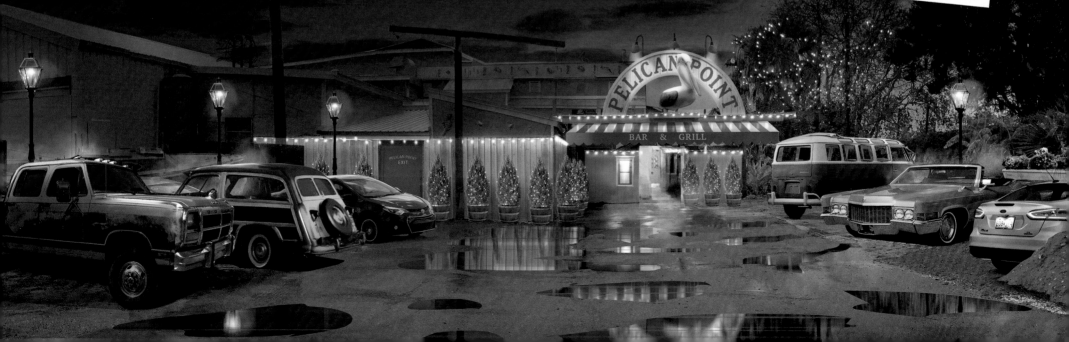

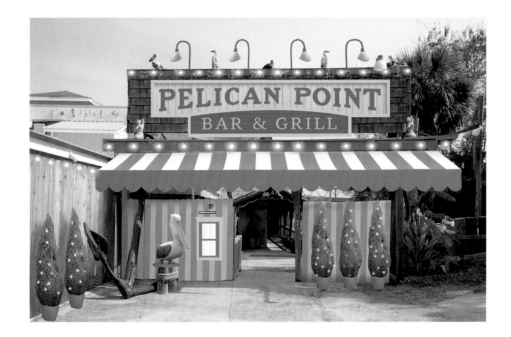

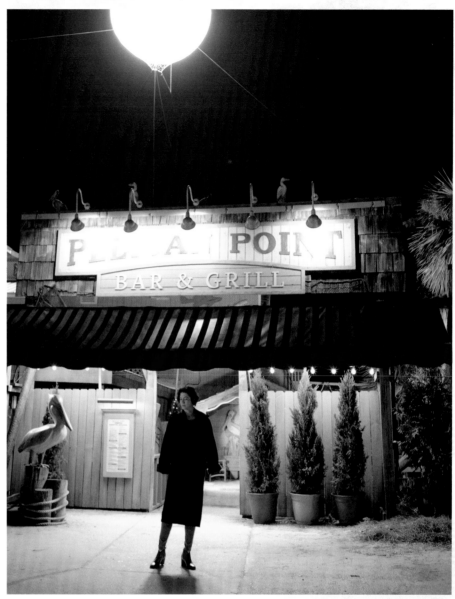

▶ Mary Elizabeth Winstead on set, photographed by Jerry Bruckheimer.

▼ Concept imagery of the Pelican Point.

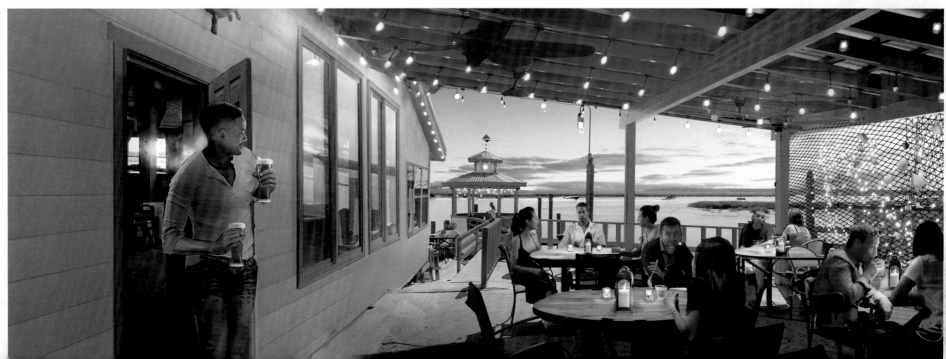

THE ESCAPE

Everything in Henry Brogan's body and soul is primed for instantaneous danger, which is exactly what occurs when a laser trip-wire on his home property is breached in the dead of night, setting off an alarm telling him that a threat is very near. "I spent quite a bit of time in the military," notes stunt coordinator J.J. Perry, "I'm a combat veteran. I relate to Henry's character, because I'm fifty-one, a little bit past my prime… but beware of the older soldier. When I was in the Army, the guys who were the most intimidating were the old soldiers who had seen a lot of combat and were still alive. So that's one of the things I thought about Henry when we were working on the night attack on his house. If someone tried to come and take me down in my home… he would know

▲ Dion Beebe on set of the escape scene. Filmed during the day but set at night.

every inch of the place, and it would be a suicide mission for anyone to try and take him down because he knows every nook and cranny and sound of that house.

"I originally thought the scene would be bigger," Perry admits, "but Ang wanted to pare it down, saying no, we'll just send a small team of guys in there. I came in a week before the scene was filmed with my stunt team, and I shot and cut the scene on a little Sony camera and showed it to Ang. He gave me a few changes, and that was the sequence."

What was truly unusual about the filming of this night attack sequence is that it was actually shot during daylight hours. This is just one of the new and developing technologies being utilized by director of photography Dion Beebe on the film, in addition to the challenges of shooting in a high frame rate and in 4K resolution 3D with Arriflex Alexa cameras especially modified for the production. "Dion is using different kinds of lighting than he's ever used in the past," says executive producer Chad Oman. "He said that working on *Gemini Man* is like going to film school

because he's learning and trying something new every single day. He's shooting day for night in a way that's never been done before. Ang believes that the human eye sees differently at night than what you see in night shots on film. For night shooting, you have to light everything that you see, and everything else goes black, but at night, the human eye adjusts and can see details way into the distance. So the way Ang has conceived of shooting night scenes, once it's digitally converted into a night scene you can still see details just as you would in real life. It's a much more realistic version of night scenes than actually shooting at night."

Henry, still the best shot in his business, quickly dispatches the assailants, and then heads to Danny's apartment to rouse her from sleep. She heads to the marina office to lift a pair of keys for the fastest boat in the marina and is attacked by yet another operative. This fight was filmed on a reconstructed version of the office interior built in the gymnasium-turned-soundstage at the abandoned Thunderbolt Elementary School within the Savannah city

limits, which served as the production's home base during the Georgia portion of the shoot.

The scene required considerable training for Winstead, but she felt that she had the track on it due to her previous training. "Thankfully, I come from a dance background, so I tend to be able to pick up choreography pretty quickly," she said during a break while rehearsing with stunt coordinator J.J. Perry. "But my main issue is that sometimes I look more like a dancer than a fighter. I have to try and beat some of those dancer habits out of me, but J.J. and his team have been so lovely to me, really positive and constructive, and they've been great at getting me to where I need to be without breaking me down." J.J. Perry put Winstead on an intense regimen that she was totally game to follow. "I had Mary in training for four weeks, about three hours a day. We did judo, jiu-jitsu, and fight training. This was kind of a new venture for Mary, but she embraced it with open arms. She trained very hard, and it was an absolute pleasure to work with her."

THE HIDDEN PASSAGE

Although the night attack by Gemini elite soldiers on Henry at his home in the Georgia woods was filmed during the very first week of production, the scene of Henry escaping through a passageway beneath a trapdoor in his bedroom was actually the very last shot on the final day of principal photography. "Because Ang and I had decided to use a real location for Henry's home," explains Guy Hendrix Dyas, "it did present a few problems when it came to the night ambush sequence. Henry is awakened by a discreet alarm system when an elite Gemini team is moving in to kill him, and he only has seconds to escape. It's a heart pounding moment in the story where the audience gets to see how prepared Henry is for a home raid. Revealed under a rug by his bed is a hidden trapdoor that leads down to a simple tunnel and an escape route."

In one of those situations where using a practical, real location denied the ability for a production designer to accomplish what was required by the script, Dyas had to take another, more complex path to fulfilling those needs. "We could not dig into the foundations of the real home we were using," continues Dyas, "and in reality we would not be able to shoot in a small tunnel easily with our cameras. We decided to build a convincing set on a soundstage at Origo Studios in Budapest months later. The set was a great deal of fun to design and construct, and, while relatively easy, we needed to make sure that all the formed concrete finishes were convincing on close inspection. The set included an upper level with a wood planked trapdoor that matched our fake version under the rug back at the bedroom location. There was an eight-foot drop down into the square concrete tunnel. The set was the final scene we shot for the film, and the crew was in high spirits. It was a fitting end to an exciting and enjoyable shoot."

▼ Stills of Henry's bedroom set (top). A 3D render of the escape tunnel through Henry's house. (bottom left). The hidden exit to the escape tunnel (bottom right).

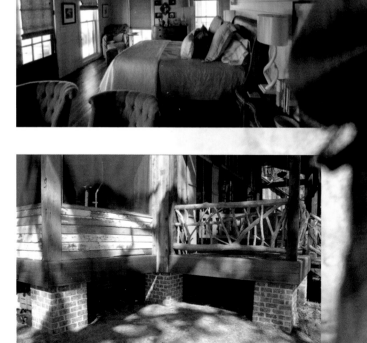

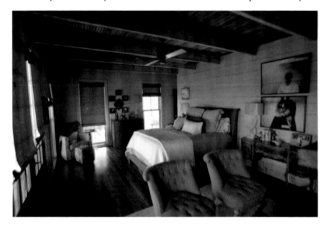

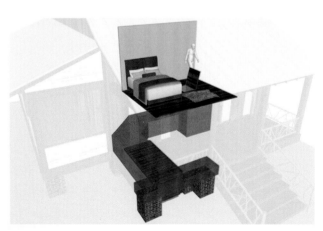

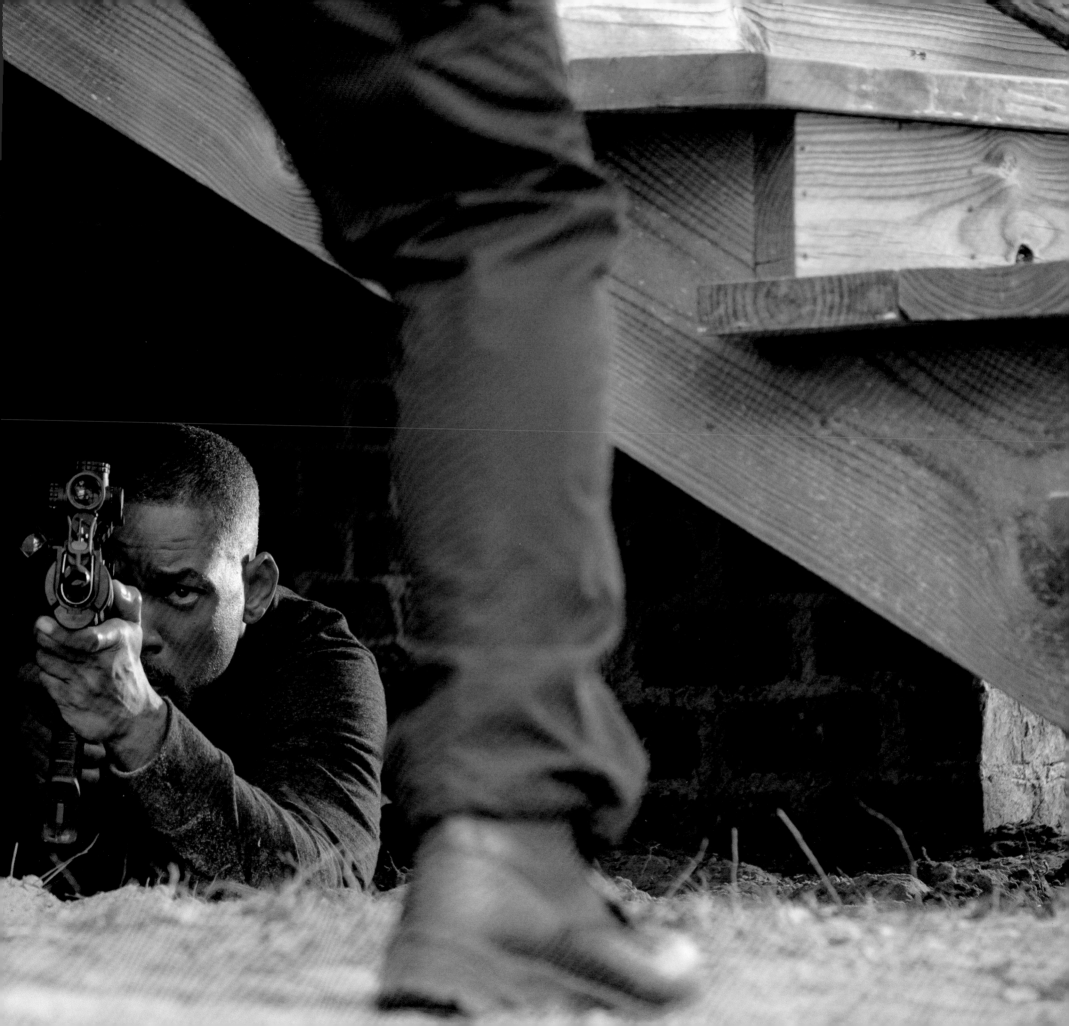

DANNY'S APARTMENT

Danny's apartment near the Buttermilk Sound Marina where she is working is exactly the kind of simple domicile one would expect from a grad student working in the dock office… rather than what she really is. "Danny is an intelligent and ambitious professional who is prepared to sacrifice lifestyle to maintain her cover," says Guy Hendrix Dyas. "Ang wanted her apartment interior to feel neglected and quite dated with no modern amenities. Through our dressing of the set we tried to show Danny's backstory, attempting to maintain her humble accommodation while focusing on her professional assignment to surveil Henry. The apartment was a set on stage in Budapest, thousands of miles away from its scripted location. In our story, the apartment was overlooking the Buttermilk Sound Marina. By using a separate exterior location near the Isle of Hope Marina near Savannah and matching the window frames to our stage set in Budapest, the illusion worked well."

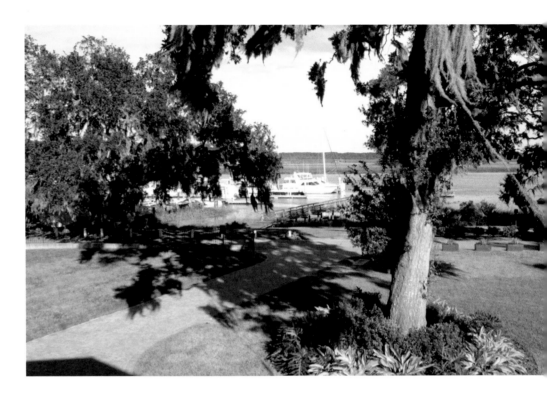

▼ Concept imagery of the exterior of Danny's apartment block.

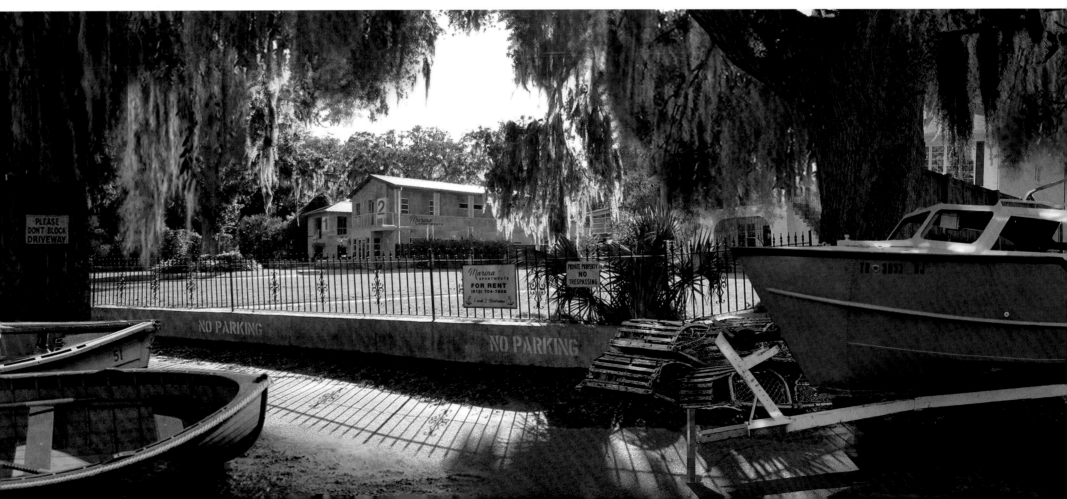

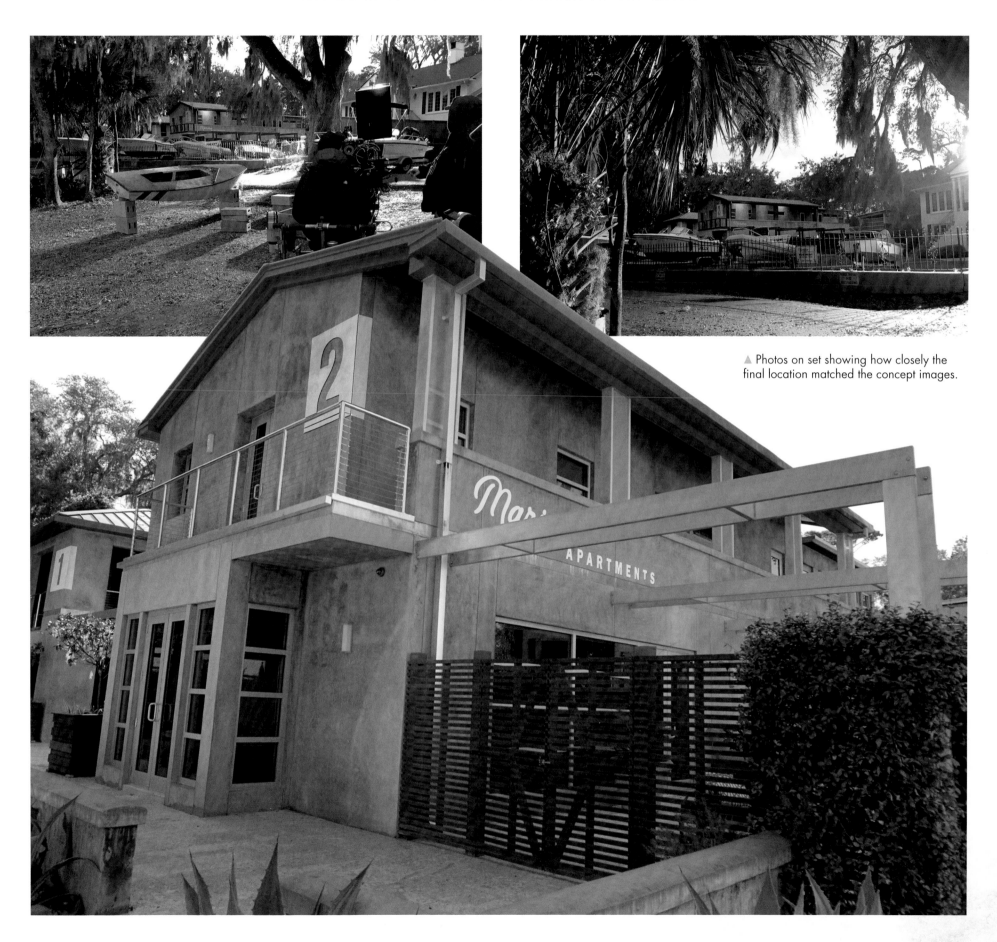

▲ Photos on set showing how closely the final location matched the concept images.

BARON'S SEAPLANE

Ang Lee, cast, and crew battled rain, chill, wind, and clouds over two days of shooting on Tybee Beach, one of South Georgia's preeminent playgrounds. Unfortunately, Tybee was doubling for what was supposed to be a sunny Florida beach, where Henry and Danny are awaiting his longtime friend and comrade to come swooping out of the sky in his aging Baron Tours seaplane like a slightly shabby *deus ex machina*. It was incumbent upon production designer Guy Hendrix Dyas to find the exact right seaplane for the scene. "The seaplane was an important vehicle to decide on, as it's Baron's introduction in our story. He's a retired agent and ex-military colleague of Henry's living peacefully in Cartagena running air tours up and down the coast for a living. I had gone back and forth on the various aircraft available to our production and finally approached Ang with the De Havilland DHC – Mk3 Beaver, which had a classic look to it. It seemed unusual for someone to own an older looking plane in our film, which to this point is full of high-tech gadgets, weapons, and vehicles, but Ang always hinted that Baron would be someone who was very likable and even a little eccentric. Our graphic design team put together a paint scheme and side graphic for the plane.

The nostalgic and friendly feel of the aircraft and the bright colors fit perfectly with Ang's description of the character. For his introduction, Baron is shown wading to shore to greet Henry and Danny from his seaplane and is portrayed brilliantly by Benedict Wong."

And while it might be said that it was no day at the beach for all concerned, particularly Dan Malone's marine department, the company plowed through and got what was needed… but not without some struggle. When the seaplane landed in windswept, rough surf, Benedict Wong recalls that "I guess we kind of didn't really take into account how quickly the tide would start coming in, and the seaplane was moving around a great deal. We tried to counter that by starting the engines and moving it back again, and there was only so much time in which I could get out of the plane before it began sliding onto the shore. It was quite hairy at times. I was thinking that we were all going to be washed away if we don't hurry up, but in some ways it was indicative about how you get past the hurdles that we face making these types of movies. The kind of elite crew that we had says OK, we have a job to do, and they get it done."

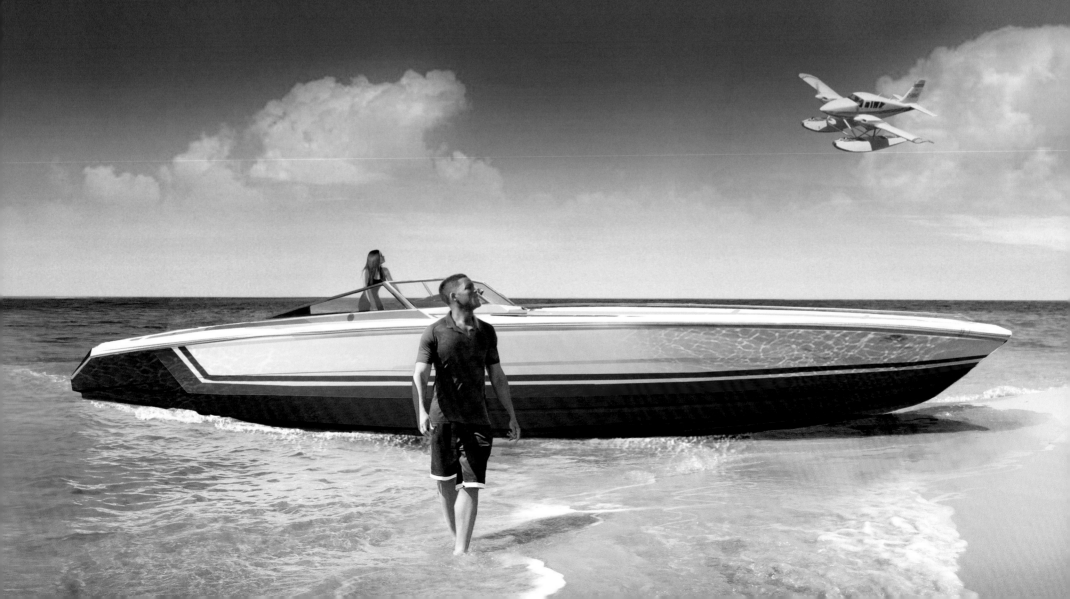

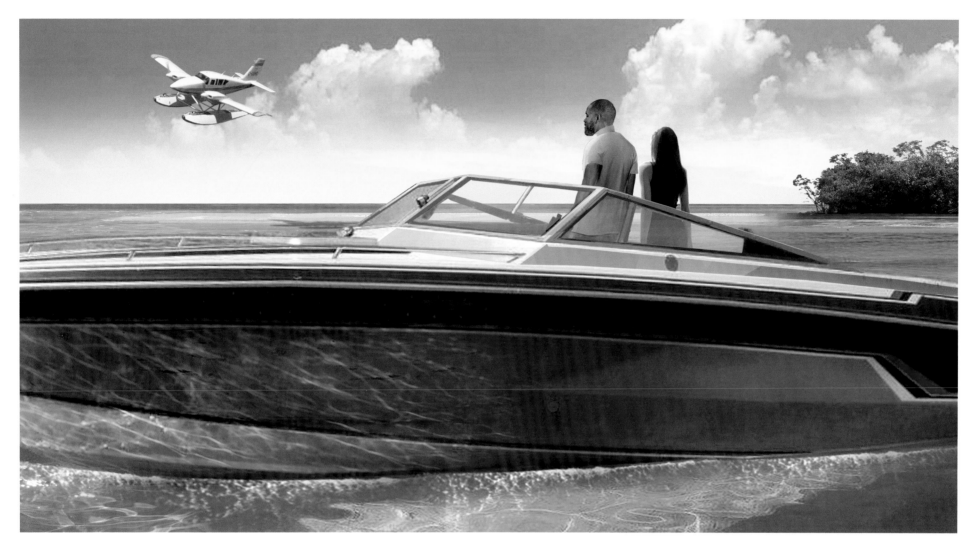

◄ Henry and Danny's trip to meet up with Baron and his seaplane, as depicted in concept art.

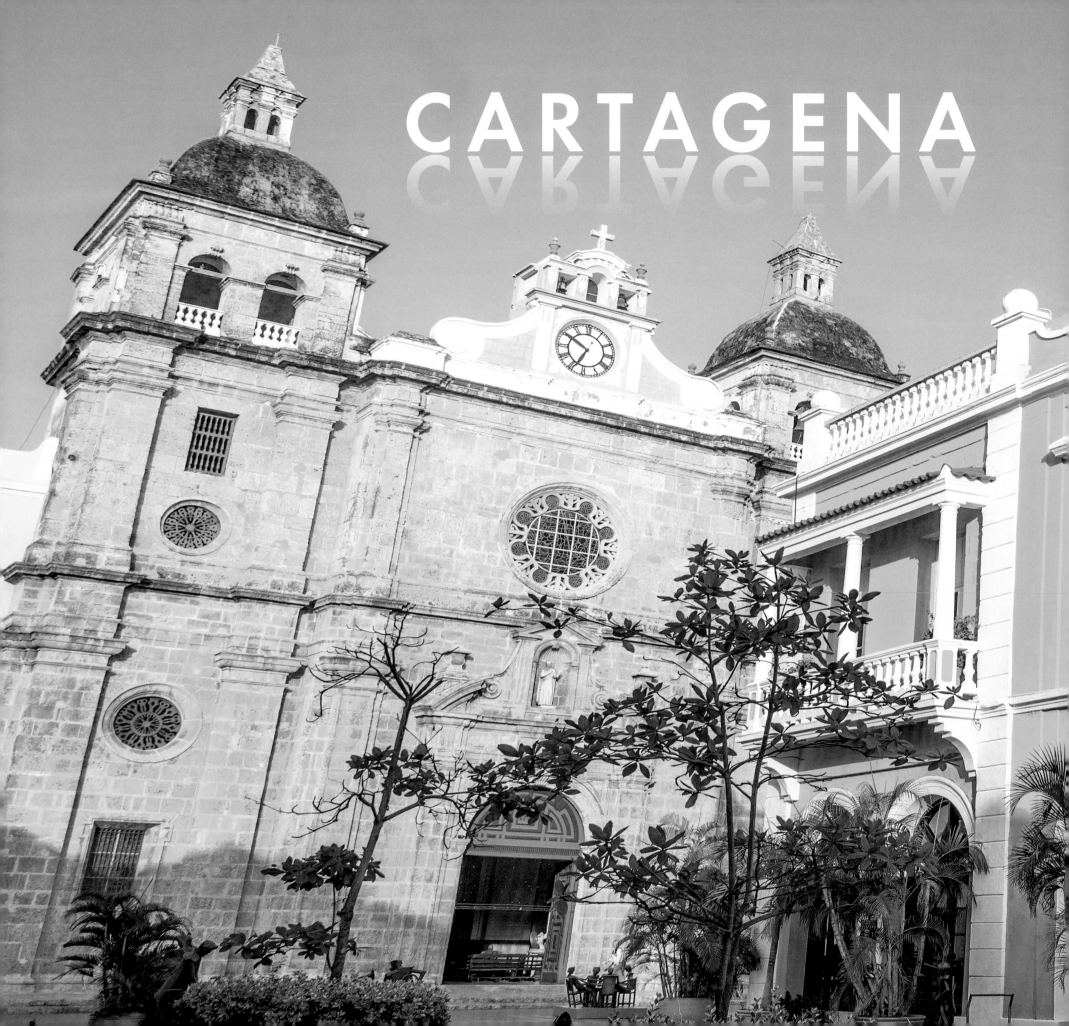

CARTAGENA

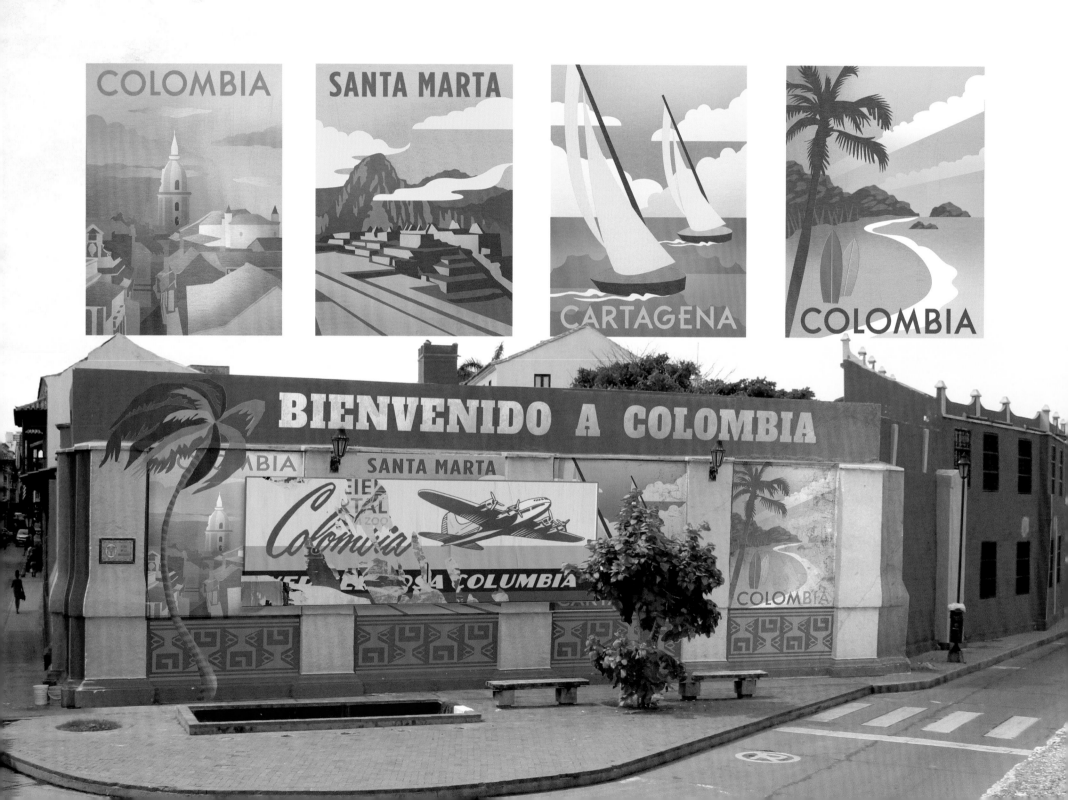

Surprisingly, considering its superbly sensual architecture and fascinating history and culture, not many films have utilized the magnificent UNESCO World Heritage city of Cartagena de Indias, Colombia as a location. "Cartagena is an amazing city," enthuses executive producer Chad Oman. "It hasn't been filmed a lot for features, so it hasn't been seen a lot on screen. It hasn't been gentrified or cleaned up for tourism, so it has this really beautiful patina of age. The colors and people are remarkable." Notes Colombia location manager Douglas Dresser, "They haven't made a major feature in Cartagena in approximately a dozen years, and so we're essentially learning together, both the city and the film crew. We're

doing some really challenging stuff, affecting a lot of residents and trying to capture the city's magical beauty. We are closing between sixty and eighty streets in the city, we have seventy working trucks and a crew of 500 that are working in streets built 500 years ago. We're chasing motorcycles, crashing cars, all in the historic center. It's pretty challenging, to say the least."

In addition to the *Centro Historico* (Old Town), the thrilling sequence was also shot in the narrow *callejones* (alleyways) and *plazas* of the distinctive working class district of Getsemani, now transitioning into a fashionable neighborhood of art galleries and cafes without entirely losing its working class roots. Other Cartagena locations for the film included the massive

◄ Early designs for the "Welcome to Colombia" murals before they were painted.

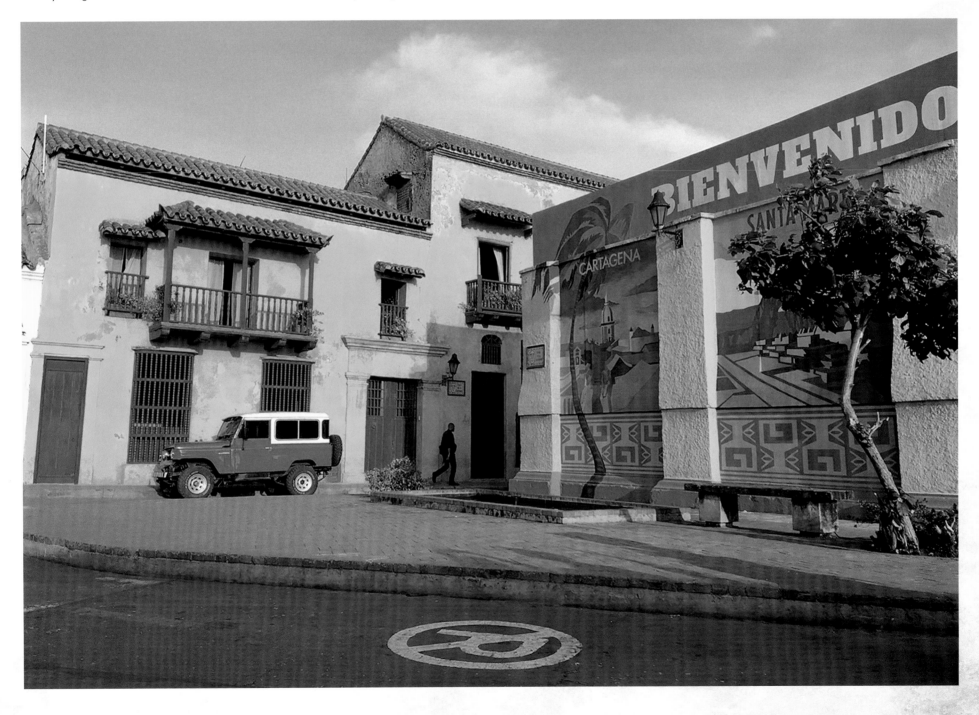

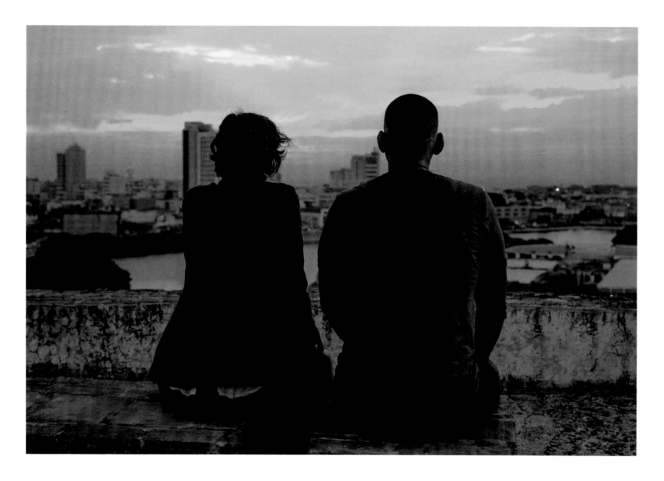

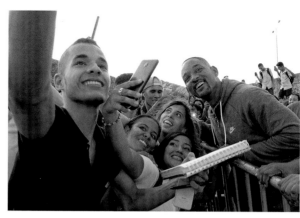

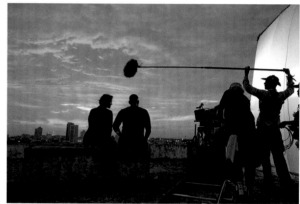

Castillo San Felipe de Barajas, an imposing structure, the largest surviving Spanish fort in the New World. In the ruthless tropical heat and humidity of Cartagena, it was no easy uphill climb, especially for crew members pushing carts filled with equipment up the steep ramps leading to the fortress, and navigating multiple sets of stairs to the top. The almost impossibly fit Will Smith, however, literally bounded up the heights of the castle with the swiftness of a gazelle, and a smile on his face. And down below, hundreds of his Colombian fans gathered, excited not only to see one

superstar named Smith, but two, as Will's son, Jaden, joined his dad on top of the Castillo at mid-day.

And on the final day of filming in Cartagena – directly following the company crew photo taken in front of a gigantic mural painted by the art department near Baron's house in the *Centro Historico* – everyone was suddenly regaled with live Colombian musicians, dancers, and local treats, a real street party courtesy of Mr. Will Smith. It was a rousingly fitting finale to a month of hard work, infused with a great deal of fun, in the beautifully intense tropical heat.

▲ Will Smith in Colombia taking photos with a crowd of fans, captured by Jerry Bruckheimer.

▼ The texture of the sets and props give a real sense of the color and life of Cartagena.

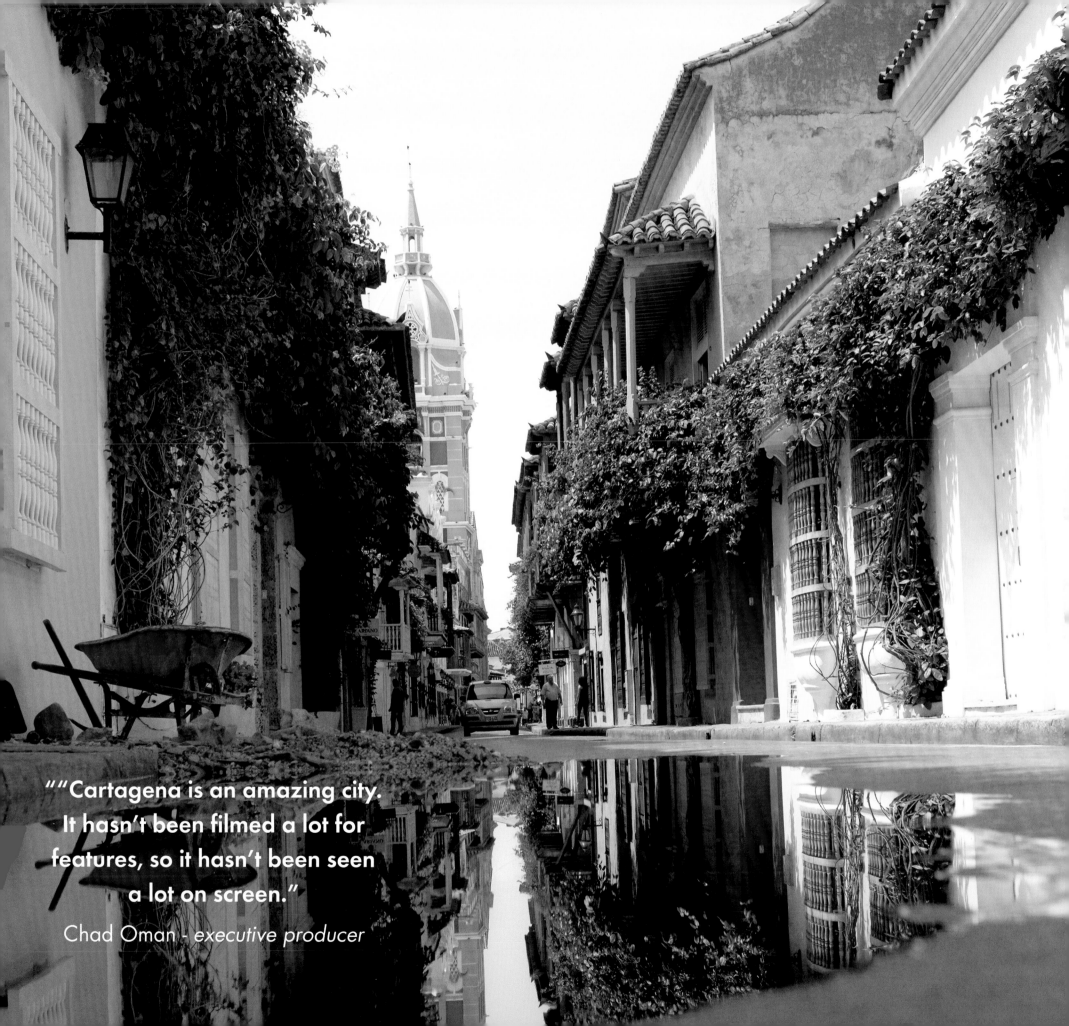

""Cartagena is an amazing city. It hasn't been filmed a lot for features, so it hasn't been seen a lot on screen."

Chad Oman - *executive producer*

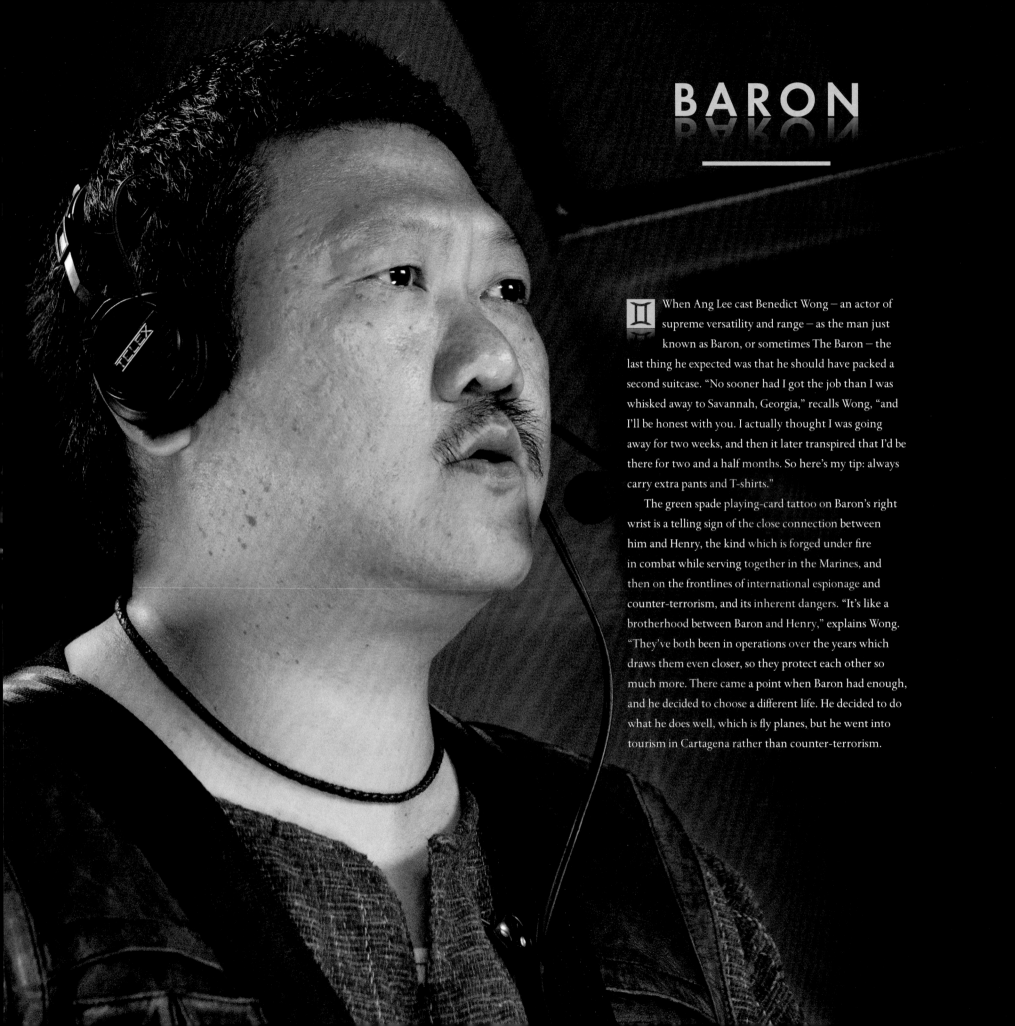

BARON

When Ang Lee cast Benedict Wong – an actor of supreme versatility and range – as the man just known as Baron, or sometimes The Baron – the last thing he expected was that he should have packed a second suitcase. "No sooner had I got the job than I was whisked away to Savannah, Georgia," recalls Wong, "and I'll be honest with you. I actually thought I was going away for two weeks, and then it later transpired that I'd be there for two and a half months. So here's my tip: always carry extra pants and T-shirts."

The green spade playing-card tattoo on Baron's right wrist is a telling sign of the close connection between him and Henry, the kind which is forged under fire in combat while serving together in the Marines, and then on the frontlines of international espionage and counter-terrorism, and its inherent dangers. "It's like a brotherhood between Baron and Henry," explains Wong. "They've both been in operations over the years which draws them even closer, so they protect each other so much more. There came a point when Baron had enough, and he decided to choose a different life. He decided to do what he does well, which is fly planes, but he went into tourism in Cartagena rather than counter-terrorism.

"But when Baron gets the call from Henry that he needs help," continues Wong, "he drops everything. They're not just bonded by a tattoo, it signifies so much more about how far they've come and to what end they will go to save each other's lives."

"Baron is a really cool character who is given a great spark of life by Benedict," says Jerry Bruckheimer. "Benny is always fun to watch and hugely entertaining, but he also projects a real edge. You just know that when the chips are down, Baron can and will do anything to help Henry, even if it means flying from Colombia to pick him up on a Florida beach and winging it back to Cartagena, or stealing a G600 private jet and flying it halfway around the world from Cartagena to Budapest. Benny is really in demand, and we were lucky to get him almost at the last minute before we started to shoot."

◄ Baron would follow Henry to Budapest and back again, nothing breaks their bond.

Adds executive producer Chad Oman, "Baron provides some comic relief, and is the out-there character of the film, and Benny is just very funny and charming. He brings a lot of color and life to the role, which brings a lot to the movie as a whole."

Costume designer Suttirat Anne Larlarb barely had time to design and build Baron's costumes, but she managed to complete the task before Wong arrived in Savannah. "Baron is the outlier, the person who left the game. He's chosen to steal away to Colombia, where he has a beautiful home. I saw pictures of what that environment would be, and that had to be in concert with his look. We start from the fact that Baron has abandoned his military past, though he needs to call it in pretty quickly in the circumstances of the film. He's moved on to a happier phase of his life, one

that's unfettered, and has gone a little bit wild. I wanted to have some Colombian elements in his costume, so he wears shorts, because I wanted to telegraph the temperature of the region and give a real sense of relaxation. He's a pilot, so we gave him his signature vest. All of Baron's stuff needs to be on him. It might be a holdover from his past."

Benedict Wong's past and even more remarkable present have seen him emerge from Salford, the historic and often gritty Northern England city which is part of Greater Manchester, the son of immigrants to Great Britain from Hong Kong. Wong rose through the ranks of British stage, television, and feature films, his will, determination, talent, and love of acting transcending numerous barriers, including early attempts at typecasting him in menial roles reserved for Asian actors, such as waiters. "I feel like I've

> "They're not just bonded by a tattoo, but it signifies so much more about how far they've come and to what end they will go to save each other's lives."
>
> Benedict Wong - *Baron*

▼ Baron enjoys his life in Cartagena but would drop everything to save a friend in need.

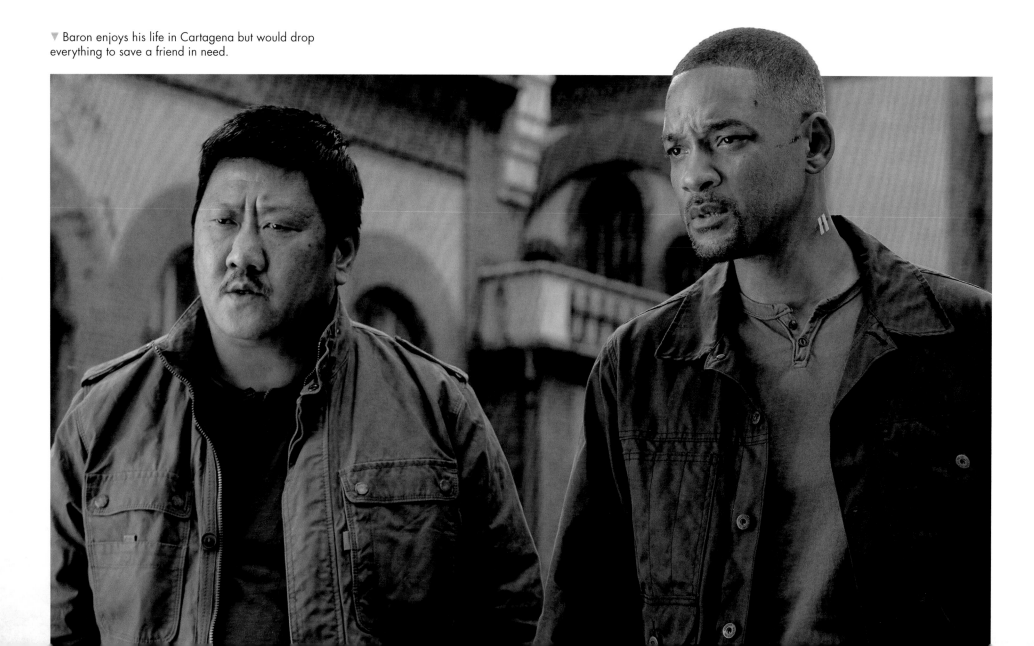

climbed every rung of the ladder," confesses Wong. "One line here, a pantomime, a Chinese theatre company, an episode of a series. But I wouldn't want it any other way. I think for me this is how I learned my trade, through some sort of apprenticeship, beginning at a theatre company where I was sweeping the floors, collecting tickets, and watching the shows playing there. I've been in the business now for twenty-eight years, and those first ten or fifteen years were a roller coaster, up and down."

With great tenacity, Wong worked his way into important productions on the British stage, including the title role as the famed artist in *#aiww: The Arrest of Ai Weiwei*, and *Chimerica*, which won five Laurence Olivier Awards. He received great acclaim for his imposing and powerful performance as Kublai Khan in the epic Netflix series *Marco Polo*. Meanwhile, his feature career was also bourgeoning with a number of notable roles in films on both sides of the Atlantic. Coincidentally, Wong was cast in a number of high profile science fiction films, beginning with Danny Boyle's *Sunshine* in 2007, and continuing with Duncan Jones' *Moon*, Ridley Scott's *Prometheus* and *The Martian,* and Alex Garland's *Annihilation*. In 2016, Wong joined the Marvel Cinematic Universe with his role as, ironically enough, Wong in *Doctor Strange*. "Noseying around on the net, I discovered that there was a character called Wong in the project, which I just couldn't believe," he says, "and I thought, come on... for the ancestors."

Wong's ancestors must be proud, as he has continued playing the role in both *Avengers: Infinity War* and *Avengers: Endgame,* just before beginning his adventure on *Gemini Man*. Most recently, Wong was invited by Anthony and Joe Russo, his *Avengers* directors, to star in their new series they produced, *Deadly Class*.

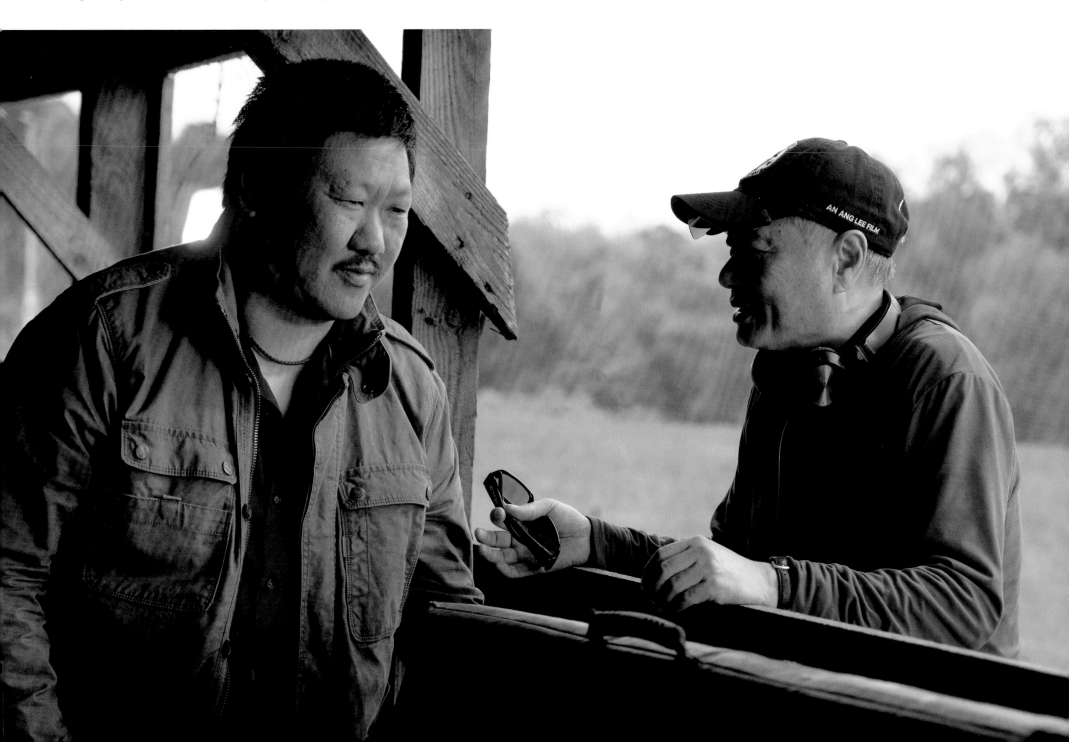

THE MOTORCYCLE CHASE

One of the undeniable highlights of *Gemini Man*, and among the most physically and technologically ambitious to film, was the spectacular chase between Henry and Junior in the streets of Cartagena, first on foot and then on motorcycles. The scene is important because it's the first time that the audience meets Junior, and that Henry has to deal with the incredible skills of his younger, and strangely familiar, pursuer. "This is the kind of sequence," says Jerry Bruckheimer, "in which every department pulls together and makes their own huge contributions. Without that kind of inter-department cooperation, the whole thing falls apart. I'm really proud of how brilliantly the teams from the US and Colombia worked together to create this memorable sequence."

Perry and his stunt team came to Cartagena four months before the filming of the sequence to begin working on its intricate choreography. "My process is always the same," says Perry. "Bring the best tools for the job, put them in the right place at the right time, and let them do it." Perry continued working on the sequence during the company's shooting in Savannah, working with co-stunt coordinator Justin Yu, fight coordinator Jeremy Marinas, and two world-class motorcycle stunt riders, Jalil Jay Lynch and Tony Carbajal. One of the true heroes of the scene was the covert camera bike, or 'e-bike' (electrical motorcycle), operator Regis Harrington, according to Perry. "Driving that

▼ The beginning of the chase scene, Henry has fled Baron's house to entice the shooter away from his friends.

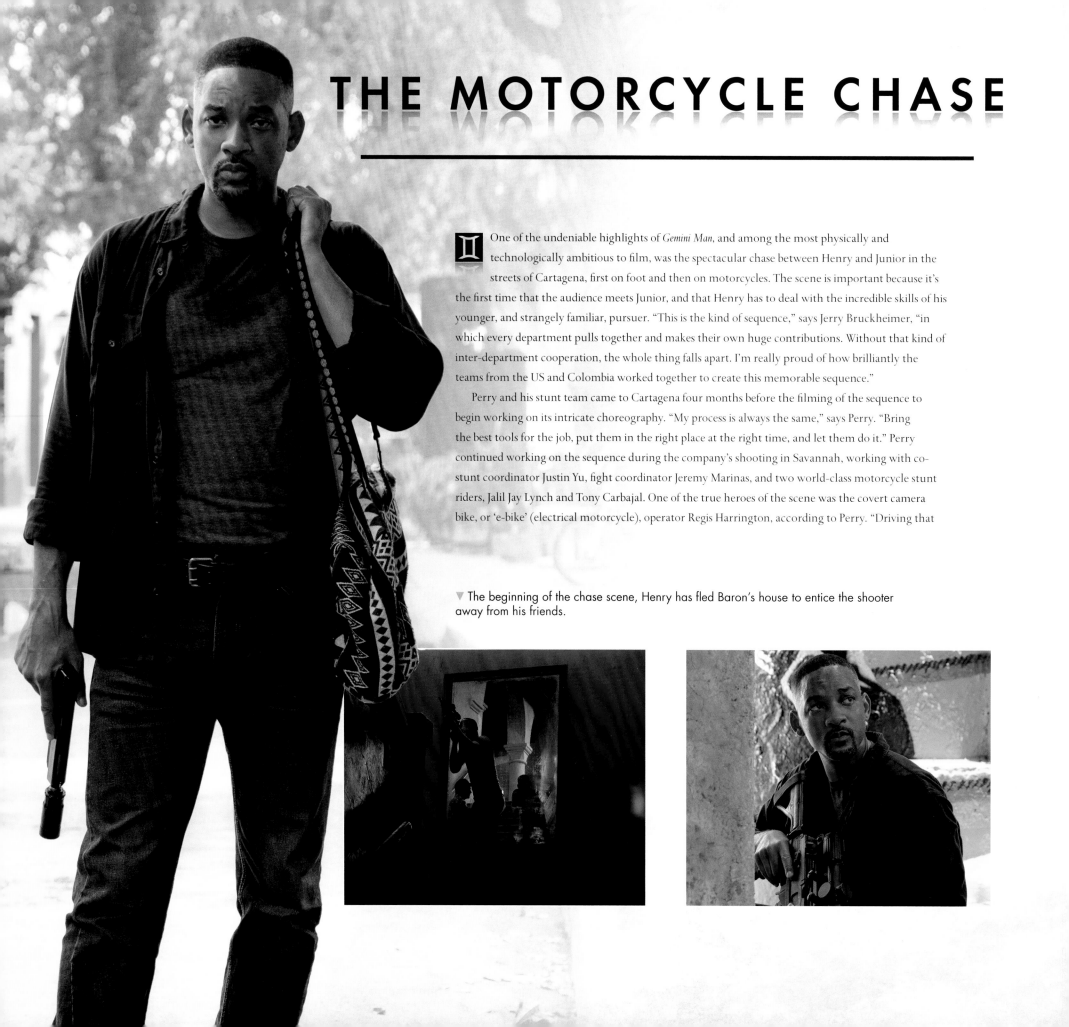

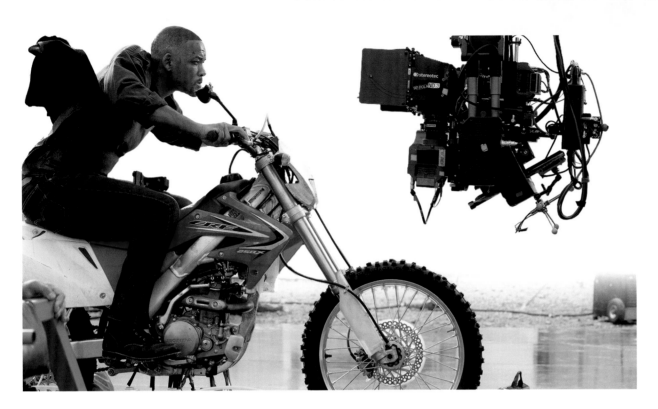

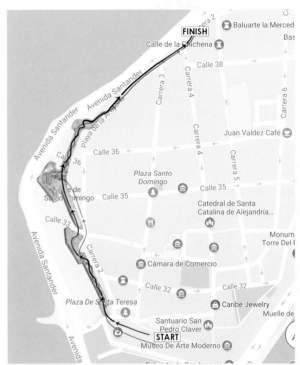

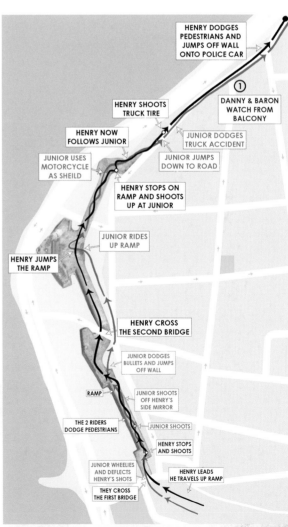

▶ A detailed map of the route the motorcycle chase would take through the streets of Cartagena.

e-bike with a 300-pound camera system in front was like riding around with a rhino sitting in front of you. You can't really see where you're going. I don't know too many other people who could do that." Harrington was called upon to sometimes drive the camera-laden e-bike through centuries-old city alleyways in long, sustained one-shots. "It is a bit of a challenge," says Harrington with more than a little understatement, "being that most action shots are done with multiple cuts. I had to chase Will's character down the tight corridors of Cartagena, and up onto the sea wall in about a forty-five second to one minute long shot with a massive 3D rig on the bike that weighs substantially more than your normal camera. This is a completely new endeavor that I'm taking, and it adds about 300 pounds onto the motorcycle. So hitting the corners correctly, and allowing stunt rider Jay Lynch to do what he needs to do to make the shot look great while staying with him is very, very challenging." Confirms Lynch, who numbers more than 250 films as a stunt player, usually as a stunt driver, "Coming out of what we called 'Speed Alley' was a big one, which is very hard to shoot. We've got pedestrians, we've got animals, we've got cars, we've got obstacles that we're swerving through, and Regis has to keep up with the speed

that I'm doing with the big, heavy camera on the front of his e-bike."

"Ang wants a lot of speed, so we had to go as fast as we could in those little tight corridors," adds Harrington, "and finally, stopping on a mark and making sure we hit it perfectly." The all electric e-bike began as a Victory Impulse. "We took it down to the frame and heavily modified it," explains Harrington, "put a camera cage of our own on it and made a purpose-built camera vehicle that is film-friendly. It's very, very quiet, there's no heat from it, and it's got really good torque."

It goes without saying that, although Will Smith did a great many stunts and riding on his own, driving a motorcycle on narrow city walls at more than 100 miles per hour occasionally has to be left to the experts. "Will can do just about everything," says Perry. "Actually, we're trying to find things that he can't do, that's how good he is. He can pretty much walk on water. He can shoot it, cut it, rig it, right it, flip it, burn it. But we didn't want to put Will in a position where we would all have to start swimming back to the States if he got hurt. So we give him what he can do perfectly and he does it."

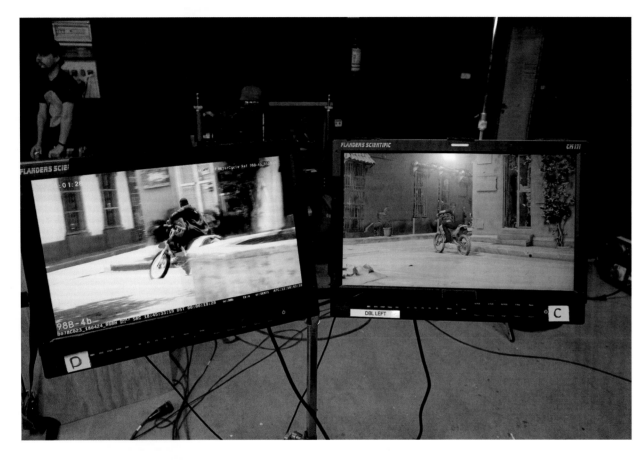

"We sweated for a long time in pre-production when planning this high-speed motorcycle chase through the streets of Cartagena," confesses director of photography Dion Beebe. "We had cameras that weighed seventy pounds, shooting in 3D, so we had to innovate in terms of how we support and move those cameras. I had a great camera crew, as well as the teams under key grip Don Reynolds and gaffer [key lighting supervisor] Jarred Waldron, and we were able to rise up and meet this challenge. But we had to move those cameras at high speed for the motorcycle scene, and you know, when you shoot twenty-four frames per second

you get motion blur and you can hide a lot of things behind that, but at 120 frames, there's no motion blur, so there's no crutch. You can't fool people with speed, so we did a lot of testing in terms of how we were going to move the camera fast, and thankfully had an amazing stunt team who could work with a motorcycle rig that could take the weight of the camera and fly through the streets of Cartagena."

A great deal of the Old Town (*Centro Historico*) of Cartagena, as well as the adjacent neighborhood of Getsemani, are seen in the course of the foot and motorcycle chase, which presented interesting challenges

▲ A 3D render of the shape of Junior on the car (top left). Tony Carbajal doubling for Junior (top middle). The final VFX version of Junior facing down Henry (top right). The many screens and cameras used to film both the on-location sequence and the VFX scenes (bottom).

for the production designer, Guy Hendrix Dyas. "We had to express the colors and textures of Cartagena in the chase sequence. Most of the time, everything's happening so fast-paced that you really don't get a chance to see what's going on, so we worked extremely hard to create a collage of color behind Will, knowing where Ang had planned his shots with Dion Beebe, and knowing what the background and environments were going to be. It gave us an opportunity to then take those backgrounds and really say, 'here's what you feel like when you're in Cartagena. Here's what you experience.' And at the same time, explain the stress that Henry is going through as he's being chased, and fighting for life at this point." Despite the fact that Cartagena is already full of its own incredibly vibrant colors, one of the important locations for the chase scene – an abandoned building – required more than a few touches from Dyas and his art department. "Several of the locations for the scene

▶ Concept art of the two motorcycles.

▼ Will Smith filming the scenes from Henry's point of vew on the e-bike with the camera system in front.

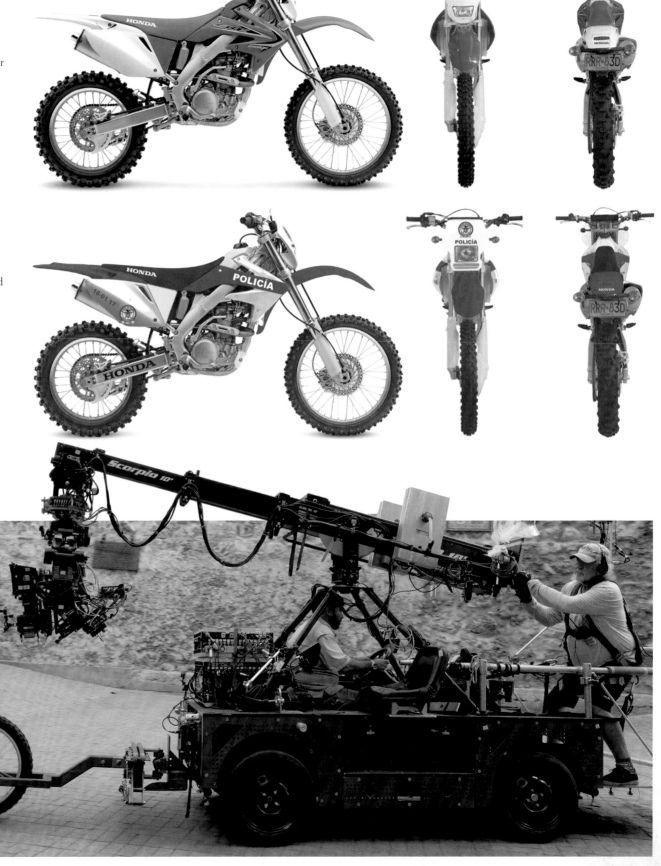

that worked for Ang ended up being disused buildings that were essentially whitewashed inside," he notes, "and they didn't express the beauty and the color that we experience everywhere in Cartagena." One of these was a huge abandoned government building which was selected as an important locale for a cat-and-mouse pursuit on foot with Henry and Junior. "So I took it upon myself and charged my extraordinary crew with painting this enormous building with extremely elaborate and very vibrant color schemes," Dyas continues, "which really were a collection of all the colors I had seen around town, all brought together into this one building that was essentially a huge courtyard that had been all white."

The foot chase and Henry and Junior's Honda CRF 250X motorcycles take the viewer through a speed tour of Cartagena, including the *Centro Historico*; the 400-year-old walls of the city known as Las Murallas; the Baluarte San Francisco, originally built by the Spanish to protect the city from pirates; and the famed Calle San Juan, a street with imaginative murals, three of which were newly contributed by the film's art department. It climaxes in the historic Plaza Teatro Heredia, in front of the magnificent early 20th century jewelbox of a theatre, with a demonstration of what J.J. Perry calls "bike-jitsu," sort of motorcycle kung fu, with Junior using his motorcycle as a tool of blunt force. For this, stunt rider Tony Carbajal had to accomplish the opposite of a wheelie, known as a 'stoppie,' coming in on the front wheel and hard braking, bringing the rear wheel up into the air.

> "Driving that e-bike with a 300-pound camera system in front was like riding around with a rhino sitting in front of you."
>
> J.J. Perry - *stunt coordinator*

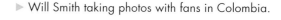
► Will Smith taking photos with fans in Colombia.

▼ A close up of Henry's tattoo.

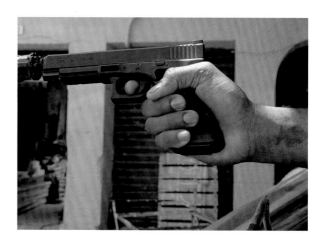

▲ Jalil Jay Lynch doubling for Junior (top left). A 3D render of Junior's face (top right). Will Smith in full motion capture (bottom left). The final VFX version of Junior (bottom right).

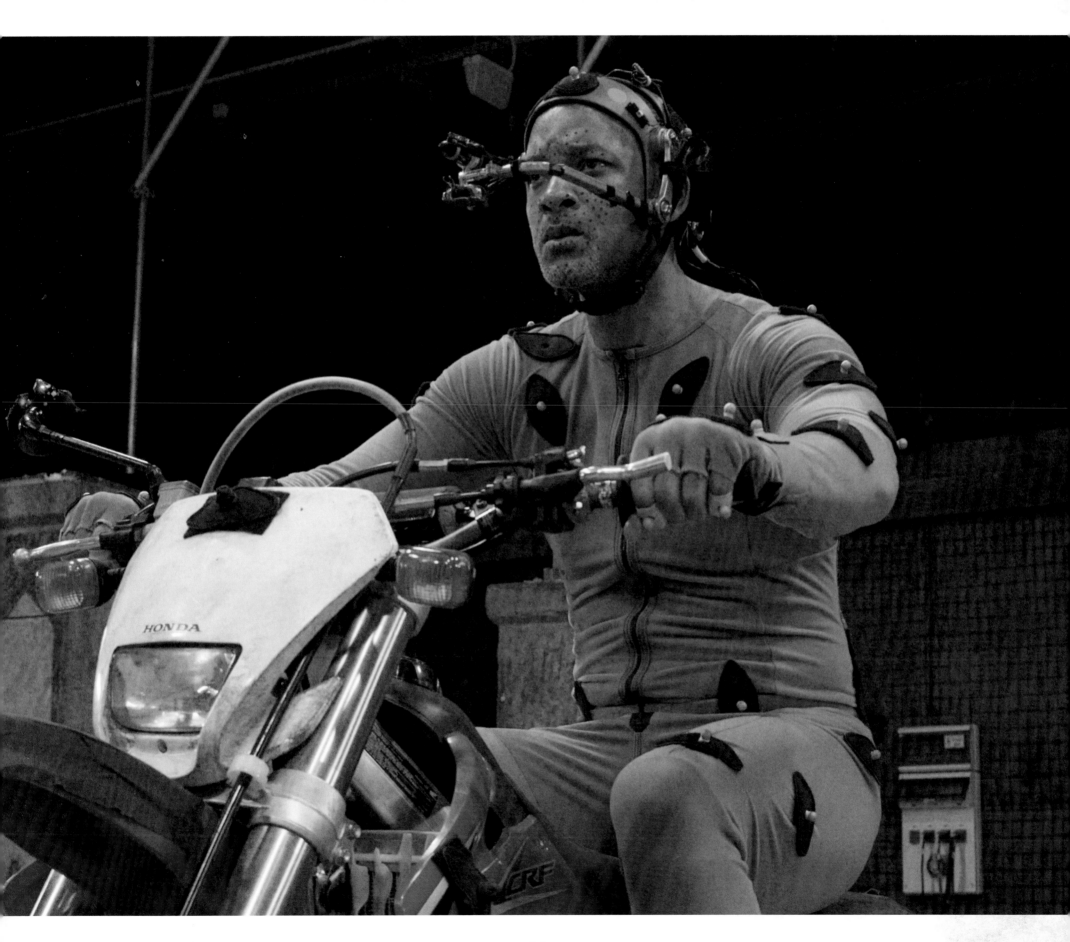

"It's a lot of precision to control and maintain it," Carbajal noted. "It's considered to be one of the most technical and harder things to do on one wheel, because there's no point of return if you go too far. You can end up flipping right over the bars and things can get ugly. The goal is to use the rear tire as a weapon."

All told, the landmark chase scene, from foot to motorcycle pursuit, required seventeen days of principal photography and one motion capture day in Cartagena, trying to be as respectful and protective as possible of the precious historic buildings and sea walls of a city that opened its arms to the company. "We've spent months working and preparing these neighborhoods," said Cartagena location manager Douglas Dresser, "and working really hard to make sure that everyone knows what we're doing and when we're doing it. We worked closely with the city, the Escuela Taller, which maintains the fortifications of the city, the Ministry of Culture, traffic departments, months and months of planning. We learned together, both the city and the film crew, as we tried to capture the city's magical beauty."

▲ Dion Beebe getting a vantage point to film the scene atop a ladder.

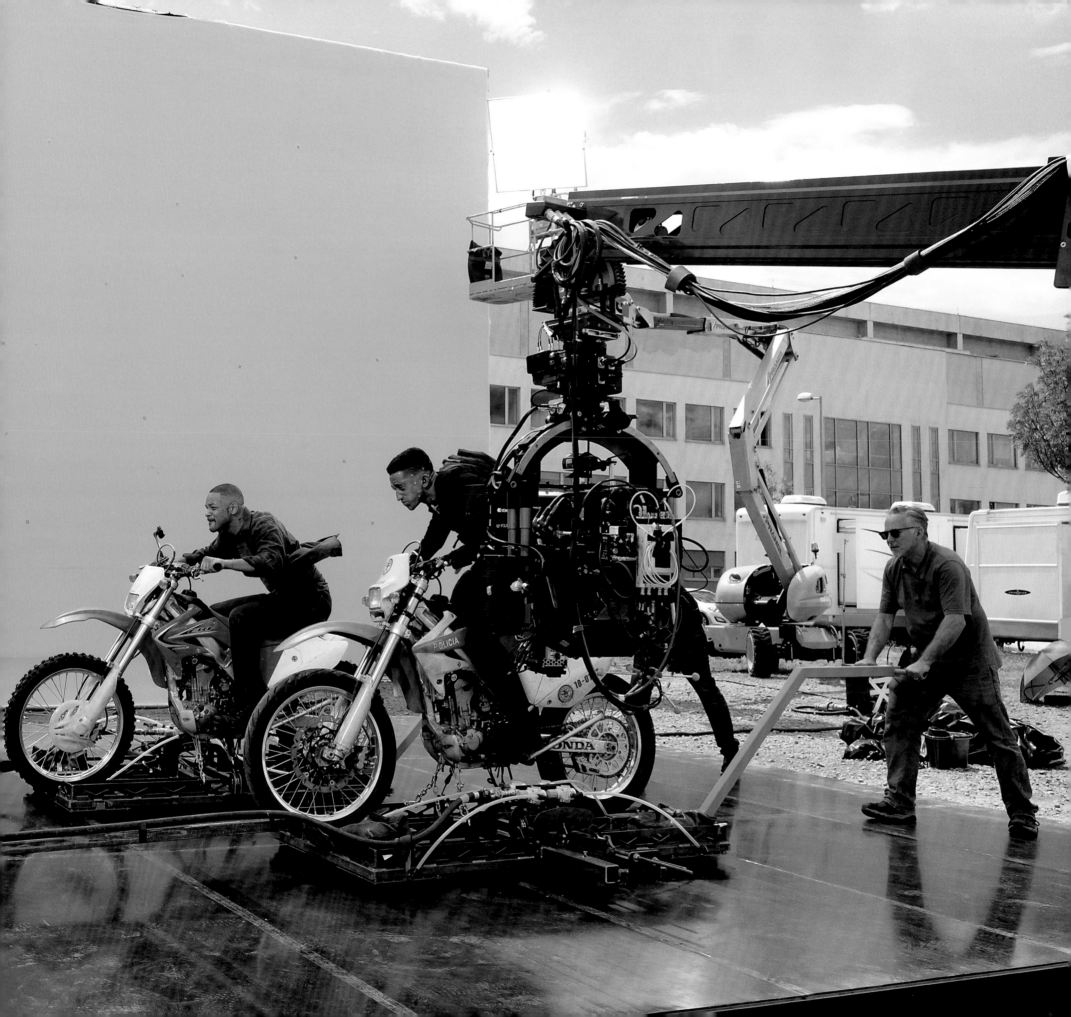

BUDAPEST

Budapest has enjoyed a filmmaking history lasting more than one hundred years, and has imported some of its most talented artists to American and British cinema. Fox Film Corporation founder William Fox, actor Bela Lugosi, director Michael Curtiz, cinematographer Vilmos Zsigmond, film music composer Miklos Rozsa, producer Sir Alexander Korda, and art director Vincent Korda are just a few of the sterling cinema talents who went global, not to mention the many fine filmmakers who remained in Hungary to create some of the world's most distinctive motion pictures. It was only proper that *Gemini Man*, released by Paramount Pictures, would film in Hungary as Paramount's founder, Adolph Zukor, hails from the small village of Ricse. More than that, as Jerry Bruckheimer simply notes, "Budapest is a phenomenal place to film." Although Budapest has doubled for several

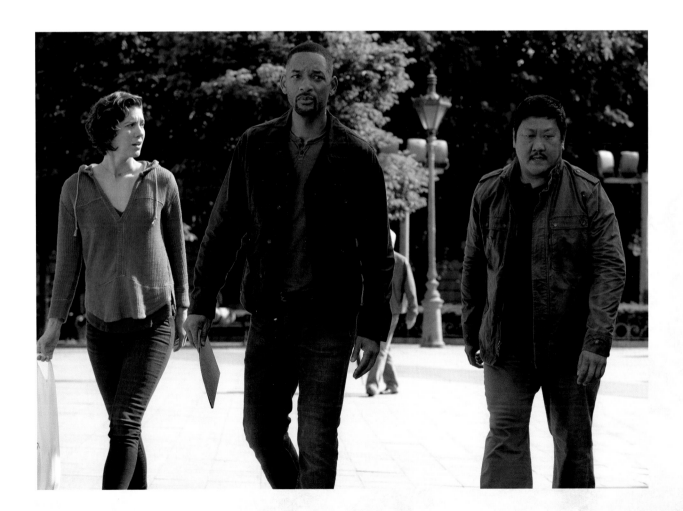

◄ Dion Beebe on location in Budapest.

97

other cities in recent years, Ang Lee wanted the great city to portray itself, and thus *Gemini Man* highlights some of Budapest's most notable attractions. Among them the Fisherman's Bastion overlooking the Danube, the neo-Baroque splendor of the Szechenyi Baths, the imposing Vajdahunyad Castle, Heroes' Square, the neo-Gothic library and campus of the Budapest University of Technology and Economics (Hungary's MIT), and the Kiscelli Museum. The *Gemini Man* company also commandeered two massive sound stages of the state-of-the-art Origo Studios, as well as exterior scenes shot at Korda Studios twenty-six kilometers west of Budapest.

"Budapest was really the perfect bookend to this extraordinary journey that we've been on as a film crew," says production designer Guy Hendrix Dyas. "We're really a band of travelers roaming the globe, putting our camera on all these incredible places, and Budapest brings to the film a kind of weight and gravitas." Adds Ronnie Kupferwasser, the film's location manager, "One of the amazing things about Budapest is the contrast it has to the other countries where we filmed. Savannah shows a fascinating side of America, Cartagena shows the beauty of South America, and then we come to Europe, and what better place than

Budapest to see the history and richness of European culture?" Executive producer Brian Bell explains that, while location scouting, "It was a question of whether we would film in Paris or Budapest and, ultimately, Ang decided on Budapest because it's less known, less seen, with more interesting locations, and it's a real filmmaking city, so there was great support." Indeed, the Hungarian crew which joined the *Gemini Man* family added yet another international layer following the Cartagena shoot with the Colombian unit, with Magyar now replacing Spanish as the on-set *lingua franca*, along with English (and occasional Mandarin from Ang Lee and his longtime associate, co-producer David Lee).

With Budapest becoming one of Europe's most popular and heavily touristed destinations, the company had to step lightly around the crowds of visitors. "Everything was scheduled very carefully by our wonderful AD and locations departments," notes Guy Hendrix Dyas, "in order to make sure that we could film and have some level of control without the enormous amount of tourists that Budapest draws. We've also done a lot of night shooting in the city, which for me personally brings about a wonderful sort of mystery to the place, on top of it being marvelously old and historical."

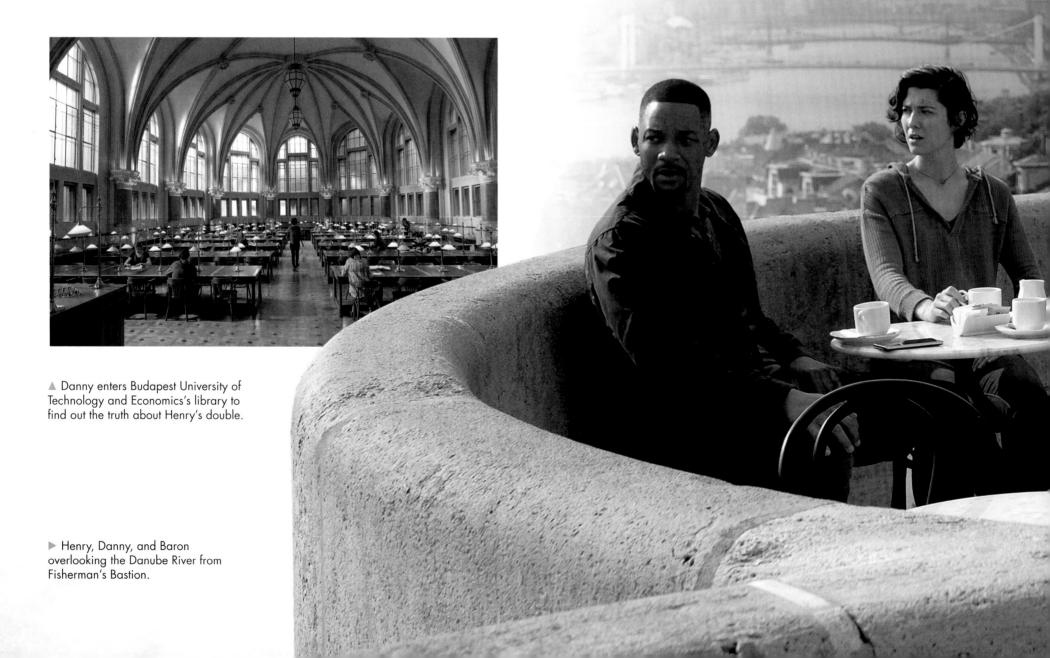

▲ Danny enters Budapest University of Technology and Economics's library to find out the truth about Henry's double.

▶ Henry, Danny, and Baron overlooking the Danube River from Fisherman's Bastion.

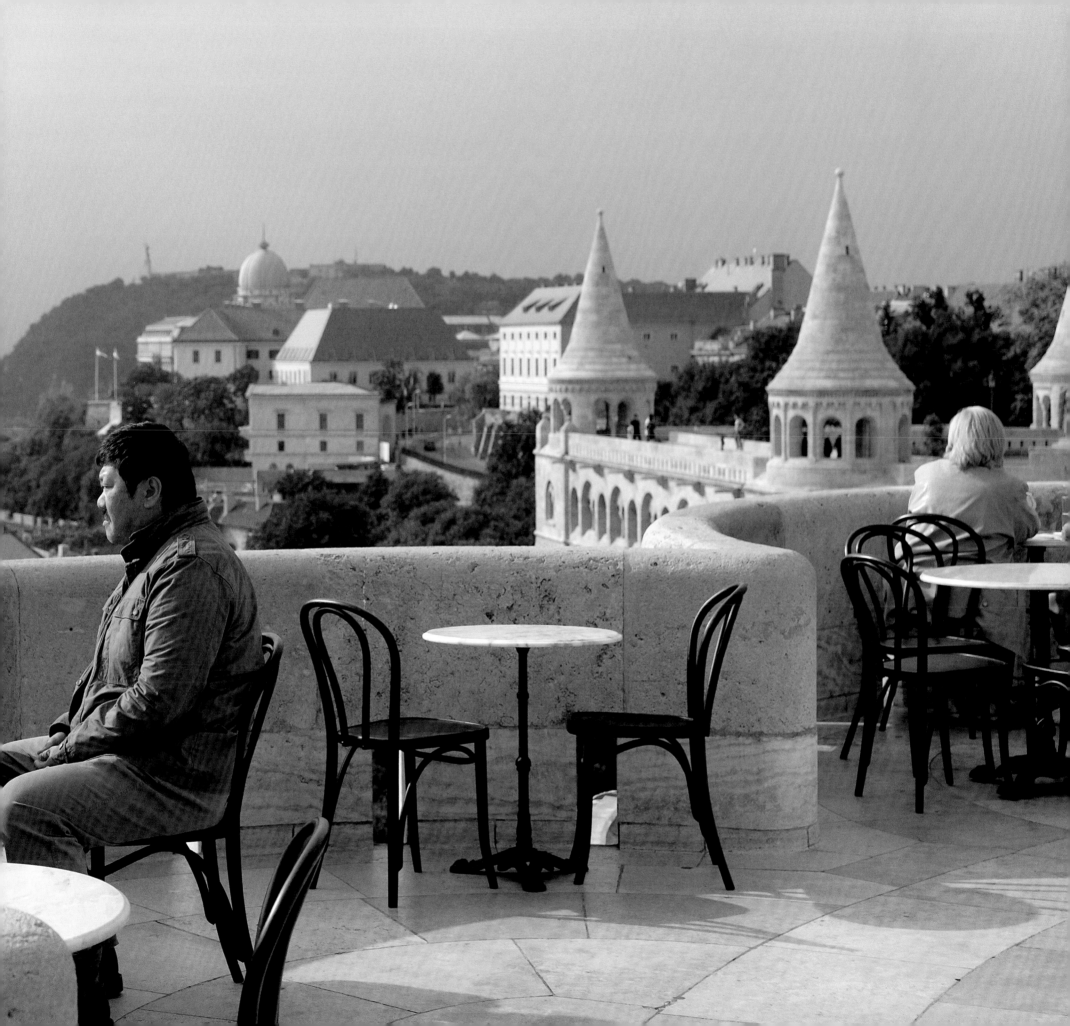

JANET LASSITER

"Ang meticulously cast every role in Gemini Man."

Jerry Bruckheimer - *Producer*

Janet Lassiter hasn't reached such a high position of authority at the Defense Intelligence Agency by being nice, or kind, or compassionate. In fact, she's tough and ruthless with a dispensable conscience. It takes someone like Janet to order a hit on Henry Brogan, the agency's best sniper, after he learns that his most recent target was someone completely other than who the file said he was. In the interest of job protection and self-preservation, Lassiter doesn't see any other way. Nor is she looking for one. Janet Lassiter is like iron encased in carbon steel.

Which makes one all the more impressed by Linda Emond, the warm, generous-spirited, and hugely talented veteran of stage, screen, and television, portraying a character utterly unlike her real self. Emond, a native of New Jersey who was raised in Southern California, has amassed a mighty résumé of award-winning performances on stage, including three Tony Award nominations for roles on Broadway, and receiving Lucille Lortel and Obie Awards for other theatre work. Emond's expert work has also encompassed television and numerous features, sought after by such directors as Mike Nichols, Terrence Malick, Spike Lee, Steven Soderbergh, Sam Mendes, Julie Taymor, and, of course, Ang Lee. Says producer Jerry Bruckheimer, "Ang meticulously cast every role in *Gemini Man*, whether on screen for lengthy or short periods of time, with the absolute perfect actors. Linda Emond is a performer who embodies experience and professionalism."

DON'T SHOOT THE MESSENGER

Janet Lassiter learns that ordering her usual decaf soy latte with an extra shot in her usual coffee shop near DIA headquarters in Maclean, Virginia can be a dangerous business. She's approached by a bicycle messenger carrying a disturbing message from Henry Brogan… who has paid the messenger enough money for him to take the chance, responding to Janet's remark that he could be guilty of aiding and abetting a wanted criminal by simply saying "Don't shoot the messenger, okay?" It's actually not the messenger who's the target. It's Janet, as Henry makes clear seconds later in a phone call he's making to her from some five thousand miles away in Budapest with Danny and Baron. "There are shooters at your ten and your two," he warns her. "Get up out of that chair and you will be AMF'd."

"What's AMF?" Baron asks Danny.

"Adios Motherfucker," she responds matter-of-factly.

▼ Janet Lassiter receives a disturbing call.

SZECHENYI BATHS

For more than a century, Hungarians and visitors to Budapest have flocked to the splendor of the Szechenyi Baths to 'take the waters' and luxuriate in its *fin de siècle* Middle European atmosphere. It's a stupendous complex built above a hot spring pumping its thermal aquavita into pools surrounded by a grand neo-Baroque building, constructed from 1909 to 1913. In *Gemini Man*, Henry Brogan, Danny Zakarewski, and Baron find themselves at the Baths for a rendezvous with Yuri, a friend of Jack Willis' "from the other side" who can provide them with information explaining exactly who and what Valery Dormov – the so-called "bio-terrorist" who Henry assassinated in Belgium – really was. The *Gemini Man* company took over the famed Szechnyi Bath complex, shooting a key sequence amidst background players frolicking in the spa waters, with a crowd of real patrons doing the same when the baths opened to the public in late morning. "The Szechenyi Baths are the most prominent tourist destination in Budapest for spa baths," explained location manager Ronnie Kupferwasser with a backdrop of splashing waters. "We are very lucky to be able to film here. It's very rare for a production to be able to come into such a grand location as this one and be welcomed in and allowed to take it over. There are a number of spas in Budapest, but Szechenyi is by far the most spectacular."

▲ The Szechenyi Baths is popular with both the tourists and locals in Budapest.

◄ Graphic signage created by the team behind *Gemini Man*.

▼ The Szenchenyi Baths in Budapest made for a picturesque backdrop to this tense scene.

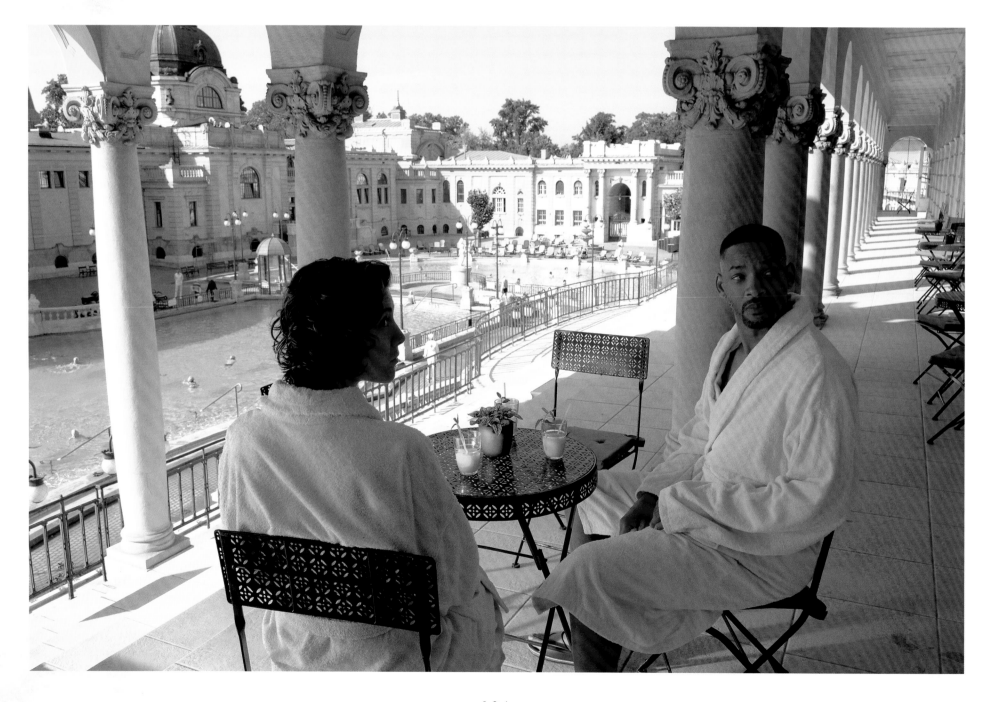

YURI

Explains Jerry Bruckheimer, "The Russian agent Yuri, although a small role, is pivotal to the story, and whoever plays the part shares the screen with Will Smith. We were lucky enough to cast Ilia Volok, a Ukrainian-born actor of great experience who brings a really powerful presence to the film." Volok, born in Kiev, brings cultural authenticity and the professionalism gained by having amassed more than 150 films, television shows and video games under his belt for the past twenty-five years. Volok was an athlete in the Soviet Union who won third place with his team at the world rowing championship before taking a career turn by auditioning for the famed Moscow Art Theatre School. Upon graduation, he literally changed directions, coming to America with only $300 in his pocket and the dream of becoming a working actor in Hollywood and on stage. A member of the Actors Studio, Volok is on the faculty of the Lee Strasberg Theatre and Film Institute in Los Angeles.

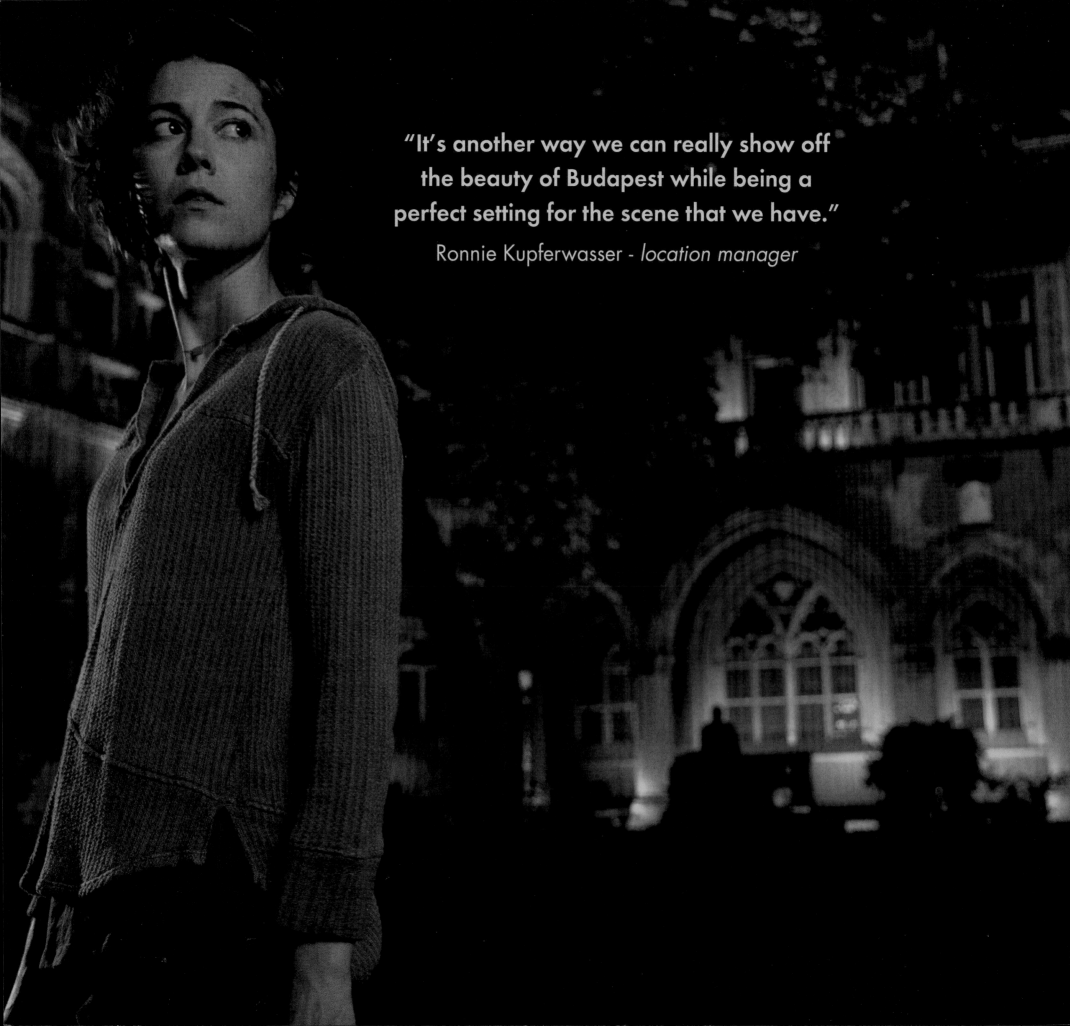

"It's another way we can really show off the beauty of Budapest while being a perfect setting for the scene that we have."

Ronnie Kupferwasser - *location manager*

VAJDAHUNYAD CASTLE

In central Budapest's City Park, near Heroes' Square, is a large, imposing complex of buildings in varying architectural styles including Romanesque, Gothic, Renaissance, and Baroque. Built for the 1896 Hungarian Millennial Exhibition, which celebrated Hungary's conquest of the Carpathian Basin in 895 and the thousand years of history which had passed since, but looking more like something out of a medieval fairytale. This is Vajdahunyad Castle, which gave *Gemini Man* one of its most dramatic backdrops for a tense scene in which Danny has a meeting with Junior in a castle courtyard at midnight. In the script, the setting is described as a "spooky castle," and in the wee hours of the night Vajdahunyad certainly qualified for that apt definition. Particularly since the castle houses a statue of Hungarian native son Bela Lugosi, still the most famous actor to portray Count Dracula.

"Vajdahunyad Castle is another of the many wonderful locations we have in Budapest," says location manager Ronnie Kupferwasser. "It's another way we can really show off the beauty of Budapest while being a perfect setting for the scene that we have." Reflecting on the determination of Ang Lee to film in places portraying themselves and not standing in for other places, Mary Elizabeth Winstead, who figures prominently in the scenes shot at Vajdahunyad, says "It's really special to be able to go to each of these places and film them for what they are. That's really exciting to me."

▲ A map of the castle used in production to plan out the action and shooting of the sequence.

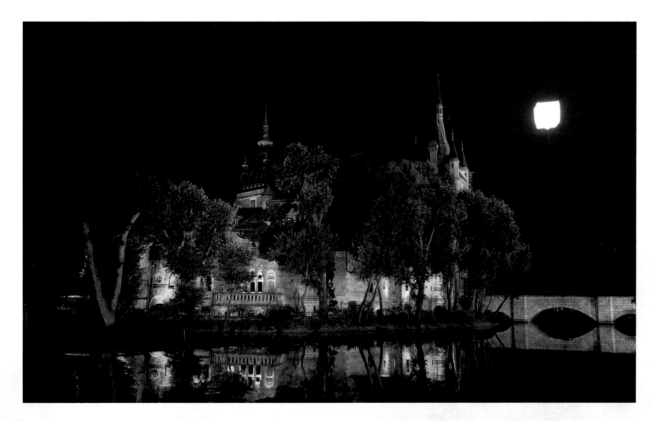

DOUBLE VISION
FIGHTING A CLONE

In the dark, medieval catacombs beneath a chapel-turned-museum, fifty-one-year-old Henry Brogan is in for the fight of his life with no less an adversary than himself: that is, his younger clone, Junior. This powerful sequence is the film's philosophical overview made tangible: one's older self literally at war with a younger and stronger incarnation. Will Smith had to face the enormous challenge of portraying both Henry and Junior at war with each other and, as Danny, Mary Elizabeth Winstead found herself in the highly unusual circumstance of acting opposite Smith as both characters. "You know, it's not too weird because of the way that we're filming," Winstead proffers. "I feel so lucky to be working with Will."

For the narrow passageways of the catacombs set, director of photography Dion Beebe and his team came up with some ingenious ways of filming with the imposing 3D cameras shooting at the high frame rate. "One of the most innovative rigs," says Beebe, "was created to shoot the hand-to-hand combat fight sequences that Ang wanted to shoot handheld. The cameras were so heavy that you could put it on your shoulder for a minute if you're lucky but, once you tilt down it's almost impossible to tilt back up. So we ended up devising this rig that wound up being called 'The Donkavator' [note: named for key grip Don Reynolds], a cable system that counterweighed the camera and basically made it weightless. You could let the camera go and it

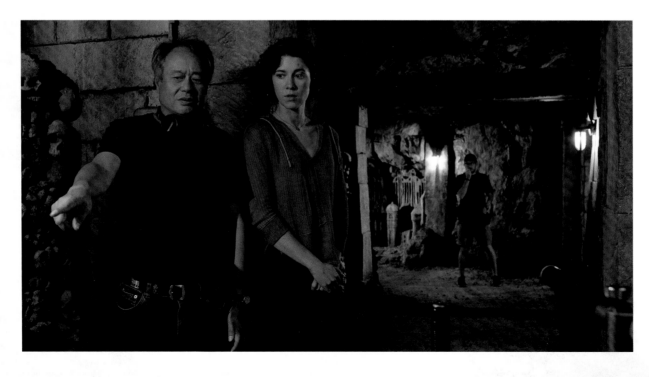

◀ Ang Lee and Mary Elizabeth Winstead stand in a unique location.

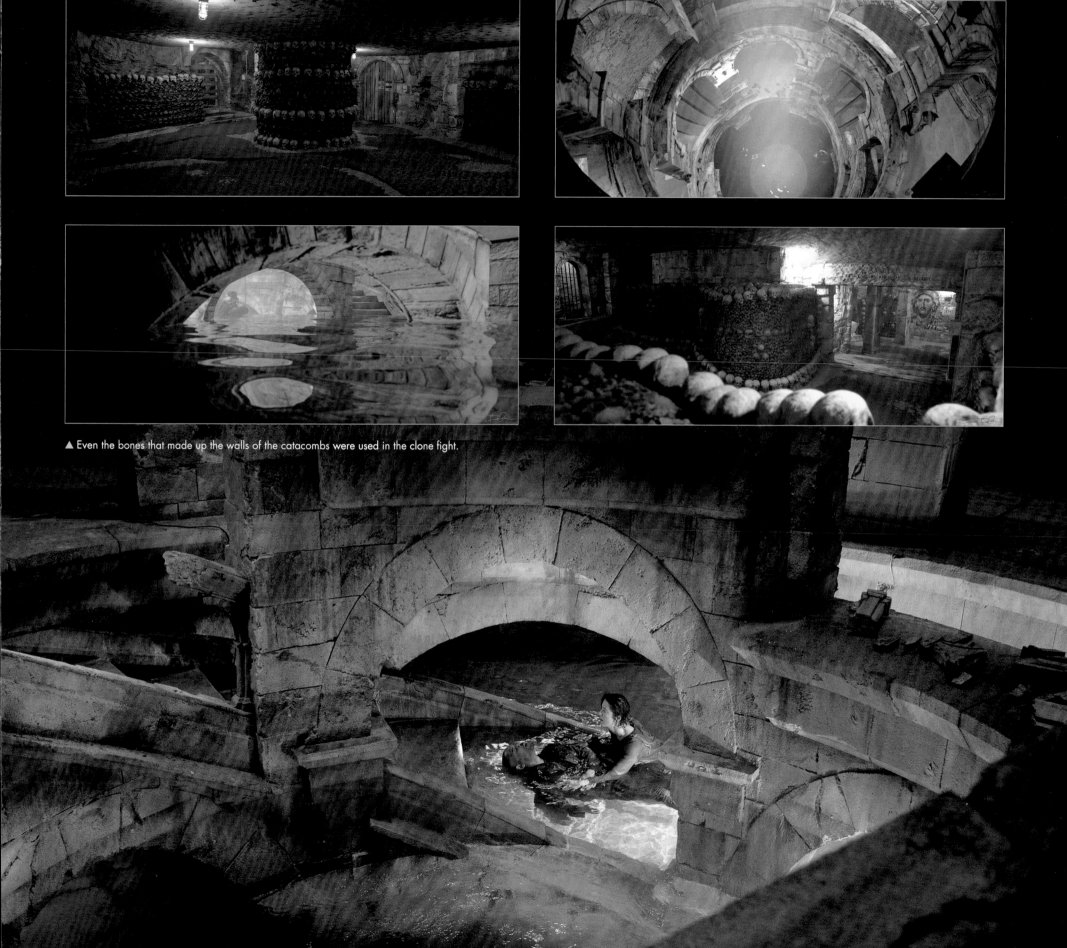

▲ Even the bones that made up the walls of the catacombs were used in the clone fight.

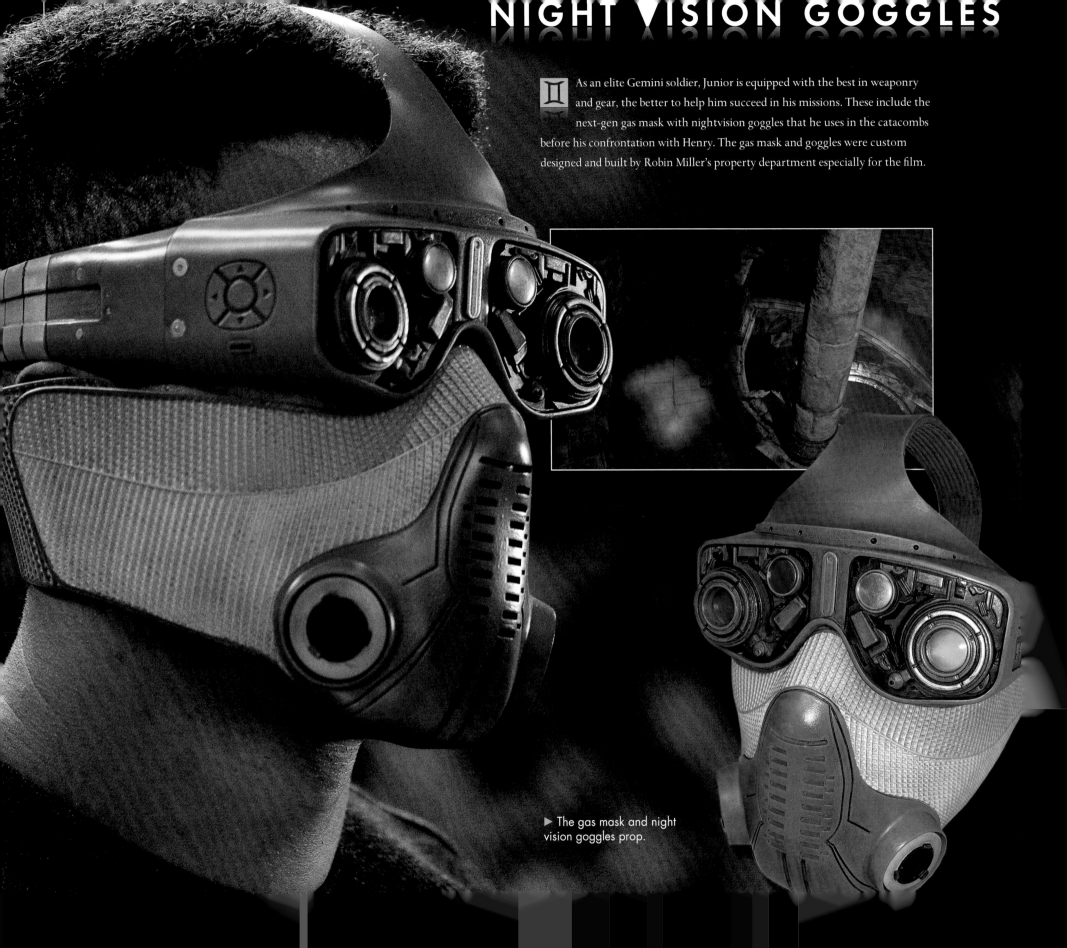

As an elite Gemini soldier, Junior is equipped with the best in weaponry and gear, the better to help him succeed in his missions. These include the next-gen gas mask with nightvision goggles that he uses in the catacombs before his confrontation with Henry. The gas mask and goggles were custom designed and built by Robin Miller's property department especially for the film.

▶ The gas mask and night vision goggles prop.

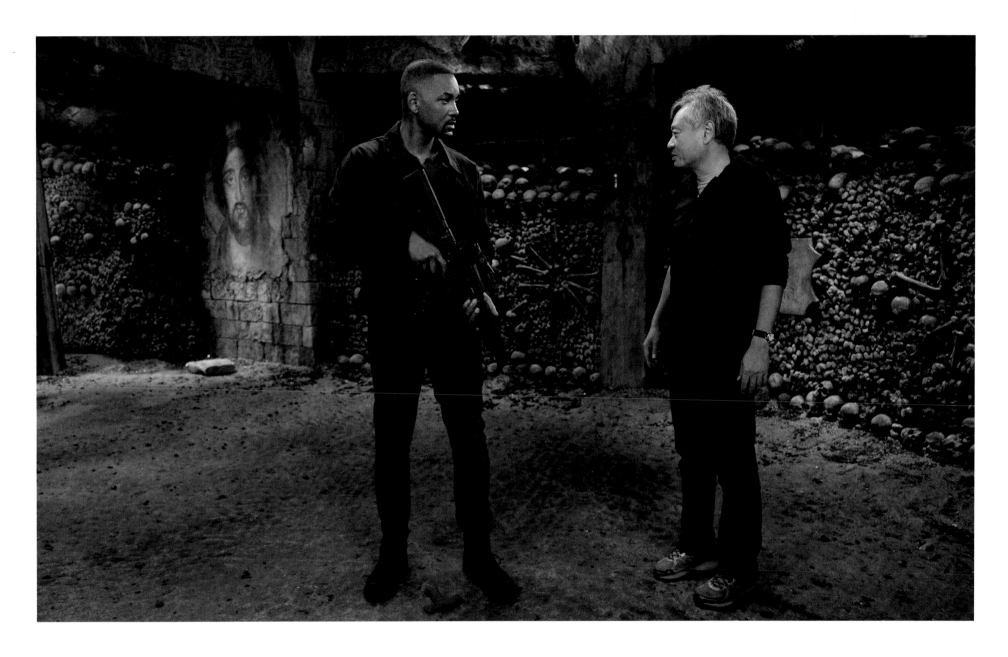

would just stay where it was, but it moved when you applied pressure. We had a rail system built into our sets and ceilings that would allow the camera to go anywhere within a space, up, down, left, right. So by eliminating the weight and having the ability to move through a room, we were then able to take this seventy-plus pound camera in hand and move it at the high speeds that Ang was demanding and keep up with the fight sequences. The crew always rose to the challenge and demands of the format, and it was really inspiring to watch, and allowed Ang to tell the story he wanted to tell without being held down by the choice of format."

It was then up to the actors, Ang Lee, Dion Beebe, and the stunt team to create the drama and mayhem inside of the sets. Lee saw an opportunity not only for an exciting action sequence, but also a philosophical confrontation. "A catacomb is where old bones are buried," Lee notes, "but a clone is the renewing of life. So it's a confrontation between life and death. By fighting, first verbally, then physically, you really visualize the inner conflict we have. I think that's what the two characters bring to us, introspection and violence. Junior is stronger and better trained, but Henry has experience, so they become a good match. And they also know each other and, by beating their opponent, they're also beating themselves."

"The catacomb scene was one of my favorites in terms of being able to

▲ The mural in the background added to the spiritual atmosphere of the catacombs.

111

"The action in the catacombs
is pretty relentless because
they're essentially using
other people's corpses
as weapons,"

Jeremy Marinas - *fight coordinator*

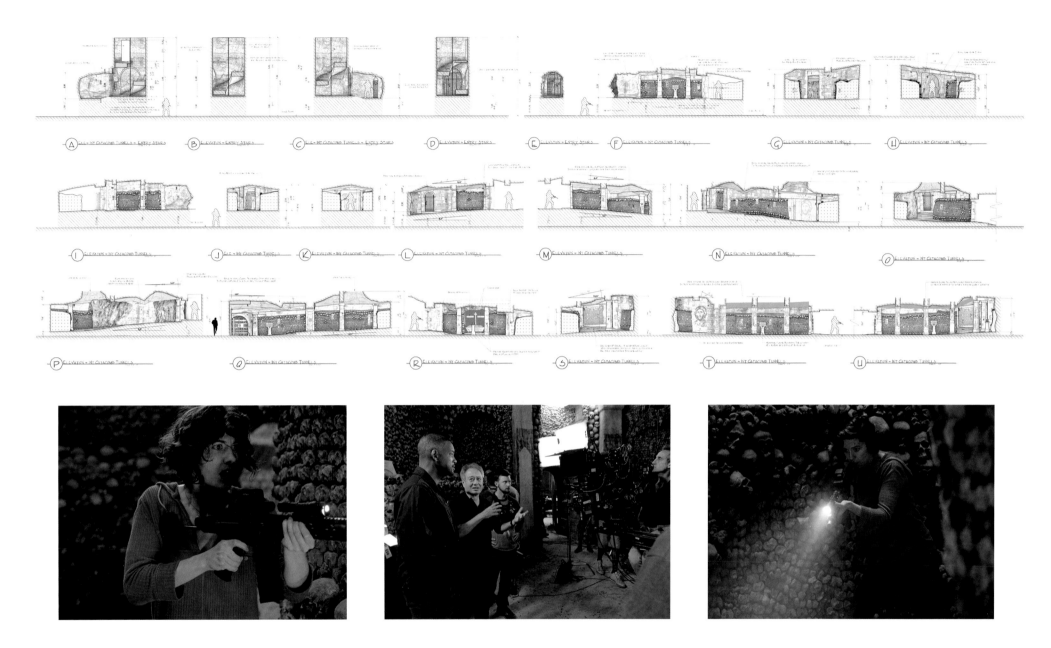

▲ Sketches of the catacomb set construction.

utilize what's around us on the set," says Budapest stunt coordinator Brad Martin. "Very rarely do you get to do a fight scene by utilizing things like bones, femurs, and skulls. One of the things I enjoy to do most in fights is to make them unique in their own special right, and this was a great setting for it." Although all actors have stunt doubles for some of the more dangerous tasks which would bring great risk, Will Smith did a great amount of the fighting and other physical feats himself in *Gemini Man*. "This is the third time working with Will," notes Savannah/Cartagena stunt

coordinator J.J. Perry, "and he's a real pleasure to work with. He's extremely involved and a tremendous force as far as work ethic goes, and has put himself forward in a lot of sticky spots. He's a committed movie star and soldier, and a good bro as well." Both Smith and Mary Elizabeth Winstead underwent rigorous training previous to the beginning of the shoot. "We had three hours a day training with Will and Mary," says Perry. "The best way to fake being a badass is by making them a badass. That's basically my mantra, and that's exactly what I did. Will was already a badass, and

Mary became one. Their ability to embrace the suck of the training and just drive through it is not easy. They really did the work and just shined."

The fight scene in the catacombs is fast and ferocious, as Henry and Junior use anything they can get their hands on, using a bone as a dagger, for instance, crashing into skulls, almost as if in a primitive age. "The action in the catacombs is pretty relentless because they're essentially using other people's corpses as weapons," notes fight coordinator Jeremy Marinas. "I've seen people choke another person

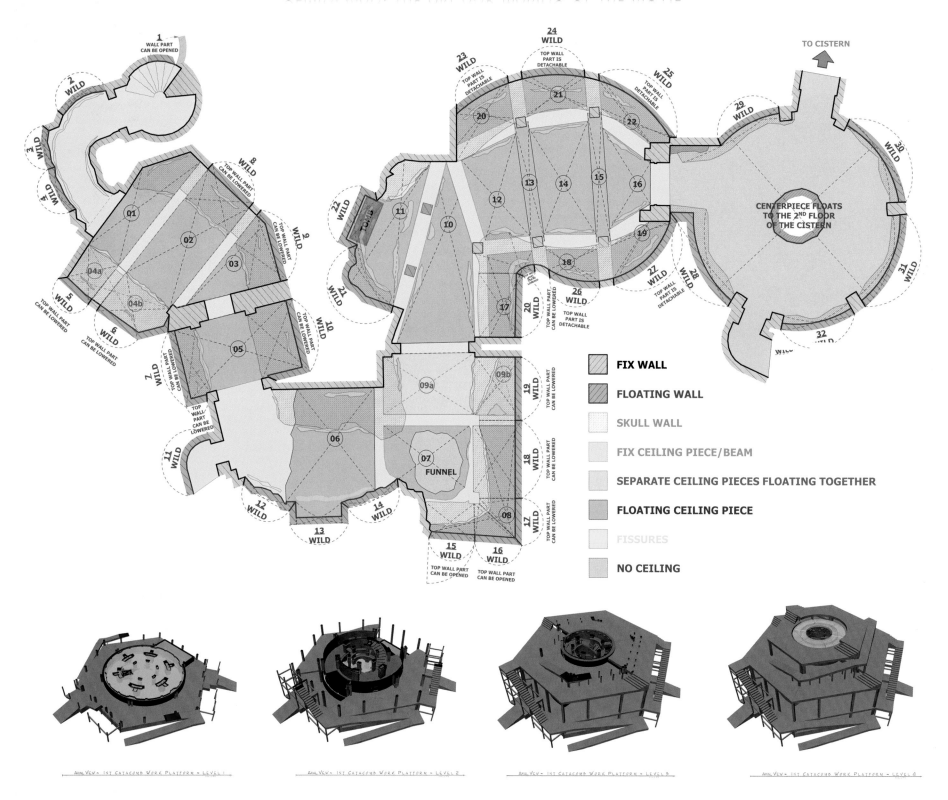

FIX WALL

FLOATING WALL

SKULL WALL

FIX CEILING PIECE/BEAM

SEPARATE CEILING PIECES FLOATING TOGETHER

FLOATING CEILING PIECE

FISSURES

NO CEILING

CENTERPIECE FLOATS TO THE 2ND FLOOR OF THE CISTERN

TO CISTERN

FUNNEL

with their hands before, but never with a bone. It's down, dirty, and gritty. The catacombs fight is the first time the viewer gets a really good look at Junior, and it also deals with the usually fearless Henry's phobic fear of water. So when he's fighting Junior, he's fighting himself, knowing that he has the advantage because he knows the weaknesses of someone in their early

twenties. And it continues when they get into the water, you have two guys thrashing around trying to do lots of damage to each other. It wasn't easy, and Will was doing a lot of the fighting himself, including the underwater portion. He and Mary were great sports, because the day they were in the water it was very cold and they didn't complain once."

▲ Detailed map of the catacomb set (top). 3D render of the constructed set (bottom).

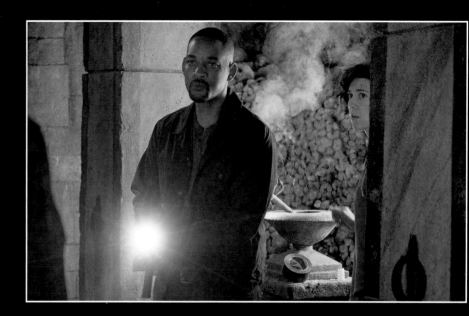

▼ Will Smith in motion capture rig filming Junior's scenes within the catacombs.

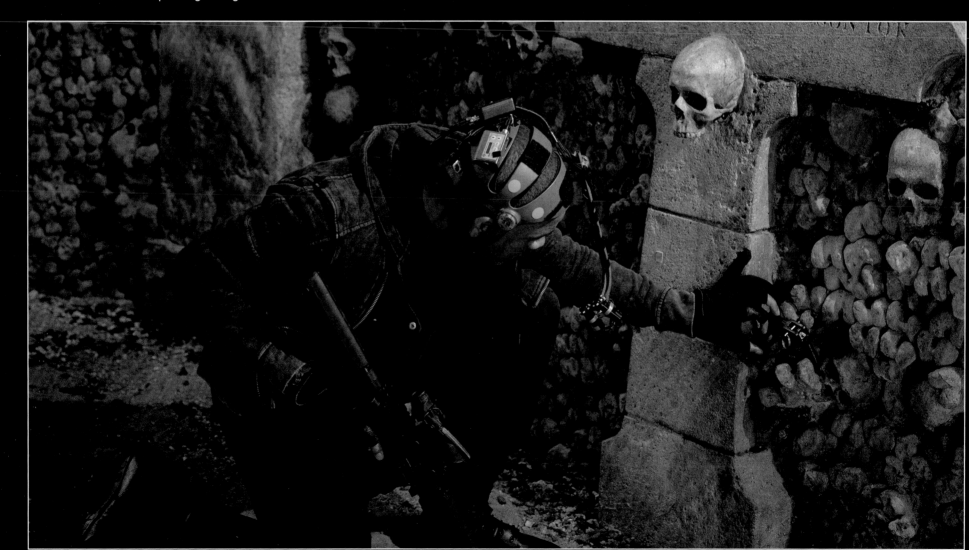

THE CHAPEL AND CATACOMBS

In the film, the ruined chapel-turned-museum that provides the entry to the catacombs below was a hollowed-out chapel now serving as a hall for special events in the Kiscelli Museum. The chapel was part of an 18th century Baroque monastery. However, for the catacombs and underwater cistern, production designer Guy Hendrix Dyas designed and constructed his largest and most impressive set pieces on Origo Studios' Stage Three.

"There's a very interesting history behind this set," explains Dyas, "which goes all the way back to the location scout with Ang Lee in the Paris catacombs." During that scout, Lee was impressed by the notion that the famed catacombs could offer highly imaginative possibilities for one of the film's most important sequences of action and drama. But when Budapest was selected as the film's European location, the filmmakers were faced with a problem: the city doesn't have catacombs of its own. Dyas would need to design and build one. "First we went to Paris and studied the real catacombs," explains the production designer, "taking pictures and looking at details to create a set for which we wanted to have a fantastically realistic level of detail." Dyas and his team indulged in some interesting cultural transference in adapting the Parisian catacombs for the film's Hungarian setting. "In the actual Paris catacombs, city authorities were concerned about the graveyards above ground in Paris for health and safety reasons, and decided to move bones down to disused mines that existed underneath Paris. When we scouted the Paris catacomb with Ang, we noticed that there were some buildings that were sculpted into the stone, and we decided to do the same in our Budapest catacomb set, creating some well-known towers and buildings around the city."

Dyas and the Budapest construction team used typical materials used for set building

▲ Blue print sketch of the catacombs featuring DIA agent.

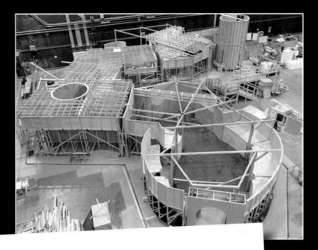
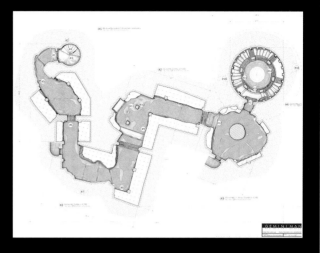

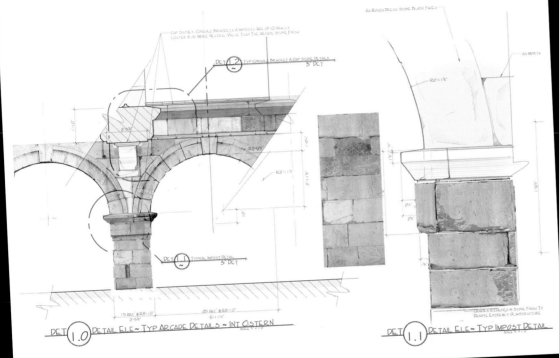

▲ Construction of the catacomb set (top left). Sketch of the catacombs from an overhead view (top right).

to resemble more solid structures, and did so in remarkable detail. "Everything from the superstructure to the columns and femur bones are all made with wood, plaster, and paintwork," notes Dyas. "As we move further into the catacombs, they become more intriguing, scary, and claustrophobic. We also have beautiful inscriptions on the tombs and placards dotted around the set, and an impressive altar where an important exchange takes place between the characters. There are also lengths of the catacombs lined with the bones of people who had died of plague, or skulls with musket roles in them and broken bones. We recreated a religious painting to give visual variation to a set which could become mundane if we had nothing more than skulls and femurs." Needing to build the imposing set to accommodate the practical needs of filming, Dyas added slots in the structure of the catacombs so that director of photography Dion Beebe could accomplish the lighting for his cameras.

There's a door in the catacomb set which, in the film, the actors smash into and freefall down into a cistern. The round structure with circular stairs and water below was an enormous thirty-five-foot-high separate structure sharing the same soundstage as the catacombs. "Again, the surfaces of the cistern set are all hollow," says Dyas, "a wooden structure with plaster and, in some cases, fiberglass and rubber surfaces. The set is completely submerged in water up to about five and a half feet. In designing the set back in Savannah, our cinematographer, Dion Beebe, requested deeper spaces so that he could get his camera further back to take in more of the scale of the space. He will create mystery and mood within the set by his lighting, which will be extremely dark, sometimes lit only by a flare."

The cistern set took approximately fifteen weeks to build, and the catacombs were a bit shorter at twelve weeks, and both of them, in the end, looked as if they had existed for three or four hundred years.

Overall Hungarian Artifacts

**From the Roman Aquinqum
till the late 18th Century**

ith the reaching of the Common Era, images of two different worlds take shape in this room. Under the name of Pannonia, the territory of Transdanubia became a strategically significant border province of the Roman Empire, with high degrees of social organisation, technical development, literacy in Latin, and classical culture. By means of the Empire's road network and long-distance trade, manufactured articles (often artistically made) and exotic foodstuffs reached Transdanubia from the Mediterranean and the western provinces. Transdanubia's inhabitants already lived not just in villages, but in towns and on villa farms also.

KISCELLI
MÚZEUM

Overall Hungarian Artifacts

**From the Roman Aquinqum
till the late 18th Century**

The culture of public bathhouses became established and games staged in am-phitheatres became popular. At the same time, the peoples living in what is today the eastern part of Hungary retained their characteristic 'barbarian' Iron Age culture. They were in constant contact with the Roman Empire, now as opponents in war, now as trading partners in periods of peace. The trading aspect of the relationship is symbolised by the market scene that is presented, one which could have existed anywhere along the border (limes).

KISCELLI
MÚZEUM

◄ Concept imagery and signage from the museum set.

CREATING JUNIOR

Some seven months before *Gemini Man* opened in theatres around the world, Ang Lee took the opportunity to screen a rough cut of the film for its star, Will Smith, who admittedly was completely unnerved to see double. "The first time it was 'whoa!' Not the Junior character as much as the shot of my current self in the same frame with my younger self. It was really scary. The technology is so spectacular that it penetrates you emotionally. Would it be able to convey the depth of emotion? And you know, Junior absolutely penetrates you emotionally.

"My second reaction was excitement," Smith says with a broad smile. Despite the fact that *Gemini Man* features nearly 1000 visual effects shots, VFX supervisor Bill Westenhofer, a two-time Academy Award winner, including one for his landmark work on Ang Lee's *Life of Pi*, has an

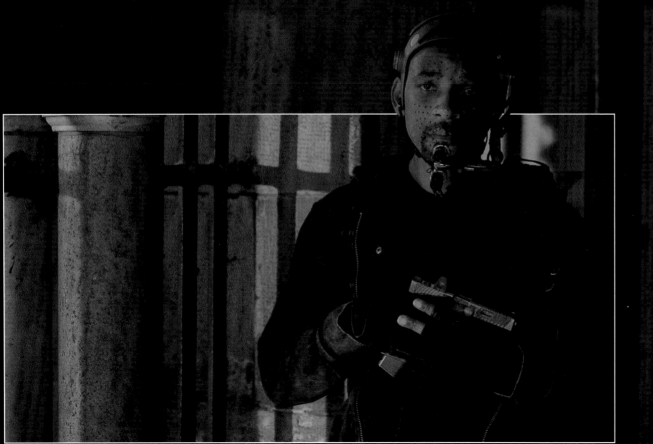

unusual goal for the film. "We want you to watch this film and not have thought that visual effects were used at all," he insists. "Ang is taking a bar that's already the pinnacle of visual effects and raising it way higher. What's awesome about working with Ang is that he treats visual effects like visual art. The visual effects that we put on frame are as important as any other department."

Westenhofer and his team inherited the Olympian task that was responsible for the seemingly endless journey of *Gemini Man* from concept to screen: how to create a believable twenty-three-year-old version of the fifty-one-year-old main character portrayed by an actor of similar age. "The hardest things to accomplish in visual effects has changed over the years," he explains. "It used to be water and animals, but we've gotten better at those things. But

there's still one hurdle, which is creating a digital human being. We've evolved over millions of years to be able to spot little things about what makes a recognizable human, so if we get that wrong on the digital side, it looks a little weird. They call that the uncanny valley, where something is off about it that's kind of disturbing to look at. So until very recently, the uncanny valley has been insurmountable." With *Gemini Man*, we're crossing the uncanny valley for the first time in this film. The character of Junior – Henry Brogan's twenty-three-year-old clone – is portrayed by Will Smith in a remarkable dual performance. Technologically, as Westenhofer explains, "In the vast majority of shots, Junior is a fully digital asset, both body and face. There were a few sequences where Will played Junior on camera and we were able to use his body, and there were also a few specific

shots where we kept the digital double's body but, in the majority of cases, we ended up doing a full replace to allow the nuances of Will's full motion capture performance to come through."

"To pull off the creation of a digital human in a leading role," continues Westenhofer, "we've enlisted the giants in the field, Weta. Guy Williams is our visual effects supervisor, and they've got an army working down in Wellington, New Zealand to create the character of Junior." Although Weta has previously pioneered such marvels as Gollum and the other digital creatures of *The Lord of the Rings* and *The Hobbit*, along with, just to name a few, *Avatar* (and its upcoming sequels), the recent *Planet of the Apes* films, *The Jungle Book,* and *The Avengers* series, as Guy Williams points out, *Gemini Man* presented an unprecedented challenge which was

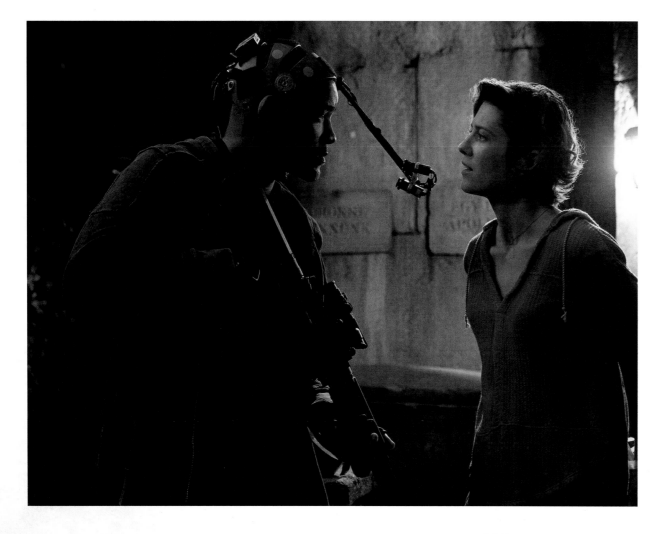

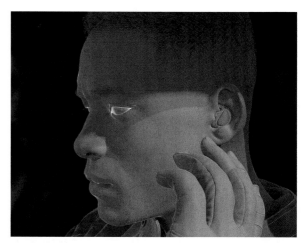

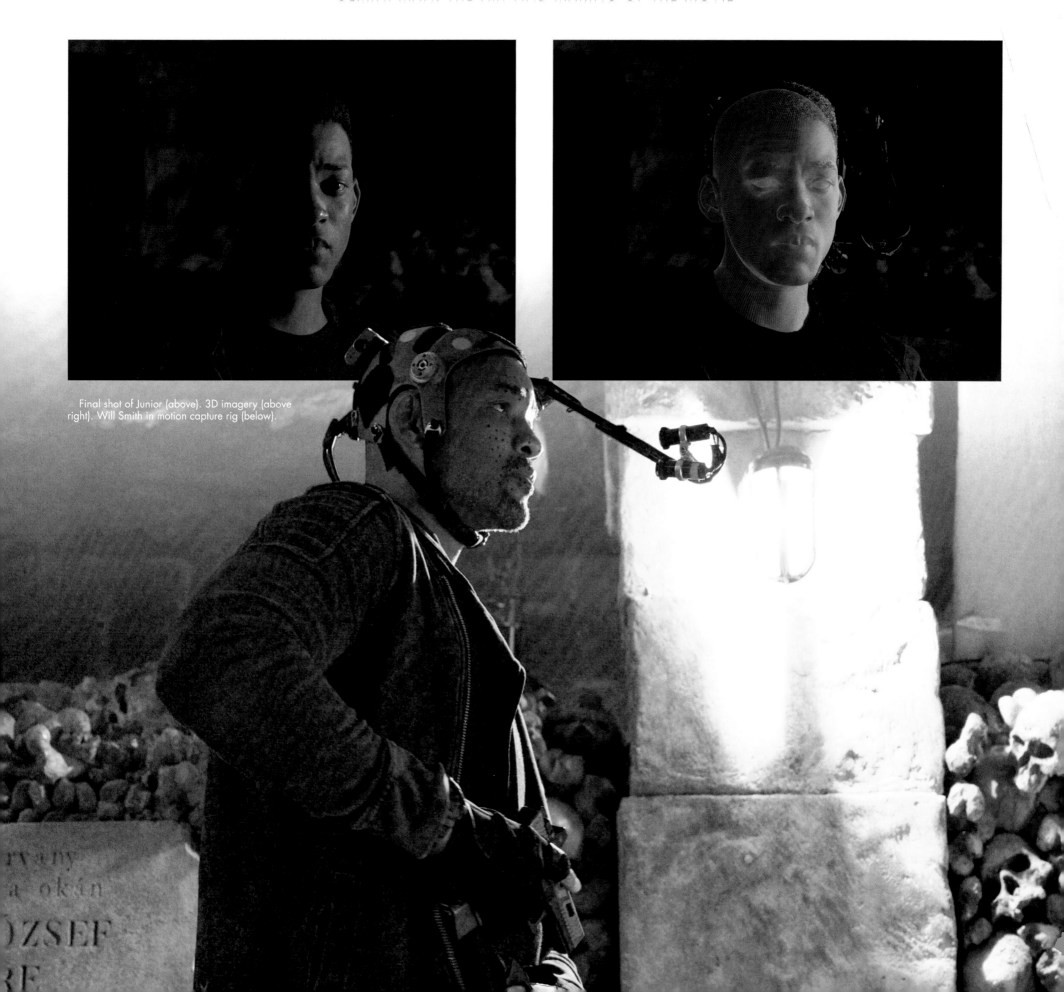

Final shot of Junior (above). 3D imagery (above right). Will Smith in motion capture rig (below).

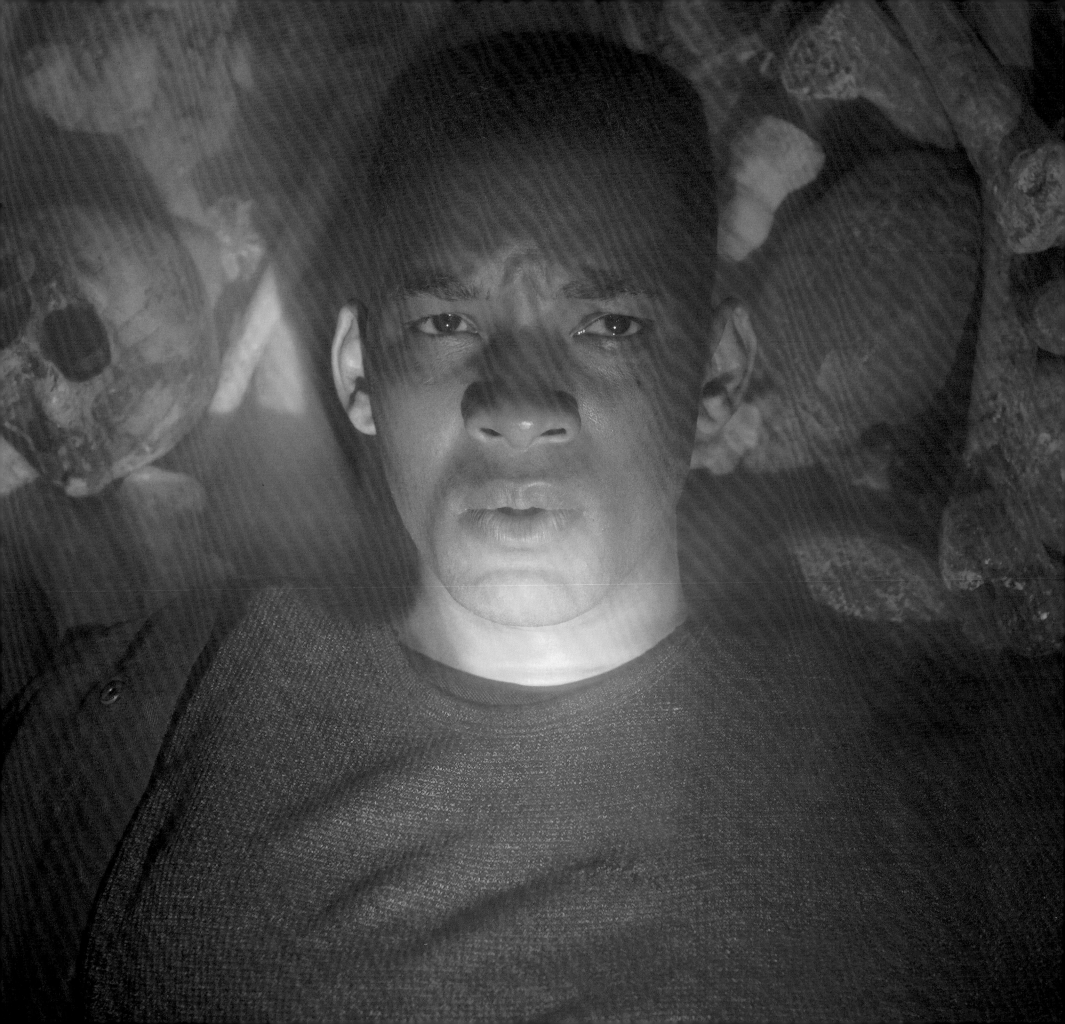

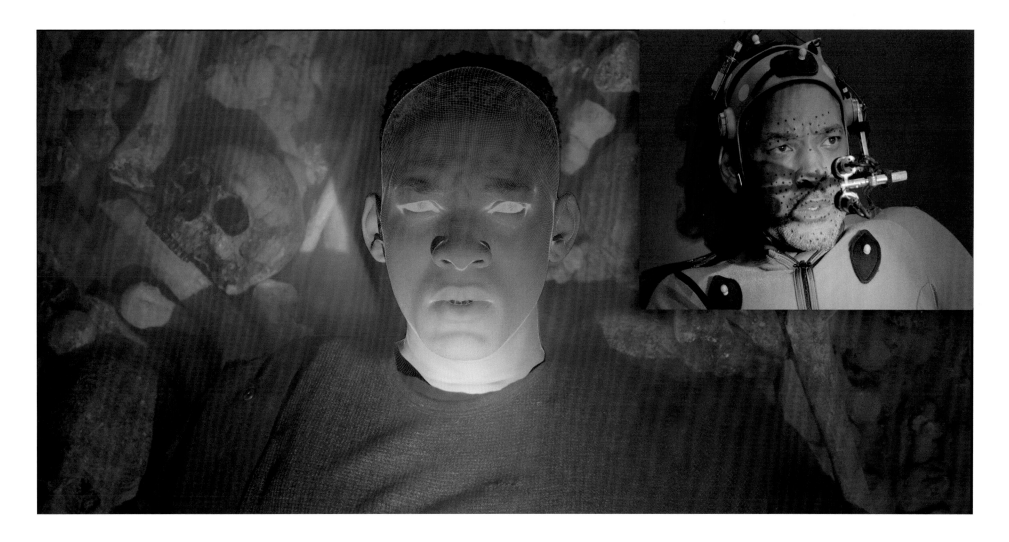

the very reason why the film couldn't be made for the previous thirty years. "There have been a few times in cinema where people have put digital humans into a shot with good success, but this is the first time where one of the leading characters of the film is a totally recognizable human. We've done a lot of creature work, but our challenge was that, for us to succeed, you have to watch *Gemini Man* and completely forget that you're watching a digital human. Will gives an amazing performance in both roles, so you have to be drawn into that performance. You can't sit there thinking oh, look, that's pretty interesting looking CG. It has to be invisible, you have to just forget about it and just relish the performance that the actor is giving you, which in this case is two performances."

"We've all grown up with Will Smith from a variety of projects from *Fresh Prince of Bel-Air* to the *Bad Boys* movies to *Independence Day* and more, so he kind of belongs to all of us," continues Williams. "We know who he is, and what he looked like as a young man, so there's no wiggle room. We have to make sure that we get every bit of his performance right. We had to scour every single piece of footage we could find, and every photograph of Will at the age of twenty-three so that we could start building Junior, but also working with Will where we put him in front of eight calibrated cameras capturing all the positions of his face."

Elaborating on the specific scenarios of how Junior was created, Williams explains, "A-B capture is where we had the characters of Henry and Junior in frame at the same time but only had access to one Will Smith." This meant Will played Henry against a body double as Junior first and then switched and played the Junior role opposite a body double of Henry. "B-Side Only is where Junior performs against another character, other than Henry, so that Will can play the part of Junior. Since it is Will playing the part, we often kept his body and only replaced his head. The last option is Stunt Capture. Here, we would shoot a stunt without Will and then add in Junior's, or Henry's, head onto the stunt performer. About half of the time, we would go ahead and replace the entire body, but this was more to do with making the stunt larger than is safely possible. The goal is to get all of Will's performance when it applies. It's his performance, his emotion, and his ability as an actor to create a rich performance, and then play off of himself. We have current Will Smith playing a role which requires a younger Will Smith, the advantage of which is that Will has obviously always been a great actor, but he's just gotten better with age."

Smith confirms that, in playing Junior, "I was trying to find the nuances, to make the voice delineations and all of those things. But then the real work started when the artists at Weta

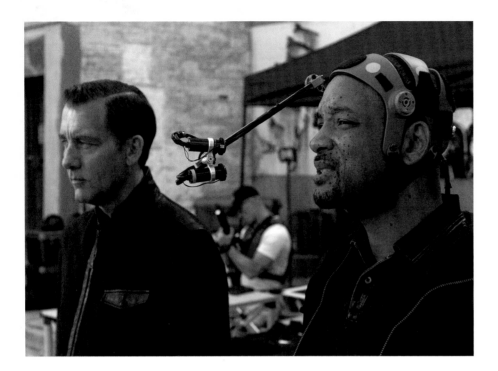

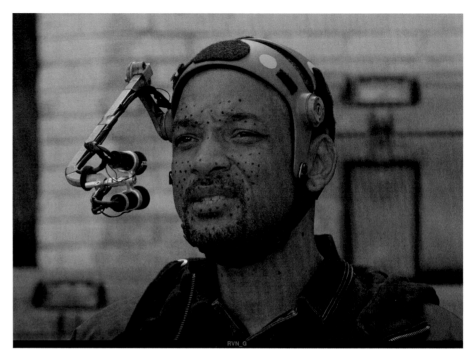

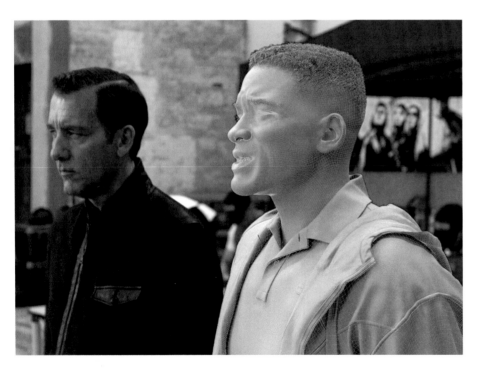

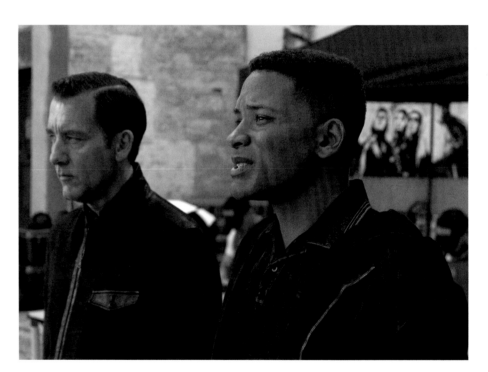

went in and began to create the character. They began to create the look, and how they were able to craft the character visually."

"One permutation that we do on set," continues Guy Williams, "is that if we're shooting a scene in which Junior is alone in the scene, we have Will performing the role wearing a helmet rig, which tracks his facial animation, allowing him to perform the role with the other actors in frame. There's a stereo pair of cameras hanging in front that are looking back at Will, with little tracking dots on his face. Those cameras allow us to understand what expressions

he uses so we can make sure that we're faithful to his performance in post-production." During filming, specially designed and placed cameras allowed Smith to see himself projected on a screen as Henry so that, when he was acting opposite Junior, he could play against his own lines. "We wanted to make sure that the timing of the scenes with Henry and Junior happened naturally, so we had his real self with his real dialogue," notes Westenhofer. "Then we re-did the scene in motion capture for Junior."

To create Junior, Guy Williams explains that "the team at Weta are modeling the character

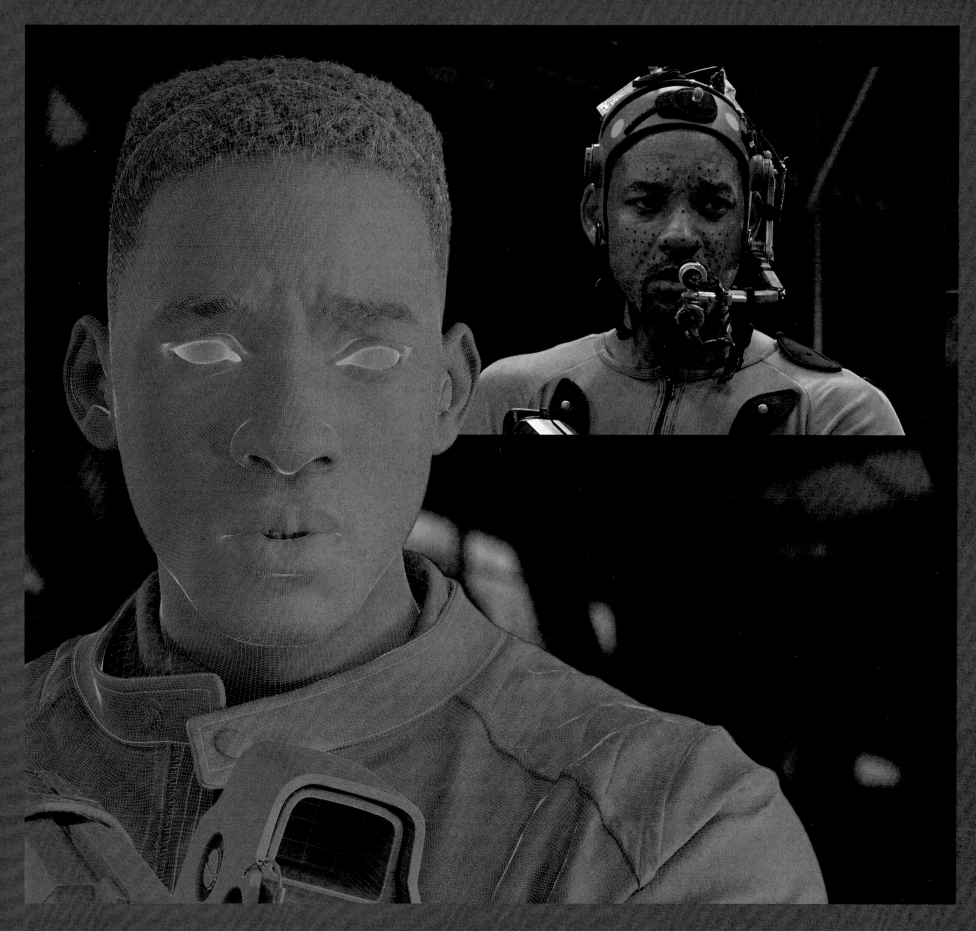

"Our goal was you don't
question if it's a latex or CG
thing, it just feels like a living,
breathing human."

Guy Williams - *visual effects supervisor*

in minute detail. For example, when we're modeling the teeth, we're not just modeling a tooth and painting it white. We are modeling the root structure inside, or where the enamel ends, all of these details are replicated so that when we create the digital version of Junior based on Will's performance, we can add those details." Adds Ang Lee, "With new thinking and improvements, we turn visual effects into visual art. The VFX and the practical must fuse into one beautiful chord." Guy Williams adds, "Another technology that we developed for *Gemini Man* is a spectral renderer that we use to render all of our CG. We have to make sure that the skin looks as real as possible, and to do that we pay insane attention to detail. Obviously, you make sure to put in blemishes on the skin, like small moles or freckles. Another thing we did was that, even though Junior is clean-shaven for the movie, we actually gave him a beard and a moustache, and then shaved it so that he has something of a 3 or 5 o'clock in the afternoon shadow. On top of that, we're simulating blood flow in the skin, so that you get these gradual transitions in color. We're also hooking the blood flow into the melanin and inulin context, so when the skin gets compressed, we actually modulate the amount of melanin and inulin that you see in the skin at that point in time. What it allows for us to have is, as Will's digital self moves around and performs, his skin just feels that much more believable and real. Our goal was you don't question if it's a latex or CG thing, it just feels like a living, breathing human."

▲ DNA test report prop from the film (top right).

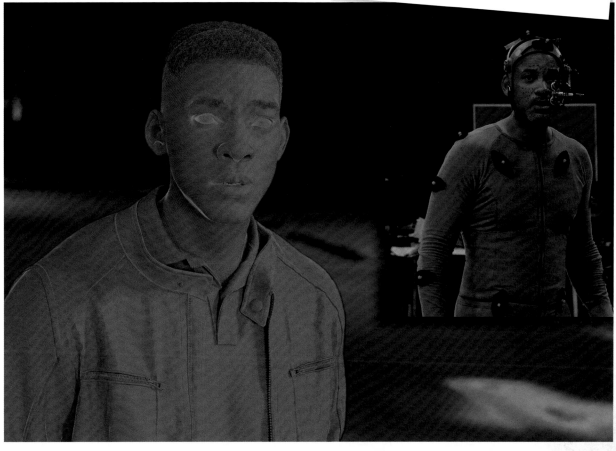

G600 PLANE

Like any good friend, Baron needs to give his friends, Henry Brogan and Danny Zakarewski, a lift. Thing is, Baron needs to give them a lift from Cartagena, Colombia to Budapest, Hungary, which is 5,907 miles away. The only answer to this dilemma is for Baron to simply find a way to borrow, by any means possible, a brand-new Gulfstream G600, one of the sleekest, coolest, most powerful jets in the world for private and/or corporate use. And the only answer for the filmmakers to film a dramatic dialogue scene inside of one was to utilize a G600 mock-up on a makeshift soundstage in a huge indoor storage facility at Gulfstream in Savannah, Georgia.

Benedict Wong confesses that he was surprisingly comfortable behind the controls of the magnificent aircraft. "Previously in my misspent youth, I was playing a lot of airplane simulator games," he says sardonically. And while preparing to film Danny Boyle's science fiction film *Sunshine*, Wong and the film's other actors experienced landing planes in a simulator at London's

Heathrow Airport. But for *Gemini Man*, Wong had to convincingly look as if he was piloting a G600 while singing at the same time. Recalls the actor, "First, our line producer, Brian Bell, e-mails me that Ang wants me to sing some Elvis in the flight deck, so I began singing my heart out in the hotel room, practicing. Then another e-mail came in from Brian saying that Ang now wanted me to sing a Ray Charles song. And I was like hang on, am I in the right film? So there I was in the flight deck of a G600 singing Ray Charles' 'I Got A Woman.'

"And," Wong jokingly concludes, "I hope to release an album when the film comes out."

The G600 flew for the first time on December 17th, 2016, and in fact did not enter service until after the company utilized the mock-up for filming. The mock-up of the flight deck at which Benedict Wong was seated is the most advanced in business aviation and features active control sidesticks, integrated touchscreen controllers, next-generation enhanced vision system, and Honeywell Primus Epic avionics. Definitely a step up from Baron's old seaplane!

◀ Concept imagery of the G600 plane.

TEAMING UP

A deteriorating barn in the Georgia countryside is the incongruous site of a highly dramatic scene in which Junior finally realizes the truth of his existence and throws in his lot with Henry and Danny. Finding the right location for this scene perfectly illustrates how even the most seemingly simple backdrops required painstaking scouting, and then the collaboration of several departments to fulfill the vision of the director.

"The barn was a difficult story point," says Guy Hendrix Dyas. "In fact, I'm not even sure the scene was originally written with a barn in mind! Our creative dilemma was that in the story we had to relocate Henry, Danny, and Baron from the airstrip where they land the private jet in Georgia to any found ground transportation as quickly as possible without detection, and yet they were stranded in a rural airfield environment with no pre-planned vehicle waiting for them. Our fugitives come across a barn offering a glimmer of hope that the building may have stored vehicles, perhaps an old van or discarded pick-up truck. The temptation to explore would be self-evident to an audience."

▲ Baron struggles to save Henry once he's hit by the bee venom dart.

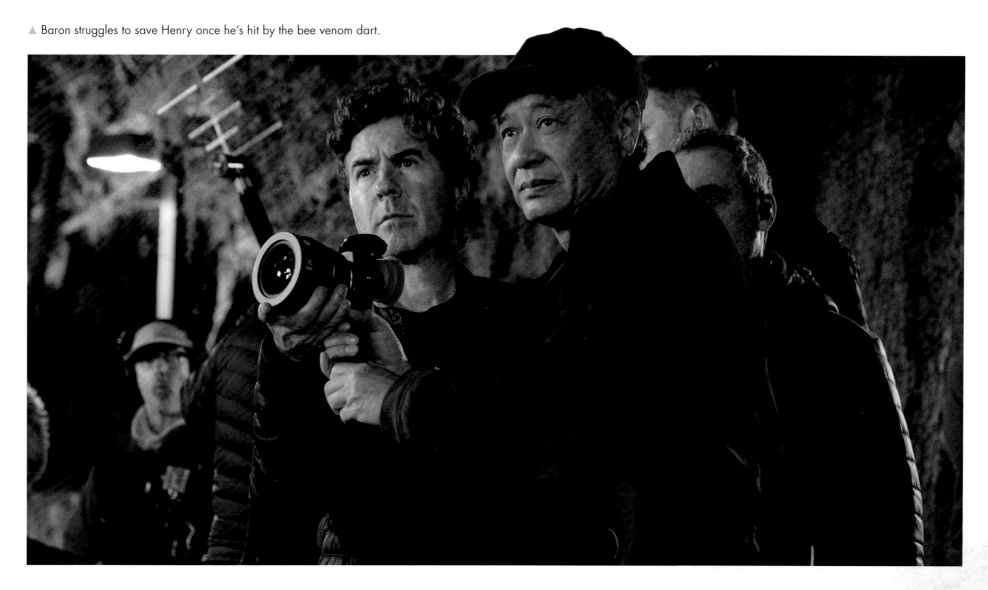

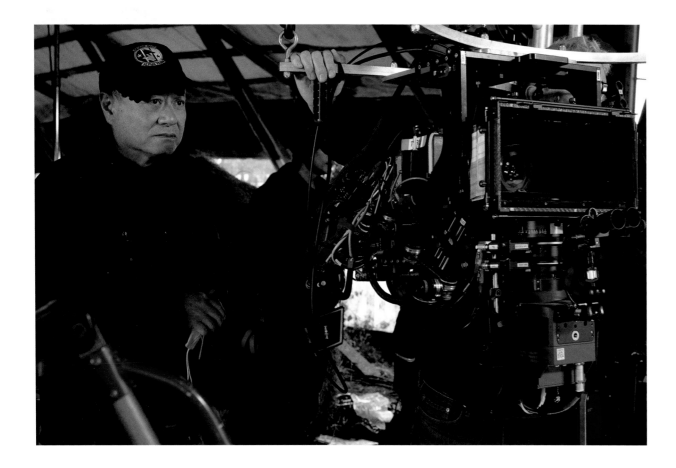

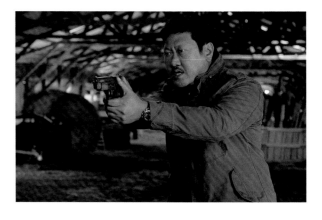

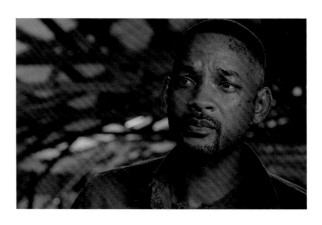

Finding that barn became the proverbial needle in a haystack search, even in a vast rural area dotted with farms. "Our location manager, Ronnie Kupferwasser, searched the rural areas around Savannah tirelessly with little success," Dyas continues, "but as options started to dwindle, in passing he showed me photographs of a curiously proportioned, dilapidated building." For Dyas, it was one of the occasional 'Eureka!' moments which finally crystallized what he had been looking for. "Ronnie had found the perfect location by proposing an old 1960s era poultry house as an out-of-the-box idea. The structure was very long and narrow with a ramshackle roofline… it looked great! It was bookended with thick brush and trees, forming a sort of wall that gave our group no choice but to pass through it to continue their search for a vehicle. Junior has anticipated their route, perhaps because instinctively he thinks like Henry, and is able to ambush the group once they're inside. It's really the turning point in Junior's belief and loyalty to the Gemini organization."

Once again, director of photography Dion Beebe used the 'day for night' technique, which per Dyas, "allowed us to obtain enough light exposure to film while the illusion of night is what the audience experiences. Dion worked with me on test samples of materials we could use to provide enough light to enter the building while providing adequate texture and semi-obscuring the area around the structure. The 'Barn Project' became a very complicated enterprise, involving the art department for design, set dressers for the interior, and the construction department to structurally support the building just in case it collapsed during filming!"

Dyas notes that everyone's efforts, as always, were in the service of Ang Lee's highly creative approach to the material. "With so many of the sets on *Gemini Man*, Ang pushed for realism," he says. "This was his artistic vision given the clarity of image experienced with 120 frames per second. It was always rewarding to watch the results during dailies, and I wonder how many of our creations will be detectable given the quality of craftsmanship and the skilled crew we were lucky to work with."

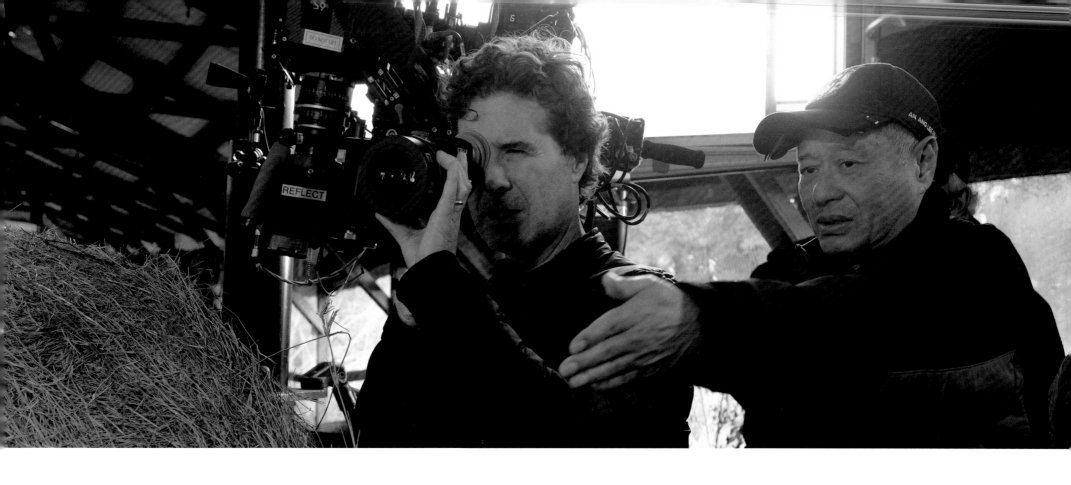

DART GUN

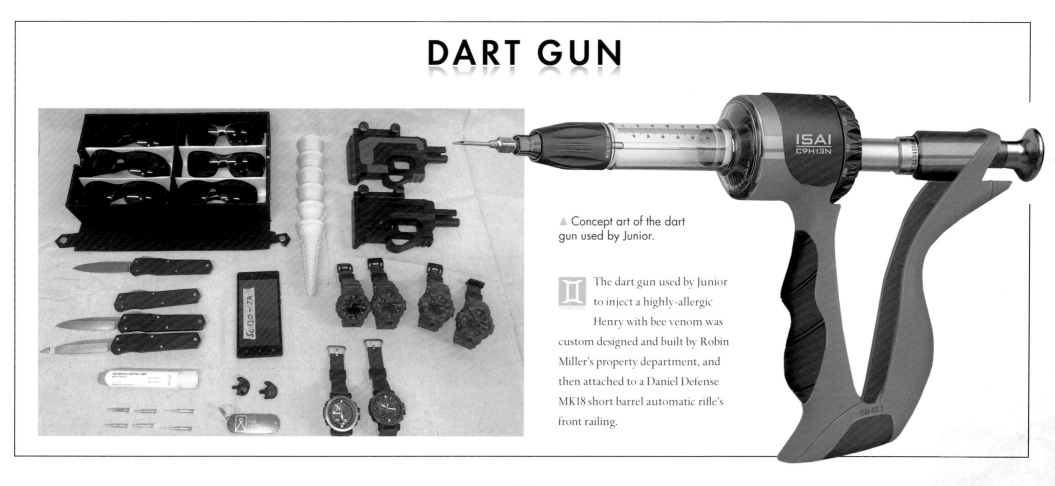

▲ Concept art of the dart gun used by Junior.

The dart gun used by Junior to inject a highly-allergic Henry with bee venom was custom designed and built by Robin Miller's property department, and then attached to a Daniel Defense MK18 short barrel automatic rifle's front railing.

THE GEMINI COMPOUND

To create the compound of Gemini Global Defense and the office of Clay Verris, its brilliant and lethal CEO, the filmmakers yoked together sets and scenes filmed in two different countries on two different continents to seamless effect, with a little Bacon on the side. Scenes set in the Gemini campus, described in the script as resembling a studio backlot, were aptly shot at an exterior city set on the backlot of Korda Studios, named after Sir Alexander Korda, one of the foremost Hungarian cinematic exports who produced some of the greatest British films of all time. Verris' office, however, was incongruously filmed inside of a space found in the Savannah office complex of the Great Dane truck company. In the film, the Gemini compound is placed near the small town of Glennville, Georgia and, although the production utilized a huge chunk of the downtown area of the real Glennville for the explosive climactic sequence, the actual Gemini facilities were shot elsewhere.

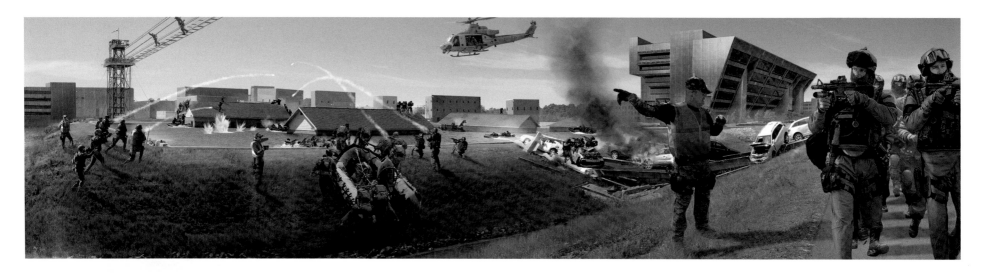

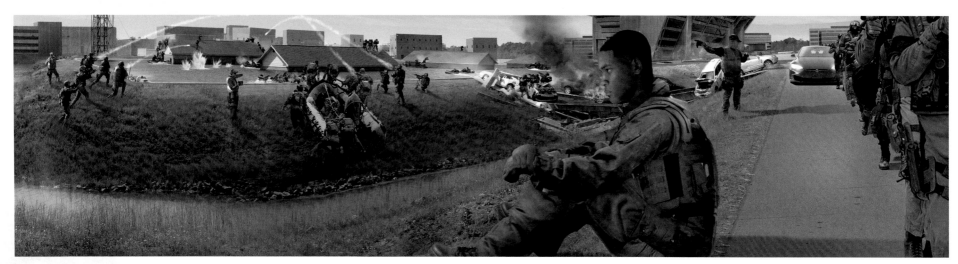

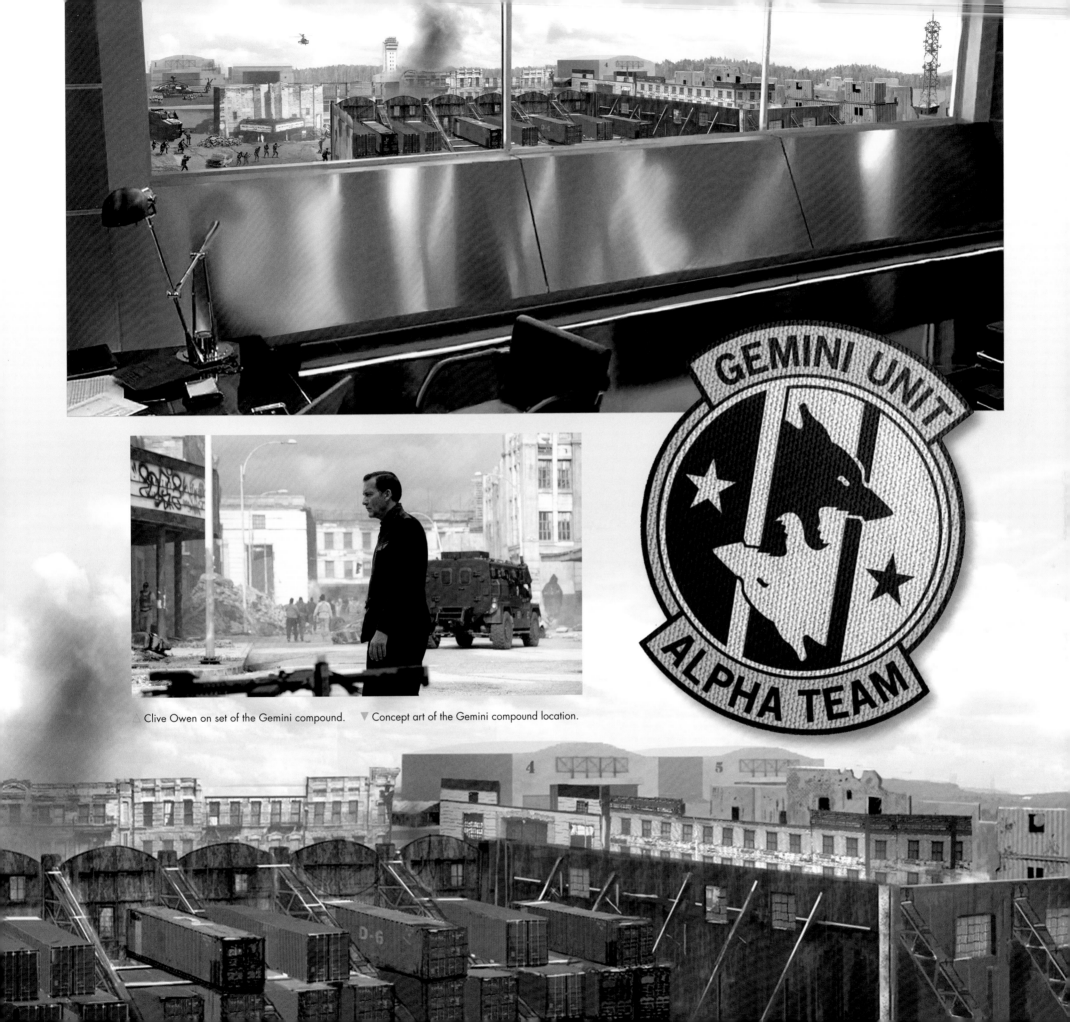

Clive Owen on set of the Gemini compound. ▼ Concept art of the Gemini compound location.

"One of the most challenging environments to design was the expansive training facility dedicated to Verris' private army for hire," says Guy Hendrix Dyas. "A businessman and mercenary, Verris has capitalized on the international demand for a small, well trained military team that is more effective and economical than a traditional full scale army. Also trained at his military academy are an elite group of highly skilled assassins. The facility has a realistic urban cityscape designed for tactical training. A series of scenarios are taught to the training cadets including hostage situations, terrorist attacks, and natural disasters followed by civil unrest."

"Verris' personal office overlooks one of these training grounds with a large window," continues Dyas. "His office is sparsely decorated with a few highly prized possessions, for example an American antique sniper rifle from 1850 and a pair of British dueling pistols from 1795." Dyas also had the notion of illustrating the state of Verris' mind and character by adding within the stainless steel walls of his office what he calls, "a vivid red interpretation of a triptych" by famed and controversial British artist Francis Bacon. "The beautiful and disturbing images first came to mind while I imagined who Verris might be," notes Dyas. "His fascination for the macabre and a self-belief in his own ability to create and alter the mind and purpose of an individual. The religious context of the pieces and Verris' desire to play God made them the perfect fit for his office. They form a wonderfully intimidating façade for any visitor to Verris' inner sanctum."

▼ Concept artwork of Junior on set of the Gemini Compound.

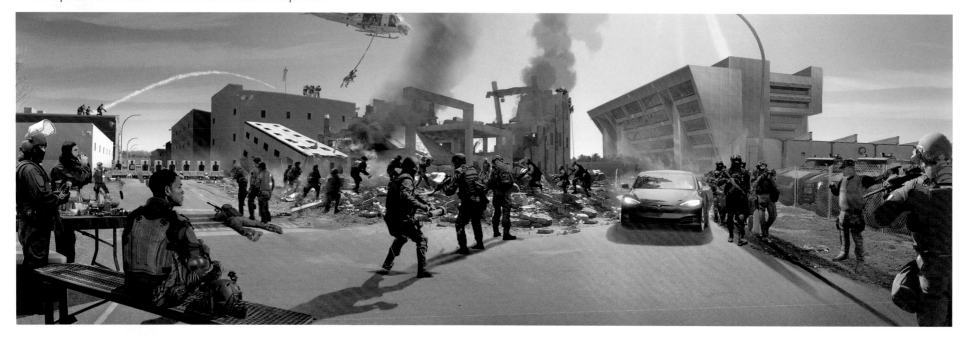

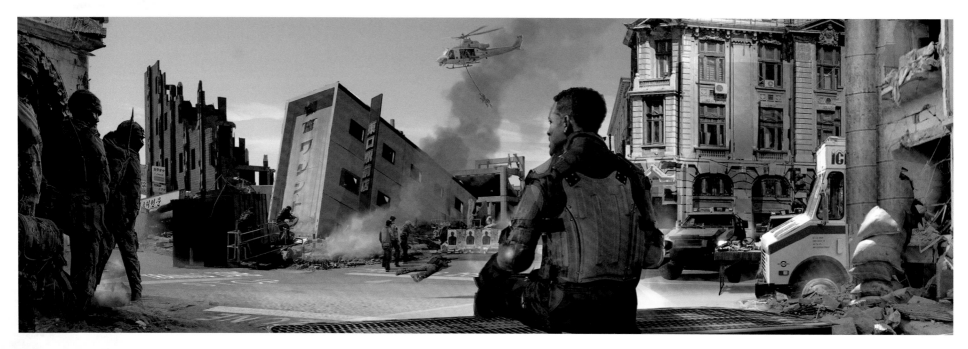

▼ Verris in his office complete with Francis Bacon paintings.

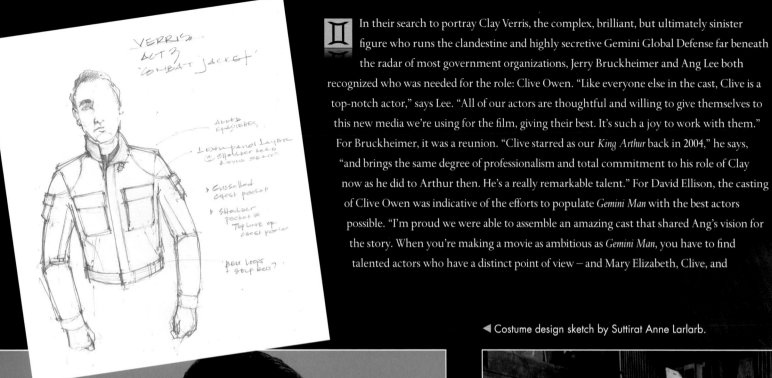

In their search to portray Clay Verris, the complex, brilliant, but ultimately sinister figure who runs the clandestine and highly secretive Gemini Global Defense far beneath the radar of most government organizations, Jerry Bruckheimer and Ang Lee both recognized who was needed for the role: Clive Owen. "Like everyone else in the cast, Clive is a top-notch actor," says Lee. "All of our actors are thoughtful and willing to give themselves to this new media we're using for the film, giving their best. It's such a joy to work with them." For Bruckheimer, it was a reunion. "Clive starred as our *King Arthur* back in 2004," he says, "and brings the same degree of professionalism and total commitment to his role of Clay now as he did to Arthur then. He's a really remarkable talent." For David Ellison, the casting of Clive Owen was indicative of the efforts to populate *Gemini Man* with the best actors possible. "I'm proud we were able to assemble an amazing cast that shared Ang's vision for the story. When you're making a movie as ambitious as *Gemini Man*, you have to find talented actors who have a distinct point of view — and Mary Elizabeth, Clive, and

◄ Costume design sketch by Suttirat Anne Larlarb.

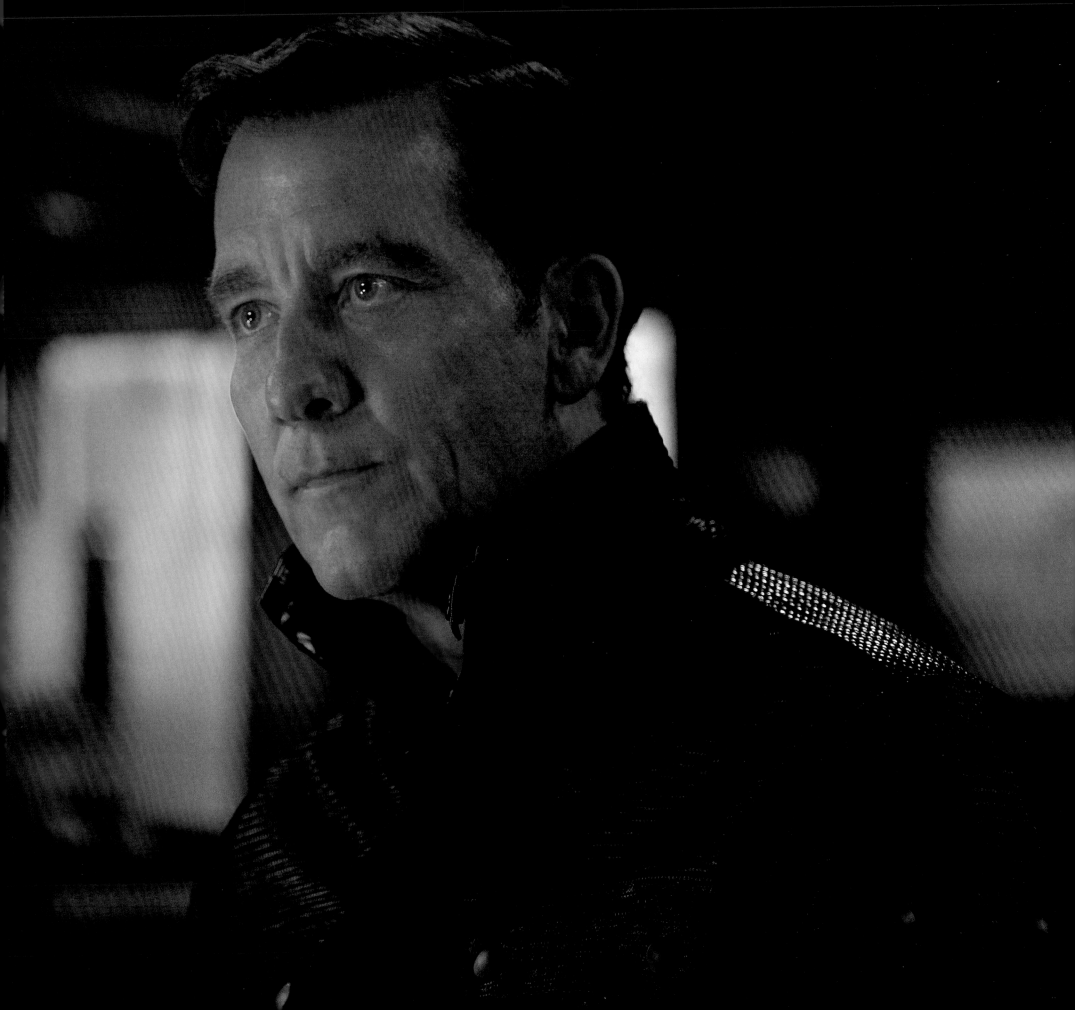

▲ Verris' fatherly relationship with Junior complicated his role as the agent's boss.

Benedict certainly do – but who are collaborative and willing to take risks." Adds executive producer Chad Oman, "Verris is a very intelligent, forward thinking character, and Clive brings real intensity and a menace to the character." For Owen, it was imperative to create a character who defies categorization or easy definition. "Would I consider Verris the antagonist? Yes, possibly some people might look at him as a bad guy, but I would never approach it like that. Basically, Clay is a military guy who has gone private, and runs a hugely expansive military-type operation called Gemini. He's become very interested in the idea that you can clone a soldier and create somebody with the skill sets and techniques that a good soldier has, and send them to war. Gemini goes to places where the governments don't want to be seen going."

The conflict between protagonist Henry Brogan and antagonist Clay Verris in *Gemini Man* is inherently powerful because the two men, their relationship once forged by experiences on the battlefield, have become split by diverging paths and attitudes. But in effect, Verris transfers his deep respect for Henry onto his younger clone. "Clay is so passionate about the Gemini project that he becomes the surrogate father to Junior, and raises him," notes Owen. "Verris is very nurturing, very fatherly, but there's also a big pressure about what this kid is going to have to deliver. Ultimately, when Junior discovers that he's a clone, it's a huge thing for him to have to deal with as a human being. It sends him into turmoil, which stresses and

worries Clay. Sending Junior after Henry is the proof to Verris that his project and the whole endeavor has been worthwhile."

In *Gemini Man*, Clive Owen plays powerful scenes with Will Smith acting as both Henry Brogan and Clay Verris' surrogate son, Junior. "It's been an absolute pleasure working with Will," he says. "He's really an unbelievable pro. I mean, he is so focused and on his game all the time, a real dream to work with. Will has got huge challenges playing two parts, so in any scene that they are both in he has to play two characters, which is a huge challenge and commitment. They are different people, the younger version of Henry doesn't have the same sensibilities as the older one, and watching Will work is hugely impressive." The technological equipment necessary to film these scenes could be distracting for any actor performing opposite Smith, but it didn't turn out that way for Owen. "Every time Will plays Junior, he has to wear a head rig helmet with cameras. You would think that would hugely affect everything, but it doesn't, in a strange way. "When I act a scene with Will when he's wearing that rig, I forget that it's there. Will is very focused, very present, so I just act with him and the rig disappears in my eyes. I have to keep out of the way of the rig when Will swings his head around, but it really isn't an issue for me at all. Some actors might express what a pain it is to have to wear that gear, but you don't get a whiff of that with Will. He constantly maintains a great attitude."

144

Clay Verris is, of course, defined by Clive Owen's powerful and vivid interpretation of the character, and that gets an assist by his very distinctive wardrobe, provided by the film's brilliantly imaginative costume designer Suttirat Anne Larlarb, who saw him as something of a 'brandmeister.' "For everything in Clay's organization – his being, his personal life – aesthetics matter, but not so much that they're distracting. Clive was such a fantastic person to work with in coming up with ideas. We had a lot of dialogue before he came to his first fitting, and responded really well to some to the early images that I had shown him and that I'd floated in front of Ang. I felt like everything Verris wore needed to be clean, minimal, vaguely nodding to the future, as though he's twenty steps ahead of everybody. And years ahead of the curve, but being so classic that you're not distracted by the fashion forwardness of it. When he walks in the room, he needs to telegraph power. When I saw how Guy, our production designer, was going to approach Clay's living quarters, his house, office, the Gemini campus, I knew that all of the design choices related to him had to be an extension of his ethos. Nothing is uneconomical or inefficient. Perhaps best representing Clay Verris' wardrobe is a jacket which Larlarb designed for Clive Owen. "It hearkens to a classic military uniform," explains Larlarb, "but in Verris' signature black rather than olive green. It has a band collar, which we decided for all of Clay's looks, even his pajamas, somewhere between a mandarin collar and classic men's wear. The collar holds Clay's head up. He's always in power. He's always thinking. He is an intellectual. He is a researcher. I wanted it to have a slightly business feel with military characteristics blended in with some very sharp tailoring."

For Clive Owen, the combination of working with Ang Lee as well as once again with Jerry Bruckheimer was irresistible. "They're a pretty brilliant combination. *Gemini Man* is huge and expansive, travels the world, a true epic. I think their coming together is great. Ang has got the full package. He knows how to orchestrate a really big, successful movie, but is always interested in the drama and the characters. And this film truly depends on that. There's no one better than Ang to do this."

THE FINAL SHOWDOWN

Will Smith, who has enjoyed his share of great action sequences throughout his career, notes that "Ang's approach to the action is that the way it looks, and the way it feels, and the way it blends with emotion, I think it's going to be a visual spectacle. And I think it also will penetrate people in an emotional way that they're maybe not expecting."

"The Glennville showdown is obviously the climax of the movie," notes Ang Lee, "where everything, all the dramatic conflict, comes to a resolution. It has to be a good fight that's satisfying as an action movie; and dramatically, you need to come to a closure… which you then want to turn into a surprise."

This high midnight confrontation in the small Georgia town of Glennville between Henry and his allies, Junior and Danny, against Clay Verris and his elite Gemini Unit Alpha Team soldiers, begins with an explosion and then moves on to pitched gun battles and hand-to-hand fighting in the streets, shops, and rooftops. The shooting of this powerful sequence stretched from five all-nighters in the actual town of Glennville, some seventy-three miles west of Savannah, all the way to several days filming in matching interiors built on a Budapest soundstage near the end of production.

Every great action scene requires a great backdrop, and the city of Glennville provided *Gemini Man* with access to nearly its entire downtown area. "They approached us and said 'We like Glennville,'" recalled the city's mayor, Chris Roessler, during filming. "It's small, not too big, you've got great artistic buildings downtown, we think it'll be a perfect fit for a movie. At first, we thought it was just make believe, but once it was clear that it was going to happen, we became excited. We're just known as a small Vidalia onion town, so to bring Hollywood to our little city was quite unique." Location manager Ronnie Kupferwasser knew the moment he saw Glennville that he had found the right place. "We searched very long and hard in the whole region looking at several towns," he says, "and when we got to Glennville it just hit all the right buttons for Ang. And after we selected Glennville as the location, we decided to change the name of the town that was in the script to Glennville."

▼ Concept imagery of the town of Glennville.

146

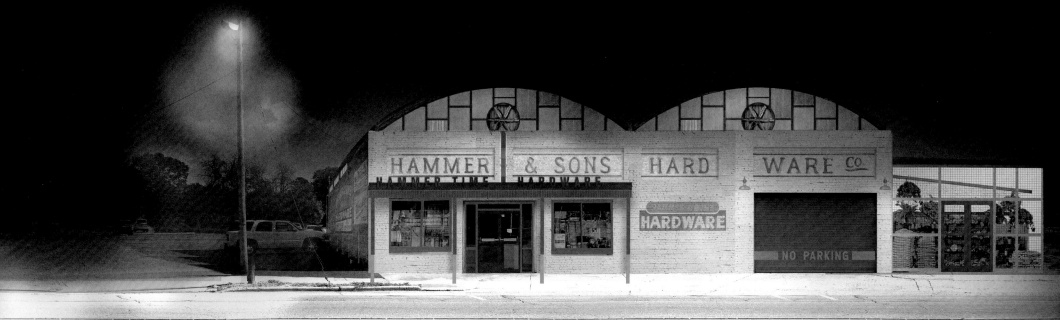

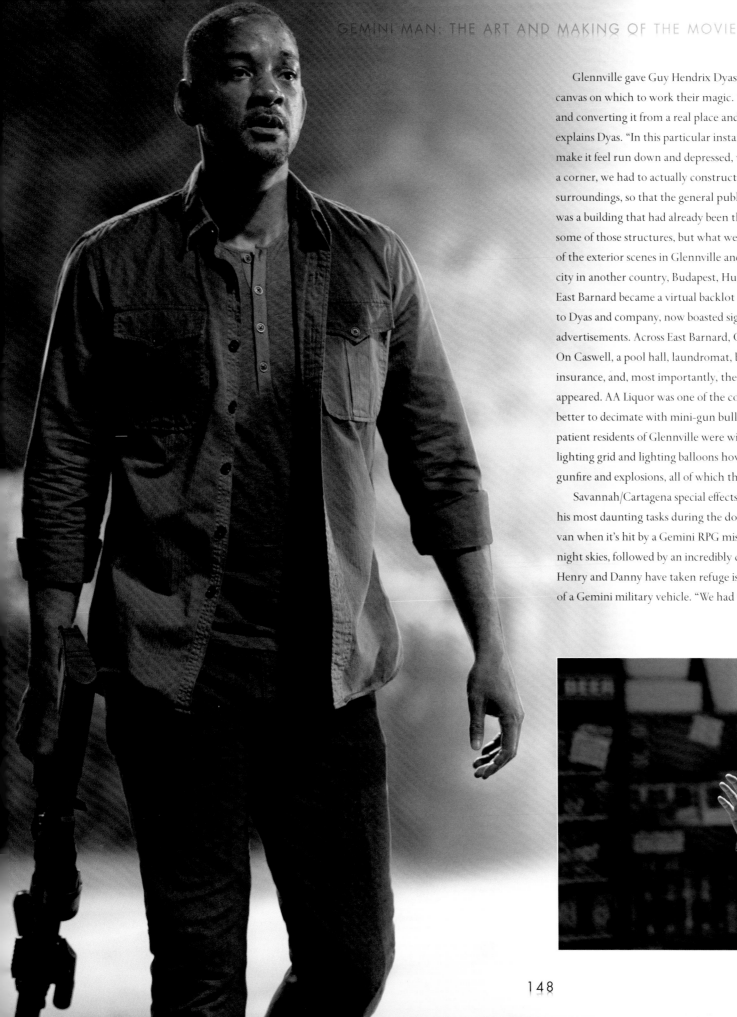

Glennville gave Guy Hendrix Dyas and the art and set decoration departments a large canvas on which to work their magic. "One of the biggest challenges was taking Glennville and converting it from a real place and changing it into an almost fantasy version of itself," explains Dyas. "In this particular instance, we had to not only dress an entire high street and make it feel run down and depressed, which was part of the storyline but, once you turned a corner, we had to actually construct entire buildings and make them fit into the existing surroundings, so that the general public could turn up and not know what was a set and what was a building that had already been there. In addition to that, not only did we have to build some of those structures, but what we were building were facades, so that we could shoot all of the exterior scenes in Glennville and then bring the interior scenes onto stage in another city in another country, Budapest, Hungary." And so, Glennville's main streets of Caswell and East Barnard became a virtual backlot for the film. The storefronts of Caswell Street, thanks to Dyas and company, now boasted signage, window displays, painted wall, and billboard advertisements. Across East Barnard, City Hall was converted into Glennville High School. On Caswell, a pool hall, laundromat, barber shop, accountant and notary public, shoe repair, insurance, and, most importantly, the HammerTime hardware store and AA Liquor Store appeared. AA Liquor was one of the constructions designed and newly built for the film, the better to decimate with mini-gun bullet-ridden pyrotechnics. The hospitable and endlessly patient residents of Glennville were witness to live displays of movie magic, from the gigantic lighting grid and lighting balloons hovering over the town like UFOs, to middle of the night gunfire and explosions, all of which thrilled rather than disturbed them.

Savannah/Cartagena special effects supervisor Mark Hawker was faced with some of his most daunting tasks during the downtown Glennville shoot. This included flipping a van when it's hit by a Gemini RPG missile in a large explosion that illuminated the town's night skies, followed by an incredibly complex set-up when the AA Liquor Store in which Henry and Danny have taken refuge is shot to smithereens by a mini-gun mounted on top of a Gemini military vehicle. "We had to rig the liquor store with 77,000 feet of wire," notes

Hawker. "Everything in the liquor store had to have bullet damage, because a mini-gun fires 3,000 bullets a minute. We had to have 5,000 bullet hits in the store, each pyro charge prepared by hand." There were also a thousand breakaway bottles inside of the store which had to be destroyed in the scene, with Hawker and about a dozen of his workers working to make it all happen to perfection with the cameras rolling in 4K HD and 3D. The first take of the scene went well, but Hawker and his team added more charges "because it just didn't seem to be lively enough. And we did a second take, and it was just beautiful."

For J.J. Perry, the Savannah/Cartagena stunt coordinator, choreographing the incredibly visceral gun battle between Henry and Danny and elite Gemini soldiers as they make their escape from the liquor store to cover across the street in the HammerTime hardware store had him reaching back to his actual Army wartime experiences. "I was in Panama in 1989 with the Noriega matter," he says, "and there was a shootout we got caught up in. When Henry and Danny are pinned down in the liquor store, they can't stay where they are because there's a mini-gun out in the street and a bunch of lone wolves coming in for the kill. My feeling was that if you push the button on a stopwatch from the time the first shot is fired, there's no time to waste. There's no choice. They have to take off and shoot their way out of there and get to some sort of real cover, even though they don't have helmets or Kevlar vests and a limited amount of ammunition. You're outnumbered and outgunned. You have to be in a real kinetic gunfight where you don't have a chance to breathe. That's what it's like when you're in a gunfight. Everything is happening super fast and all you have is to focus and keep moving. That's it."

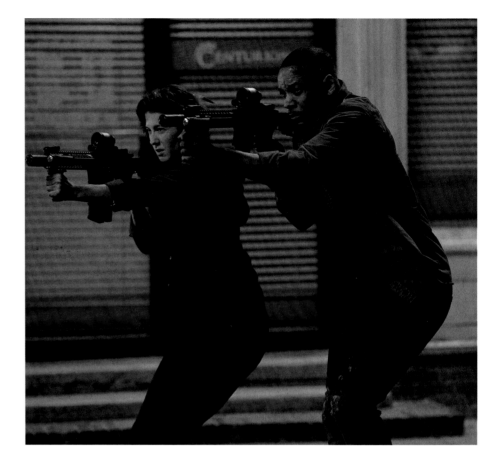

▼ Danny and Henry worked well together in the battle at Glennville.

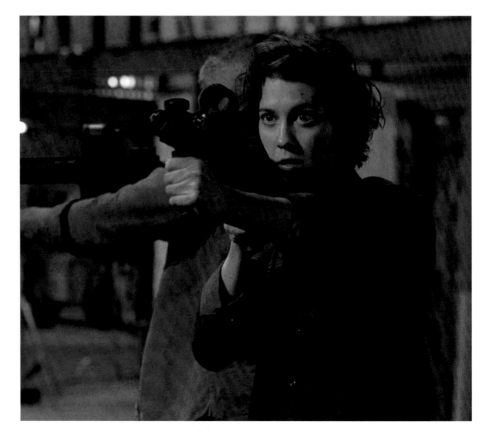

150

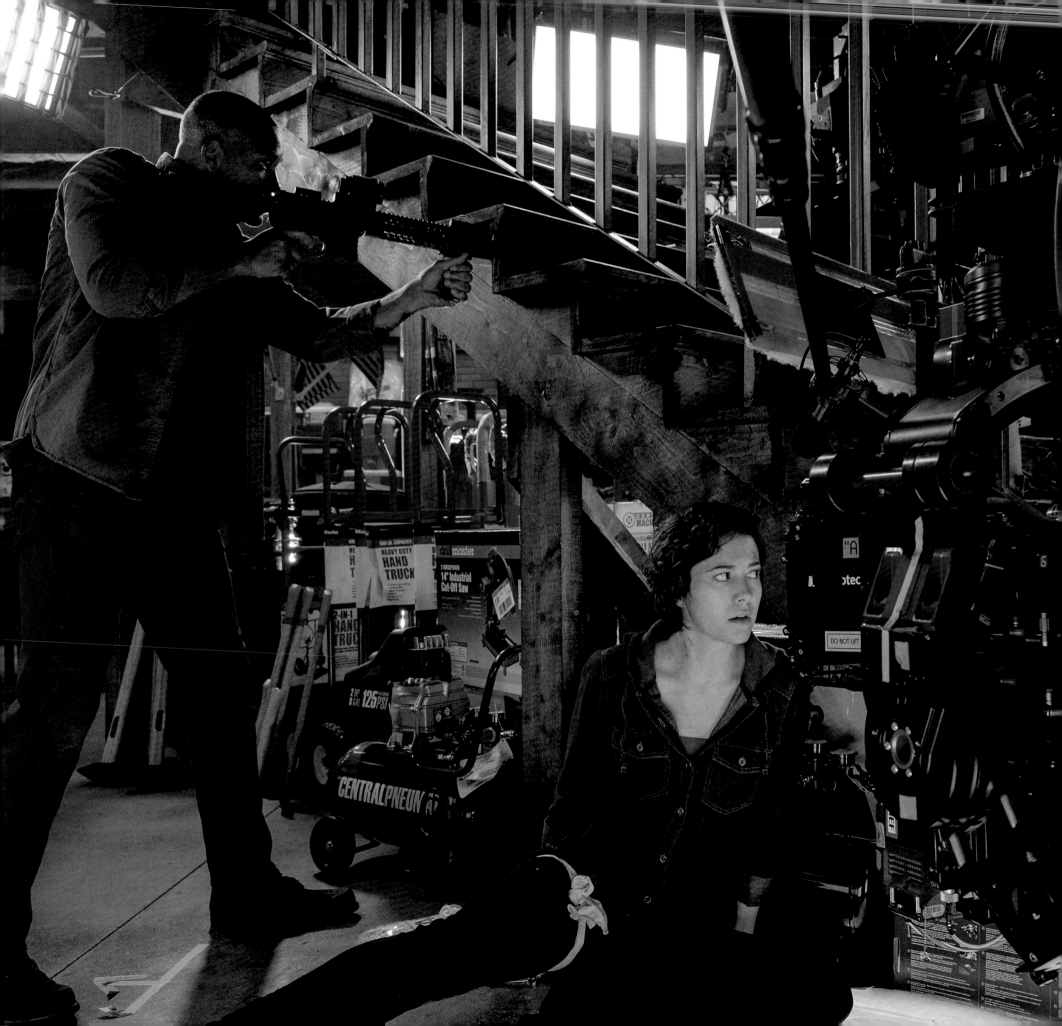

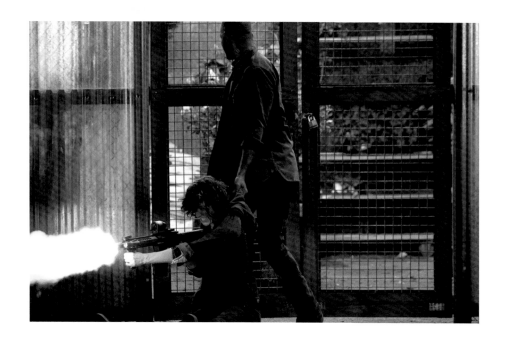

▲ A gripping scene captured by Jerry Bruckheimer in one of his on-set stills.

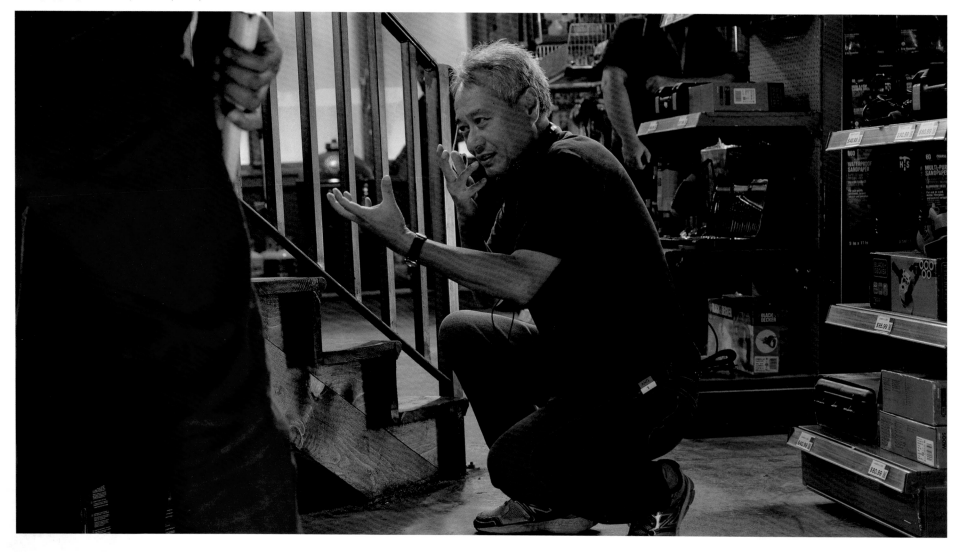

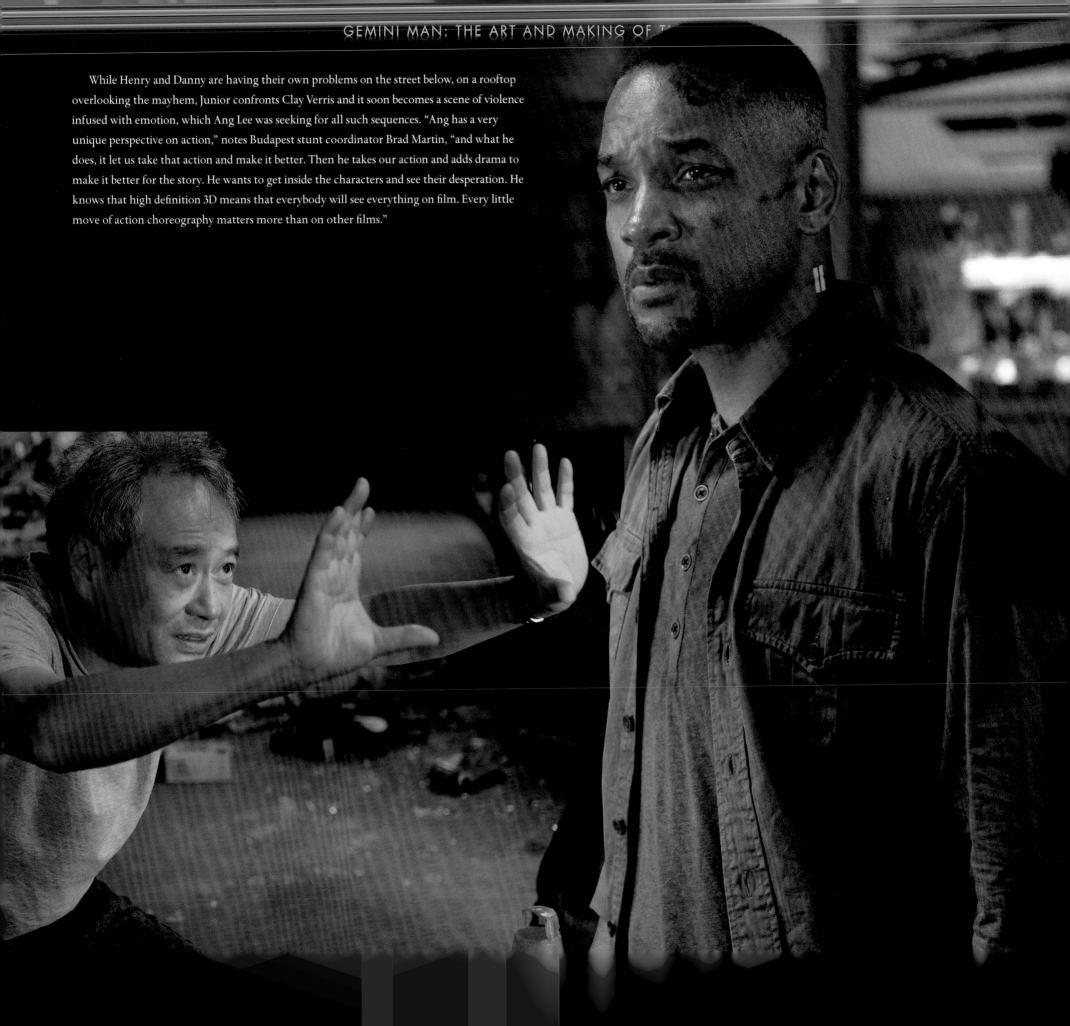

While Henry and Danny are having their own problems on the street below, on a rooftop overlooking the mayhem, Junior confronts Clay Verris and it soon becomes a scene of violence infused with emotion, which Ang Lee was seeking for all such sequences. "Ang has a very unique perspective on action," notes Budapest stunt coordinator Brad Martin, "and what he does, it let us take that action and make it better. Then he takes our action and adds drama to make it better for the story. He wants to get inside the characters and see their desperation. He knows that high definition 3D means that everybody will see everything on film. Every little move of action choreography matters more than on other films."

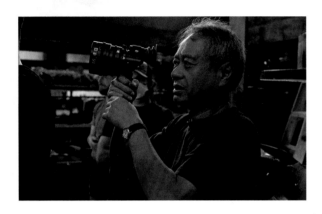

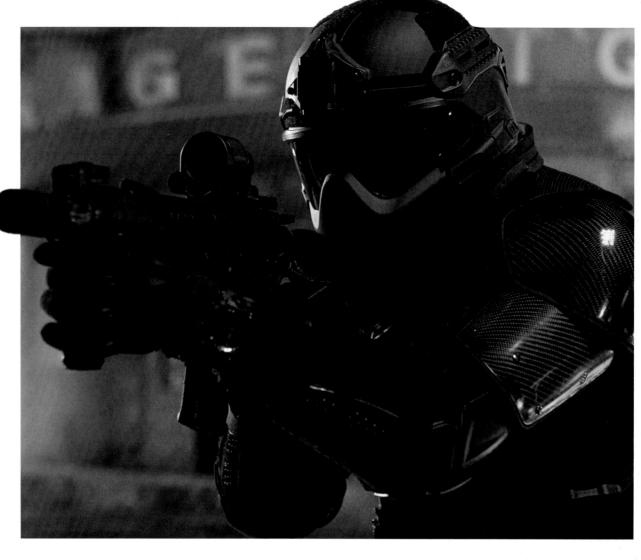

For this scene, Clive Owen was briefly filmed on top of an actual building rooftop in Glennville. The roof was then recreated on a Budapest sound stage for the filming of the fight with Will Smith as Junior. "Will is such a consummate professional," enthuses Martin. "He started off in music, so his ability to remember choreography first and foremost is amazing. He just picks it up immediately, and then he obviously brings his acting factor to it, so not only is Will able to do the choreography as well as many stunt players, but he brings a level of emotion to it which stunt players can't possibly do.

"But Clive Owen was the one that I was pleasantly surprised about," continues Martin. "I didn't expect him to do such a great job on the rooftop. He gave us three or four days of training, and that's all he really needed. Like Will, his ability to retain the choreography was amazing."

Adding to the drama of the sequence is the intimidating armor which clads the Gemini Unit Alpha Team soldiers, created by costume designer Suttirat Anne Larlarb. "They had to be a further extension of the ethos of Clay Verris," she explains. "I actually went all the way back to medieval armor, to just look at what has lasted through the centuries. Some of that is technical, how a body can move in a hard object. Essentially, we wanted to hone in on the kind of truths of what a fighting force would be, and then add a layer of the future to it." The Gemini soldiers are clad in custom helmets and modified belts, holsters, elbow, and knee protection, and are armed with Seekins Precision automatic rifles and Glock 17 pistols, fearsome weapons all.

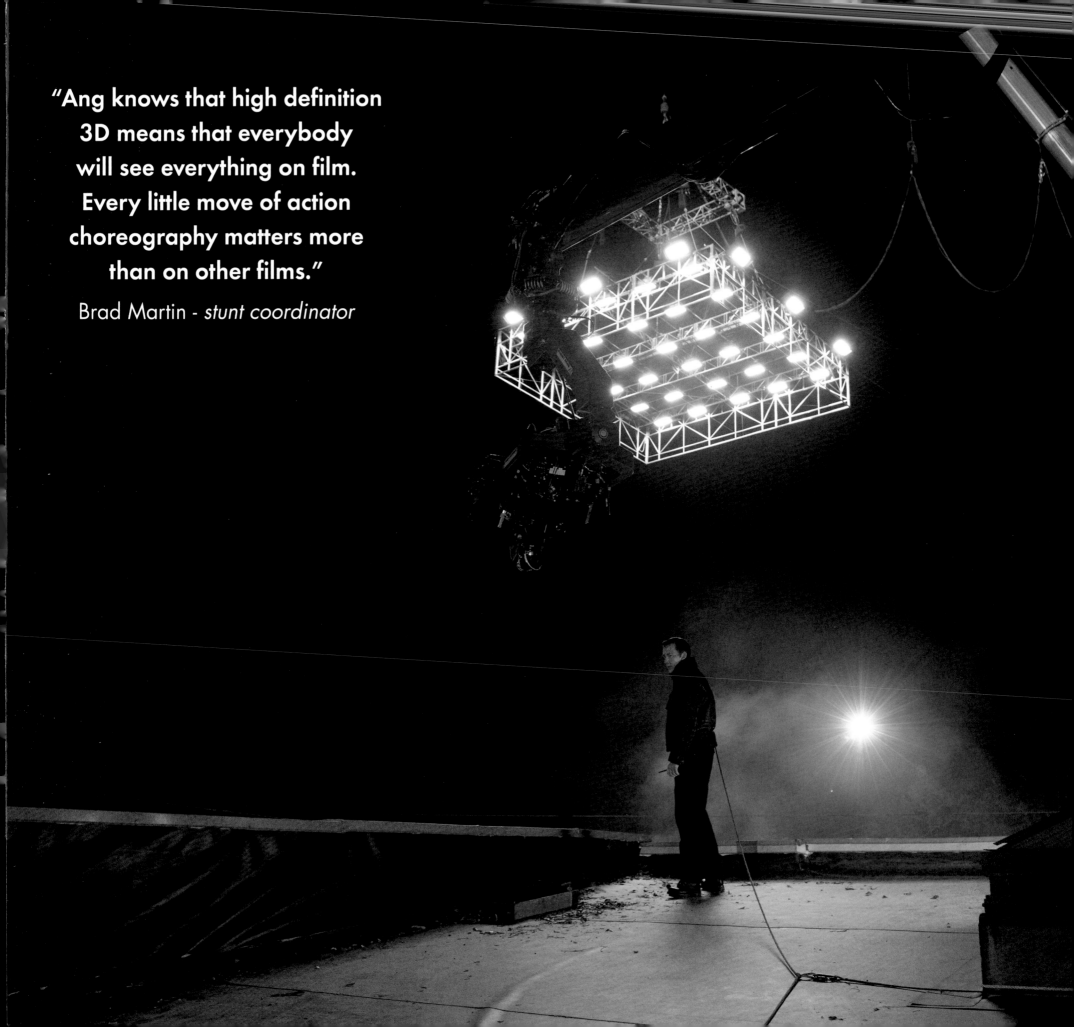

"Ang knows that high definition 3D means that everybody will see everything on film. Every little move of action choreography matters more than on other films."

Brad Martin - *stunt coordinator*

THE HARDWARE STORE

Crew members who worked from beginning to end on *Gemini Man* could be excused for seeing double when it came to one of the film's most important sets, the HammerTime hardware store in Glennville, Georgia, the site of a fiery and devastating climactic scene in the film. Indeed, while the façade and the interior front section of the store were part of a complete makeover that Guy Hendrix Dyas' art department did of the main street of the small town during the phase of filming in Georgia, that same façade, plus an entire huge interior, was constructed on Stage 4 of Origo Studios… 5,500 miles away from each other. "Our set decorator, Victor Zolfo, did an extraordinary job bringing an authentic American small town hardware store to life in a Budapest studio," says Dyas. "The front part is an absolute match for what we had in Glennville. We shipped a lot of these items here in a big container from the US. But just behind it is a huge, warehouse-like environment that's aged to feel like it's been here for two or three generations. The name HammerTime was sort of a 1980s take on what used to be called Hammer and Sons, which is kind of our in-joke. We have two arched roofs and a series of skylights, which play an important part in the story with Gemini elite troops closing in on a siege with Henry."

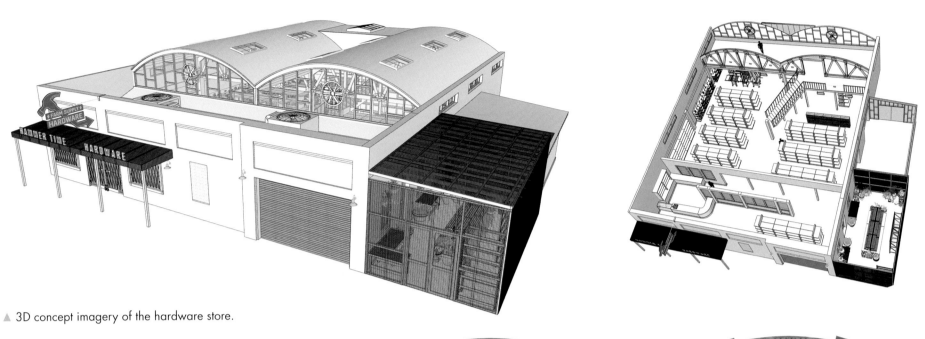

▲ 3D concept imagery of the hardware store.

▲ Construction of the hardware store

THE MASKED ASSASSIN

Henry's final, fiery stand against Gemini includes his battle with a terrifyingly skilled masked assassin who crashes down into the hardware store through a skylight and, as the screenplay describes, "seems to be moving without his feet even touching the ground. Fast, agile, smart, lethal." Notes Budapest stunt coordinator Brad Martin, "Our fight choreographer Jeremy Marinas has brought in, first all of, his talent, and second of all, his choreographing for tricking, which is a style of kicking, flipping, and utilizing martial arts. We've brought those elements into the masked assassin in this fight scene. Jeremy himself got into the suit of the character, and he was amazing. Our other stunt double for that character is Marko Zaror, who is also a 'tricker' in his own right and helped us choreograph some amazing and unique action."

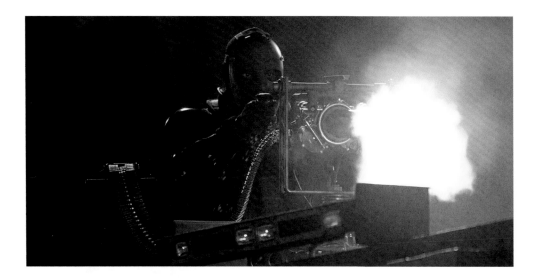

▶ Costume design concept by Suttirat Anne Larlarb.

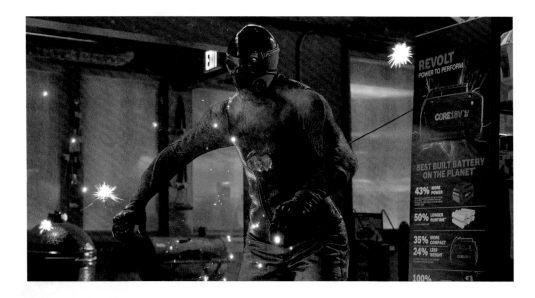

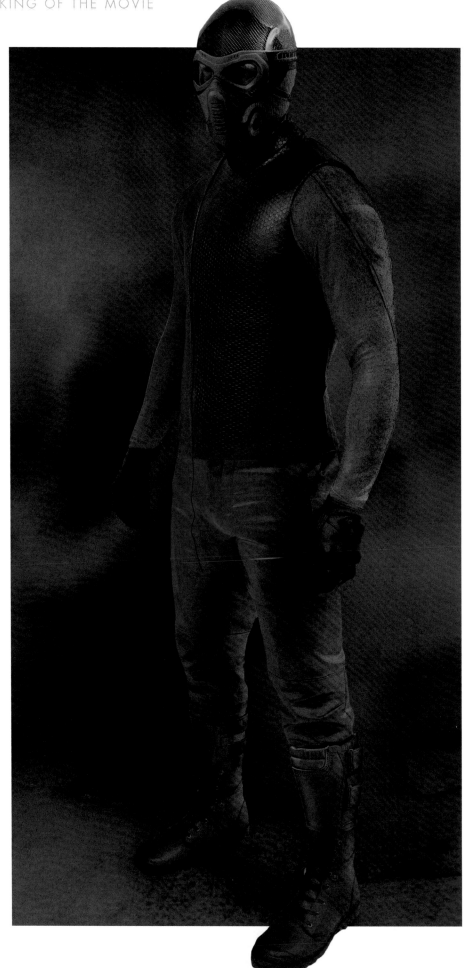

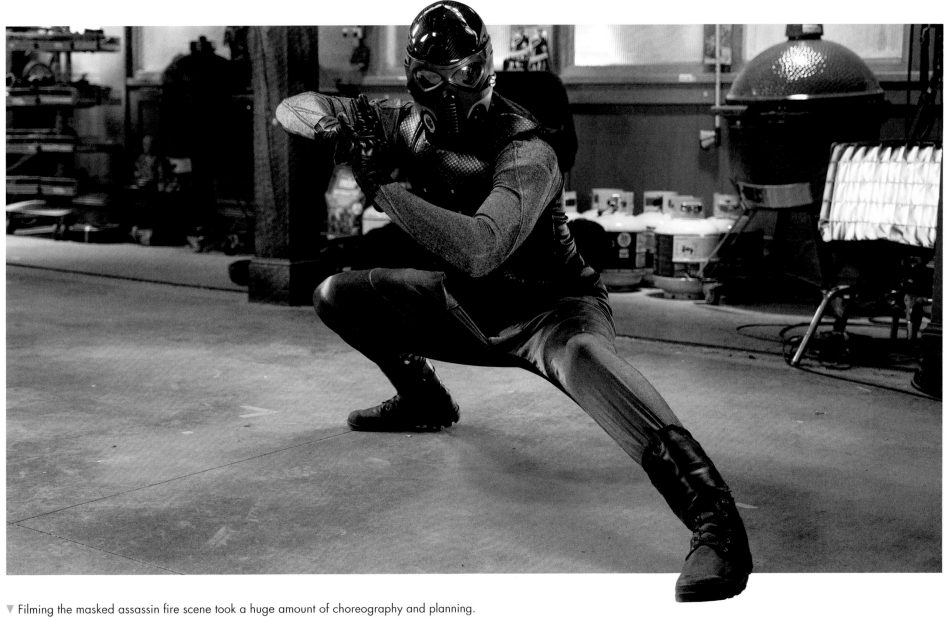

▼ Filming the masked assassin fire scene took a huge amount of choreography and planning.

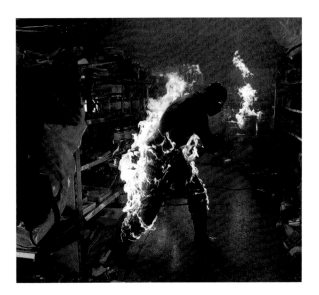

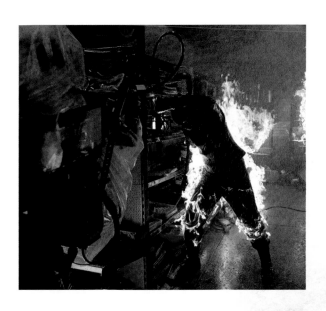

NEW IMMERSIVE CINEMA
AN EVOLUTIONARY LEAP

In 1903, at the dawn of both the 20th century and the history of motion pictures as a form of popular entertainment, the final shot of Edwin S. Porter's seminal *The Great Train Robbery* literally sent audiences ducking for cover or hiding under their seats when a medium close-up of the bandit leader fired his pistol point-blank directly at the camera. That was 116 years ago. Today, more than a century beyond, with all of the technological changes in how films are made, the viewing experience has remained much the same, and even with the development of color, sound, widescreen, and 3D, audiences are now immune to the startling immediacy that Porter utilized to call attention to something utterly new.

However, Ang Lee, one of the foremost creative filmmakers of our time and a relentless innovator, has, for several years, looked to new technologies as a means

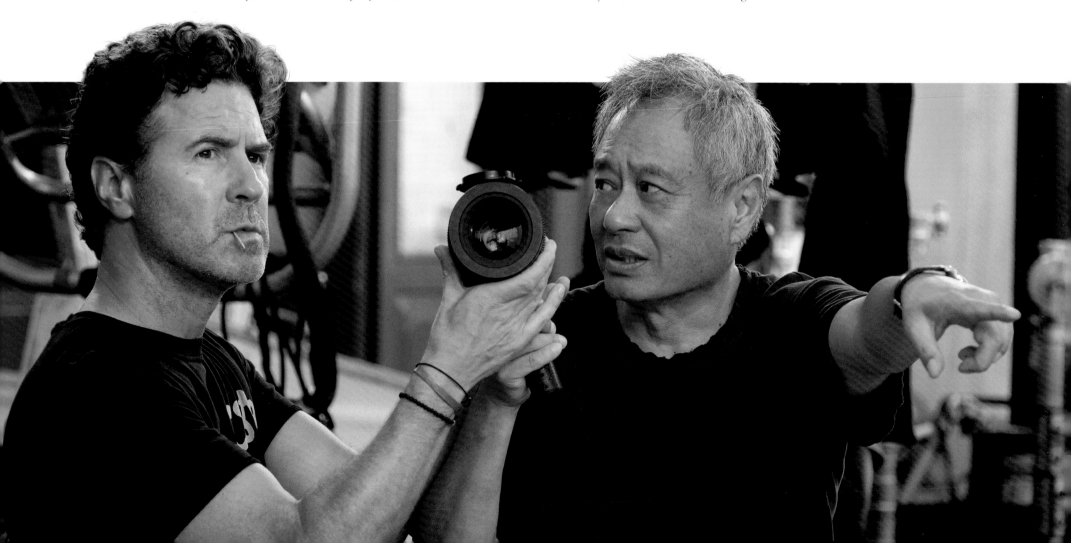

of pushing cinema, and the experience of viewing it, out of sheer passion for the medium… its history, its future, and its limitless possibilities. With *Gemini Man*, Ang Lee and his team, with the full support of his producers, Jerry Bruckheimer and David Ellison, are literally developing technologies never before seen, utilized or, in some cases, previously imagined. Which, for *Gemini Man*, means shooting the film in 4K resolution, 120 frames per second, in 3D, high dynamic range (HDR) with newly redeveloped ARRI camera equipment especially modified for the production resulting in a richer experience for the viewer on many levels. In addition, the visual effects and CGI technologies created for the film push beyond the envelope and into a whole new realm.

Says the film's technical supervisor, Ben Gervais, "There are several specific elements that define this new medium. The first is 3D, which itself demands digital capture because of the precision and accuracy of synchronizing the two cameras/eyes, which is the second element. When we see movies screened in 3D, our minds want to believe that the images in front of us are real, not a picture on a wall. This changes the viewer's mindset, and we become more aware of everything in the image, one of the first things we notice is a blurred, strobing effect. This effect, called judder, is much less noticeable in 2D, and in fact has become part of the 2D filmmaking aesthetic over time. As we watch the same effect in 3D, it becomes intolerable, and the way to mitigate it is through the third element: higher frame rate. At sixty frames per second, the strobe effect is nearly gone and the image becomes watchable. At 120 frames per second, the image becomes remarkably clear, and to achieve an unprecedented level of clarity, fine detail and the proper level of light, we will use 3.2K resolution, projecting the images at a brightness of twenty-

eight-foot lamberts per eye, through 3D glasses, which is four times brighter than the best 3D theatres available now, and eight times brighter than a standard 3D theatre."

"Since we have reduced or removed all of these previous limitations," says Ang Lee, "we now need a new kind of moviemaking. The combination of these elements: 3D, digital cinematography, high frame rate, high resolution, and increased brightness becomes 'new immersive cinema.' Because of the rich level of detail we gather, we are able to more directly read into characters through high frame rate." Ben Gervais points out that Ang Lee's interest in this incredibly advanced technology is at the service of story and character. "Your brain starts to treat what you're watching as something more real and intimate. You're more attached and can relate to the person on the screen more than you can watching a film at twenty-four frames per second. It doesn't give the viewer a choice to be a passive observer. Ang has one of the most intense respects for the history of film. He's not rejecting what's come before. What he wants audiences to do is to embrace something new." Adds 3D supervisor Demetri Portelli, "When we met Ang, he said we have to go as explorers and be pioneers of a new aesthetic. Ultimately, we have to serve a good story that people enjoy, and not to call attention to itself."

"In an action movie like *Gemini Man*," says Gervais, "we can take the audience on a rollercoaster ride with this technology that they've never experienced before. We've seen all the cool explosions that have ever been done on film, so how do we make it engaging in a different way? You immerse the audience in the story, make them feel that they're there, and make it visceral. And to bring them closer to the characters."

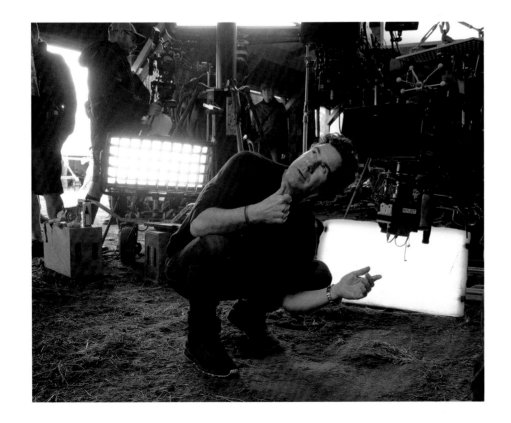

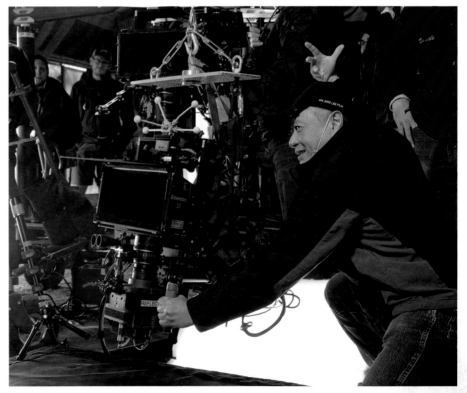

ACKNOWLEDGMENTS

To begin, thanks to Jerry Bruckheimer, David Ellison, Ang Lee, Will Smith, and every single one of the actors and crew members of *Gemini Man* who worked so lovingly on four exceptional locations: Savannah, Cartagena, Budapest, and New York City. To one and all, thank you, gracias, and koszonom! It was an honor and an unforgettable journey to share the set with so remarkable a company. All honor to unit photographer Ben Rothstein, whose talents are evident in the pages of this book, and I am grateful to production designer Guy Hendrix Dyas, costume designer Suttirat Anne Larlarb, VFX supervisor Bill Westenhofer, VFX producer Karen Murphy, VFX associate producer Yasamin Ismaili, and Weta VFX supervisor Guy Williams for their special contributions.

In addition to the man behind the company name, profound thanks to all of my colleagues at Jerry Bruckheimer Films, past and present, including Chad Oman, Melissa Reid, Charlie Vignola, John Campbell, and Hallie Reiss. My thanks and gratitude to everyone at Skydance Media, particularly Anne Globe for inviting me to write this book, as well as Sean McGinn and Wilder Heuga for their invaluable assistance. And I doff my hat to everyone I worked with at Paramount Pictures throughout production.

At Titan Books, editor Eleanor Stores was an absolutely wonderful collaborator and guide, the best I could have hoped for. And gratitude to Tim Scrivens for his beautiful design of the book.

A salute to Mark Herzog, Kimberly Panunzio, Jack Kney, and their great team at Herzog & Company.

And, as ever, endless appreciation and love to my wife, Yuko Kikuchi Singer, and our daughters, Miyako and Kimiko, who are forever my inspiration and my reason not only for being, but doing.

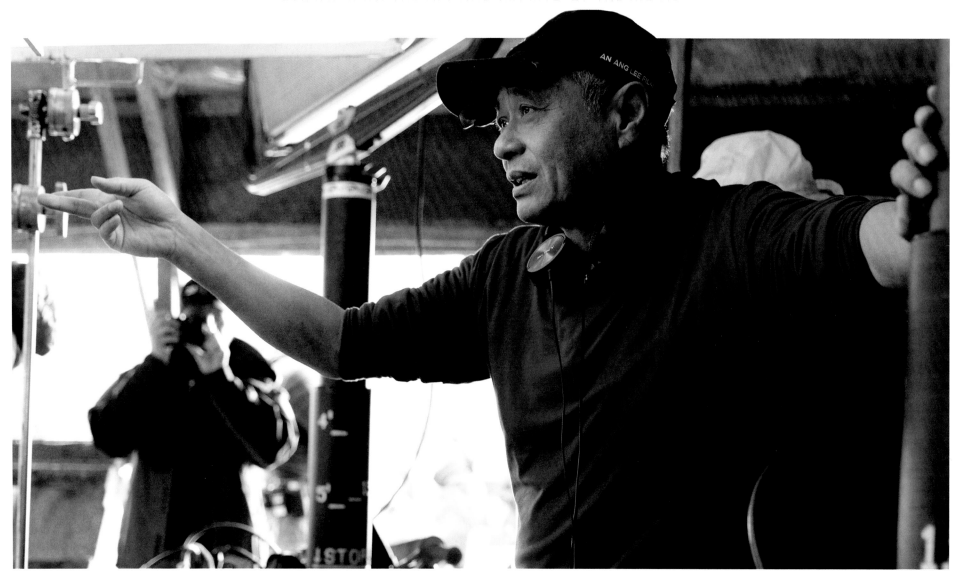

Says *Gemini Man* director of photography Dion Beebe, "Ang has faith in the power of this medium to tell visual stories as a heightened viewing experience. You throw out everything you thought you knew and start again. Ang would be the first to admit that he's learning and searching every day and trying to better understand and utilize it. This is certainly one of the hardest films I've worked on, but it demands that an audience sit up and pay attention."

Principal photography, which began with the banging of gongs and the lighting of incense in rural Georgia, ended with a spectacular display of celebratory fireworks in the skies above the Origo Studios backlot in Hungary. A gigantic, luminescent moon in a clear sky further illuminated the *Gemini Man* crew as they exchanged compliments and farewells. Ang Lee, so reserved and focused throughout the difficult shoot, warmly embraced every member of the cast and crew, and thanked them for their hard work and dedication. Ang Lee knew that he and the entire company of *Gemini Man* were taking a mighty and perhaps risky leap into the future, but he advised them to "stay alert, always question what you firmly believe in, and be willing to step out of your comfort zone. We must approach this new cinema with a new humility. We're at the very beginning of a new kind of cinema, and we have to be humbled to some degree. There is much to learn, but nothing yet to be taught. The only way for us to learn is to challenge ourselves, and to help each other figure it out through process. We must embrace the unknown, and relish exploring a new medium free of preconceptions and baggage. I believe that this is a new relationship between us and cinema. The way we engage with the cinematic experience would be fundamentally different: it's not interactive, but it is more immersive. The audience becomes participants when the moviemaker offers the invitation."